MW00528119

The Chaplin Machine

# The Chaplin Machine

Slapstick, Fordism and the
Communist Avant-Garde

Owen Hatherley

 Pluto Press

First published 2016 by Pluto Press
345 Archway Road, London N6 5AA

www.plutobooks.com

British Library Cataloguing in Publication Data
A catalogue record for this book is available from the British Library

ISBN  978 0 7453 3601 5  Hardback
ISBN  978 1 7837 1773 6  PDF eBook
ISBN  978 1 7837 1775 0  Kindle eBook
ISBN  978 1 7837 1774 3  EPUB eBook

Typeset by Pluto Press

Simultaneously printed in the European Union and the United States of America

# Contents

*Soldiers! don't give yourselves to brutes – men who despise you – enslave you – who regiment your lives – tell you what to do – what to think and what to feel! Who drill you – diet you – treat you like cattle, use you as cannon fodder. Don't give yourselves to these unnatural men – machine men with machine minds and machine hearts! You are not machines! You are not cattle! You are men! You have the love of humanity in your hearts! You don't hate! Only the unloved hate – the unloved and the unnatural! Soldiers! Don't fight for slavery! Fight for liberty!*

*In the 17th Chapter of St Luke it is written: 'the Kingdom of God is within man' – not one man nor a group of men, but in all men! In you! You, the people have the power – the power to create machines. The power to create happiness! You, the people, have the power to make this life free and beautiful, to make this life a wonderful adventure.*

*Then – in the name of democracy – let us use that power – let us all unite. Let us fight for a new world – a decent world that will give men a chance to work – that will give youth a future and old age a security. By the promise of these things, brutes have risen to power. But they lie! They do not fulfil that promise. They never will!*

*Dictators free themselves but they enslave the people! Now let us fight to fulfil that promise! Let us fight to free the world – to do away with national barriers – to do away with greed, with hate and intolerance. Let us fight for a world of reason, a world where science and progress will lead to all men's happiness. Soldiers! in the name of democracy, let us all unite!'*

Charles Chaplin breaks character in
*The Great Dictator* (1940)

# Introduction
## Americanism and Fordism – and Chaplinism

*Let's examine Lenin's views (in a London music hall) as reported by Gorky. 'Vladimir Ilyich laughed easily and infectiously on watching the clowns and vaudeville acts, but he was only mildly interested in the rest. He watched with special interest as workers from British Columbia felled trees. The small stage represented a lumber yard, and in front, two hefty fellows within a minute chopped down a tree of about one meter circumference.*

*'Well, of course, this is only for the audience. They can't really work that fast,' said Ilyich. 'But, it's obvious that they really do work with axes there, too, making worthless chips out of the bulk of the tree. Here you have your cultured Englishmen!'*

*He started talking about the anarchy of production under capitalism and ended by expressing regret that nobody had yet thought of writing a book on the subject. I didn't quite follow this line of reasoning but he switched to an interesting discussion on 'eccentrism' as a form of theatre art. 'There is a certain satirical and sceptical attitude to the conventional, an urge to turn it inside out, to distort it slightly in order to show the illogic of the usual. Intricate but interesting' [. . .] Let's analyse this extremely important excerpt.*

*1. Lenin is interested in eccentrics.*

*2. Lenin is watching the demonstration of real work.*

*3. He evaluates this first class work as senseless and wasteful: he talks about the anarchy of production and the necessity to write about it.*

*4. Lenin talks about eccentrism in art, a sceptical attitude toward the conventional, and the illogic of the usual.*

*The transition which Gorky missed is that the wastefulness,
and so to speak, the absurdity of the capitalist world could
be shown through methods of eccentric art with its sceptical
attitude toward the conventional.*
   Viktor Shklovsky, *Mayakovsky and his Circle* (1940)[1]

## Pick Up Your Pig Iron and Walk

In his 1911 book *The Principles of Scientific Management*, the
American industrial theorist and engineer Frederick Winslow
Taylor recounts how he managed to make an ox-like Dutch
immigrant called Schmidt carry a seemingly impossible
quantity of pig iron in his job at the Bethlehem Steelworks.
Taylor has already outlined how the precise measurement and
recording of a worker's most minute physical actions by specially
trained overseers can be collated, and calculated so as to plan
the most efficient series of movements for the purposes of
production. When the worker is trained to use these techniques
in their work, the result is massive increases in productivity.
The problem is that 'it is impossible for the man who is best
suited to this kind of work to understand the principles of this
science.'[2] So, Schmidt is teased by Taylor into increasing his
workload by asking him repeatedly if he is a 'high-priced man',
and dangling the possibility of a pay rise in front of him, if only
he will follow very precisely the dictates of the supervisor:

  Well, if you are a high-priced man, you will do exactly
  as this man tells you to-morrow, from morning till night.
  When he tells you to pick up a pig and walk, you pick it
  up and you walk, and when he tells you to sit down and
  rest, you sit down. You do that right straight through the

day. And what's more, no back talk. Do you understand that? When this man tells you to walk, you walk. When he tells you to sit down, you sit down, and you don't talk back at him. Now you come on to work here to-morrow morning and I'll know before night whether you are really a high-priced man or not.[3]

Barely able to speak English, as Taylor carefully records ('Vell – did I got $1.85 for loading dot pig iron on dot car to-morrow?'), Schmidt is nonetheless able to understand eventually what a pay rise means, largely via the harshness of the instruction and the focus on the money at the end of it, as:

with a man of the mentally sluggish type of Schmidt it is appropriate and not unkind, since it is effective in fixing his attention on the high wages which he wants and away from what, if called to his attention, he probably would consider impossibly hard work.[4]

'This goes on,' writes Bernard Doray in his study of 'Taylorism', 'until Schmidt "sees", and deluded by his desire to be well-thought-of, agrees to accept a fool's bargain which will allow him to make $1.85 by handling 48 tons of pig iron a day rather than making $1.15 by handling thirty tons.' Doray continues: 'There is something masterly about this. Were it not for the context, we might be dealing with a stage hypnotist or a circus act.'[5] This book is about people who imagined turning industrial labour into a circus act.

In the immediate aftermath of the revolutionary wave of 1917–19, there was perhaps a rather unexpected rise in enthusiasm among the revolutionary leaders for the seemingly oppressive and anti-worker methods being developed in the

industrial north of the United States of America, particularly by Taylor and the 'time and motion' theorists that came after him, and their apparent application in the immense, integrated car factories of Henry Ford. This reached its greatest extent in the new Union of Soviet Socialist Republics, where a former metalworker, trade union leader and poet in the Proletkult ('proletarian culture') movement named Alexei Gastev founded a Central Institute of Labour to train workers in the new socialist state in accordance with Taylorist principles, which had now been taken to the level of being applied even outside of the factory and in everyday life. At the same time, there was a massive rise in the distribution of American cinema and other forms of mass culture, particularly the 'slapstick' comedy of Charles Chaplin, Buster Keaton and Harold Lloyd, along with great adventurers and stars like Douglas Fairbanks and Mary Pickford. As a rule, these are treated as rather separate phenomena. At moments they clash, entirely by accident. In their work on the creation of the Soviet 'planned economy', E.H. Carr and R.W. Davies notice a critique of the new focus on the scientific management of labour, technocracy and assembly line production, summed up by Gastev in *Pravda* as accepting that:

> the time has gone beyond recall when one could speak of freedom of the worker in regard to the machine [. . .] Manoeuvres and motions at the bench, the concentration of attention, the movement of the hands, the position of the body, these elementary elements of behaviour become the cornerstone.[6]

At a conference of the Komsomol in 1928, we find a sharp reaction to this among young Communists. 'Chaplin, speaking

for the Komsomol, fiercely attacked Gastev's "anti-Marxist" platform (which makes) the worker an adjunct of the machine, not a creator of socialist production. Gastev in his understanding of the new worker is indistinguishable from Ford.'[7]

Here, Charles Chaplin's otherwise unknown namesake in the Young Communist League has prefigured the critique of Fordism and Taylorism that the man himself would make in his 1936 film *Modern Times*. But what if scientific management and slapstick comedy were not actually antipodes at all, but instead were closely linked and complementary phenomena?

## The Other American Dream

The setting for this book is an unplanned cultural exchange that took place between three poles. Two of these consisted of the Trans-European route that stretched from Weimar Germany to the USSR; a route common both to the Third International and the international Constructivist movement – which, in a nod to the Comintern itself, described itself in the early 1920s as the Constructivist International[8] – moving between Moscow and Berlin, with various stopping points in between – but with a difficult and ambiguous relationship with Paris, and a practically non-existent one with London and New York.[9] The two countries which are the poles of this movement, the Weimar Republic and the Union of Soviet Socialist Republics, were both the ambiguous product of socialist revolutions, largely administered by self-proclaimed Marxists, both using some form of mixed economy throughout the 1920s in the absence of the World Revolution which was seemingly in the offing between 1917 and 1923. The third entity is 'America'. This should not necessarily denote the actual political space of the United

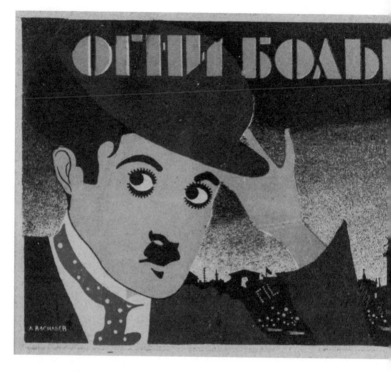

*Soviet Poster for Charlie Chaplin's* City Lights, *1934*

States of America, but a collection of ideas, technologies, mass produced art objects and archetypes. The United States is the home of the Ku Klux Klan, of the Pinkerton strike-breaking gangs, of the Red Scare and the mechanisation of labour; but 'America' is also the home of Charlie Chaplin, Henry Ford, Thomas Edison, Frank Lloyd Wright, awe-inspiring industrial monuments, mass abundance – and the mechanisation of labour.[10]

'America' was the place where humankind had begun to shape nature to its will, 'the Motherland of Industry', a land

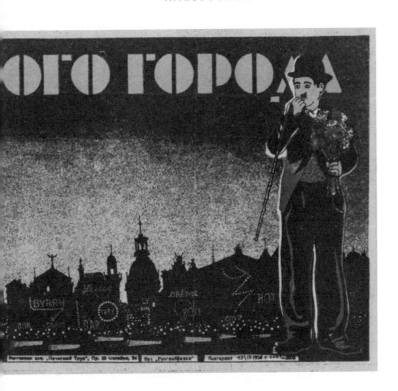

of social peace and astounding technological dynamism, and occasionally our protagonists had to remind themselves that it was also a political adversary. Yet the fact that very few of the figures who will populate this book actually visited the United States, and that even those who did formulated their ideas about 'America' beforehand, meant that for them America was a dream, not a place. It was, in fact, the locus for a gigantic act of collective dreaming on the part of both political activists and politicised aesthetes, as well as a focal point for the populations they attempted to mobilise (or whose mobilisations they

were forced to respond to). 'America' was, then, for the political aesthetics of the Moscow–Berlin axis in the 1920s, a series of dream-images – fantasy projections conveyed in architectural projects, in poetry, in advertising and propaganda posters, attempts to will an Americanised communism into being via imagination and reverie.[11]

To a large degree, previous analyses of these dream-images, such as Richard Stites' *Revolutionary Dreams*,[12] Susan Buck-Morss' *Dreamworld and Catastrophe* and Stephen Kotkin's *Magnetic Mountain*, have focused on the element of industrial dreaming that is common throughout the period. For all its virtues, this can lead to neglect of the popular, collective and directly political elements in this dreaming. Accordingly, it is necessary to discuss Chaplin *and* Ford *and* Lenin, to connect Edison *and* Frank Lloyd Wright *and* Walter Rathenau – to discover a more conflicted, comic, collective form of American dreaming. The deep involvement in 'American' popular culture on the part of the Constructivist avant-garde does not fit with the occasionally still prevalent notion of an elitist high modernism aloof from popular forms and mass culture. Yet, what took place in the 1920s was a reciprocal process, a tense and ambiguous dialogue. In this, the Constructivist obsession with American mass media could not be further from the more recent celebration of popular culture as consisting in little 'resistances' against sundry 'totalising' forces, whether state power, class analysis, economic planning or modernism itself. This was one of the central claims of postmodernism in the 1980s, emerging at a couple of removes from the notion of popular subcultures as a form of 'resistance through rituals', developed by the likes of Dick Hebdige and Stuart Hall at the Birmingham School of Sociology. By contrast, the 1920s largely didn't see an uncritical celebration of popular culture, or a patronising elevation of

an undialectically formulated 'popular taste' above the efforts of intellectual avant-gardes. Rather, there were a series of critical engagements, where certain elements in a given object or form would be borrowed, some emphasised, while others were rejected as reactionary or not politically useful.[13]

These dream-images are not purely celebratory, and nor are they purely Fordist and Platonic – they are thoroughly historicised, and they undergo a series of morphings and warpings depending on place and politics. The same photograph – and it is usually a photograph of 'America', rather than a first-hand experience – becomes a multitude of different images. The parameters of the present work are, as we have noted, summed up in a series of proper names: Ford plus Chaplin plus Lenin. This work aims to give all three equal emphasis, displaying and analysing in its fullness the interplay between industrial organisation, comic entertainment and socialist politics in the aesthetics of the avant-garde. This is in order to treat the political aesthetics of the time in immanent terms, welding each element together, rather than imposing a Cold War (or post-Cold War triumphalist) grid on them. If at one point histories of the avant-garde were criticised for emphasising aesthetic affinities and alliances rather than political affinities, it seems that now the reverse move must be made – to emphasise the concrete centrality of the political context.[14]

Bertolt Brecht claimed in 1932 that 'photography is the possibility of a reproduction that masks the context. The Marxist (Fritz) Sternberg [. . .] explains that from the (carefully taken) photograph of a Ford factory no opinion about this factory can be deduced.'[15] This is no doubt true of the industrial propaganda and *Neue Sachlichkeit* industrial photography he was referring to, and while a single photograph of a factory can tell us very little about the direct relations of production

inside, it can communicate an enormous amount of political–aesthetic information when placed in historical and political context, and when arranged in contrast with other images – a montage principle favoured by Brecht himself. So, here, we put into juxtaposition particular images and objects from the Berlin–Moscow–'America' axis as political and aesthetic dream-images. The various dreams are not, however, considered to be of equal political value. The dreamers range from industrialists to aesthetes, from proletarians to bureaucrats, from architects to propaganda designers, and the oneiric energies they convey with each image shift each time that it is morphed and adapted.

It is important to tie this closely to the processes of revolution, reaction and reform that link the revolutionary period of 1917–23 with the consolidation of Stalinism and Nazism in 1933–36. We must not patronise Constructivism as a kind of aestheticism of politics and machinery that only affixes itself to politics through an aesthete's fetishisation.[16] A generation which battled through civil war, revolution and the privations of what can now be seen as an abortive attempt at creating socialism, does not deserve to be treated as naive and unworldly. In addition, while I will be careful not to present an avant-garde that corresponds with my own political predilections, and have no intention to ignore domination when I see it, the present work takes particular issue with Boris Groys' view of the Constructivist avant-garde as a proto-Stalinist experiment in Hegelian totalisation; this is buttressed by a reading of the particularly extravagant writings of Kasimir Malevich and, more seldom, of a couple of writers from LEF, in *The Total Art of Stalinism*.[17] It is a smart work of satire and an insightful attempt to inhabit the Stalinist mindset, but it is a book which should never have been taken seriously as a work of avant-garde

scholarship, so flagrant is it in its extrapolation from minimal sources into the description of a large and multivalent political–aesthetic movement.

The 'dream-images' discussed in this book consist mostly of mass-produced forms like cinema and poster design, which are discussed both through direct analysis and via the contemporary observations of both Soviet contemporaries and the international visitors that Trotsky contemptuously described as the '*flâneurs*' of the Soviet Union.[18] The accounts of travellers between America, the Weimar Republic and the USSR are sporadically used, both as a means of delving directly into the atmosphere of the period, and to comment on the sometimes remarkable, often disastrous geographical reach of the Comintern. These accounts often stress a choice between competing 'new worlds'; the reformed capitalism of post-war Central Europe, the Bolshevik experiment, and nascent Fordism in the USA. Ernst Toller's posing of this wager is typical:

> both [the USSR and USA are] young and with unimpaired belief in their own strength. But the America of today, controlled by a small section of callous financiers, *was* the Land of the Future. Russia *is* the Land of the Future.[19]

## Life Slap-Up

Let's begin with an 'obvious' example, one where 'America' appears to be attacked by the moralising Soviets. Dziga Vertov's 1926 documentary film *One Sixth of the World* is a panoramic picture of the industries and peoples of the Soviet Union, composed as a publicity film for Gostorg, the USSR's foreign trade corporation, and it begins with an image of

*The 'Chocolate Kiddies'*, One Sixth of the World

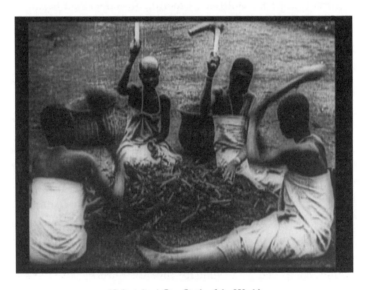

*'Colonialism'*, One Sixth of the World

that which the Soviet Union is not. A black American jazz band[20] plays furiously, with the players losing themselves in their gestures and emphases, while affluent whites shimmy and foxtrot with similar abandon. This, Vertov's intertitles unambiguously declare, is the decadence of a dying class, the dance as the system goes down; and it is immediately contrasted with images of share-cropping, and of black labourers in Europe's African colonies, linking the bourgeoisie's enjoyment of jazz to their exploitation of Africans and African-Americans.

Yet there is something more complex at work than a mere juxtaposition of bourgeois leisure and exploited labour. Elizaveta Svilova's fast-cut editing picks up the pace of the dancers, cuts precisely to their rhythmic movements, creating a pace and pulse which continues through the rest of the film. The American pop-cultural form may seem like the opposite of the gigantic revolutionary enclave, but this is deceptive. Instead, the avant-gardist Vertov takes what he requires from it – the metropolitan dynamism of its rhythm and pace – while refusing to ignore the networks of exploitation of which it is a part. Vertov and Svilova's sect, the 'Kinoks', were at the edge of the Soviet avant-garde that was *most* critical of American importations, with Vertov's frequent blasts against the fiction film, whether it be 'Dostoevsky or Nat Pinkerton'. However, even the famous slogan of the Kinoks, usually translated as 'life caught unawares', has resonances which suggest comedy as much as revolutionary high-seriousness. Ben Brewster translates the phrase as 'life slap-up'.[21] Post-revolutionary life slipping on a banana skin, a pratfall, as a vertiginous and hard-to-negotiate new space – the world turned upside down.

Life slap-up can not only be seen in the unexpected corners of the urban environment captured against their will by Vertov

and the Kinoks' Kino-Eye, but it can also be found in imaginary, prospective space. After Vladimir Tatlin's Monument to the Third International, the first major Constructivist environments are sets for theatrical comedies. Liubov Popova's set for Meyerhold's 1922 production *The Magnanimous Cuckold* or Alexander Vesnin's for Alexander Tairov's *The Man Who Was Thursday* are the exemplars; their open-frame, industrial scaffolds and moving parts create a comic environment where the ground can be literally moved from under your feet, inspiring as a means of dealing with a new kind of physical movement. It is these alignments – the political critique of, and dynamic sympathy for, American mass culture; the conception of contemporary urban life as necessarily comic, as 'slapstick', containing plenty of 'new stupidities' as well as revolutionary new forms; the creation of a new comic space, via both architectural and directly physical means – that will run through this book. Americanism here is *Chaplinism*.

## American Montage and Comic Geography

One of the most complete statements of Chaplinism is in Lev Kuleshov's *Art of the Cinema*, published 1929 in Moscow. He describes the birth of the Soviet filmic avant-garde as the result of a critical laboratory analysis of the American film and its component parts.

We began to analyse not only separate shots of a film but studied its entire construction. We took two films, for example – an American one and a comparable Russian one – and we saw that the difference between them was enormous. It became apparent that the Russian film was

constructed of several very long shots, taken from one given position. The American film, on the other hand, at that time consisted of a large number of short shots taken from various positions, since it can be explained that for the price of admission the American viewer pays at the theatre, above all else, he wants to receive the maximum degree of impressions, *the maximum degree of entertainment, and the maximum degree of action in return.* [Italics mine] [22]

This sense of maximised sensation, of an overwhelming on-rush of impressions, is the direct effect of the American film, one which can then be adapted for the purposes of Soviet left art. Kuleshov continues:

thus, thanks to the commercial determinant of the American film, thanks to the very tempo of American life, much more accelerated than the tempo of Russian or European life, thanks to all this, what struck the eye watching the American films is that they consist of a whole series of very short shots, of a whole series of short sequences, joined in some determined order of priority – as opposed to the Russian film, which at that time consisted of a few very long scenes, very monotonously following each other. Working further, on comparing an American film to a Russian one in order to test its effect on the viewer, we became convinced that the fundamental source of the film's impact on the viewer – a source present only in cinema – was not simply a showing of the content of given shots but the organisation of these shots among themselves, their combination and construction, that is, the inter-relationship of shots, the replacement of

one shot by another. This is the fundamental means of the impact of film on the viewer.[23]

This was internalised by the Soviet directors to the point where, when he writes in 1929 that 'short montage was then called American montage; long montage – Russian', he knows that at the time of writing the order has been reversed.

> All that is well done in Soviet cinema is done by this method [. . .] But while the Americans were the origina-tors of it, now we, having developed and used that which was conceived by the Americans, are carrying the work to a new frontier [. . .] what I am going to deal with now will, I think, appear simply amusing to everyone. It is so naïve, so primitive, and so obvious. But at that time (and that time was rather recently) it seemed to be such 'incredible futurism' that a bitter battle was waged against it.[24]

But most fascinating for our purposes, Kuleshov describes, as his exemplar of the possibilities inherent in this Soviet–American montage, the use of tricks to create an imaginary, comic geography.

> The primary property of montage, which is now perfectly clear to everyone, but which had to be defended rabidly and with inordinate energy then, consists in the concept that montage creates the possibility of parallel and simul-taneous actions: that is, that action can simultaneously be taking place in America, Europe and Russia: that three, four or five story lines can be edited in parallel, and in the film they would be gathered together.[25]

So, for example,

> Khoklova is walking along the Petrov street near the
> 'Mostorg' store. Obolensky is walking along the embank-
> ment of the Moskva river at a distance of about two miles
> away. They see each other, smile, and begin to walk toward
> one another. Their meeting is filmed at the Boulevard
> Prechistensk. This boulevard is in an entirely different
> section of the city.[26]

This much is simple enough, and would only strike a Muscovite
as strange. But then,

> they clasp hands, with Gogol's monument as a back-
> ground, and look – at the White House! At this point,
> we cut in a segment from an American film – The White
> House in Washington. In the next shot they are once
> again on the Boulevard Prechistensk. Deciding to go
> further, they leave and climb up the enormous staircase of
> the Cathedral of Christ the Saviour. We film them, edit
> the film, and the result is that they are seen walking up
> the steps of the White House.[27]

In this sense, 'America' is suddenly enormously close – but the
dream is parodic.

However, the 'Americanism' of Kuleshov's theory does not
end there – it continues into an incorporation of Taylorist
Time and Motion study into acting. First, it is for the sake of
clarity, perhaps in order to restore some sort of visible order
via the human body, in a context of fast-cut near-chaos. 'If a
person is to move on all these fundamental axes of his bodily

parts, and their combinations of axial movements, they can easily be apprehended on the screen, and a person working can take his work into account at all times and will know what he is about.'[28] These new movements must be incorporated to the point where they are no longer even thought about:

> the whole secret to driving a car lies in its being driven automatically: that is, one doesn't consciously think about when it is necessary to shift gears, as all of this done mechanically and instinctively [. . .] the qualified film actor, whose entire technique is calculated to give a comfortable reading of his screen performance, is the result of exactly this same sort of training.[29]

It is enormously telling that Kuleshov uses these Fordist metaphors in describing the movement of the human body in the new Constructivist comic film. Comedy and scientific management, defamiliarisation and discipline are inextricable.

## Chaplin versus Ford

Ironies abound in the transmission of American forms, and those Kuleshov points out are not the least of them. It is interesting, although perhaps not surprising, that dissections of the 1920s cult of Americanism concentrate on that element which is most amenable to the 'totalitarianism' thesis. That is, the notion current during the Cold War and given an enthusiastic reinvigoration by Boris Groys in the last couple of decades: that most if not all elements in early Bolshevik culture pointed towards an inevitable expansion of domination and total control over every element of life. Certainly, there are many

elements which support this thesis. Taylorism and Fordism – notwithstanding the arguments for their usefulness to the cause of working-class advancement in the corpus of Lenin or Gramsci, either as labour-saving methods or as a destroyer of the remnants of craft traditions and peasant mentalities[30] – are clearly practices which lead to the precise managerial control of the worker; and as Doray points out, this over-determines their 'scientific' nature. Writing in the 1980s, he stresses that:

> scientists regard (Taylorism) as a perversion of the scientific approach because it bears the scars of the social violence that characterised the society that gave birth to it. Aspects of reification which the scientist would regard as normal in the experimental context become unbearably offensive when they are blatant indications of a certain style of social life.[31]

This would seem to be an incontrovertible point. Scholars of Taylorism and Fordism such as Mary Nolan put the interest in it on the part of the post-revolutionary European left as a sign of deficient political imagination: 'the shared productivism and technological determinism of the Second and Third Internationals led to a shared inability to imagine any forms of production other than highly rationalised ones.'[32] In the process, they participated in enforcing forms of work that workers found depressing, tedious and physically painful, and accepted only when the trade-off was higher wages and consumer goods – and sometimes, not even then.

The deployment by Constructivists of these ideas and techniques in areas that are not directly productive, such as film and cinema, as described above by Kuleshov, but most famously in the biomechanics of Vsevolod Meyerhold, would seem to

involve extending that domination to the sphere of entertainment and contemplation. This in turn apparently links up with Leninist, vanguardist politics to the point where a technocratic theory of total control becomes a Bolshevik *gesamtkunstwerk*; where culture, like scientific management is imposed upon the worker, with the avant-garde (in the sense of the various collectives of 'Left' artists, whether those associated with the Bauhaus and the Ring in Germany or the circles around LEF and October in the Soviet Union) playing at being cultural Leninists, fighting over which of them gets to dominate the benighted (but ever more valorised) proletariat. This argument has some truth, but conspicuous is the tendentious removal or downplaying from the historical record of a major component of (principally Soviet) Americanism as it was formulated by the various (anti-)artistic avant-gardes. The texts of Americanism are often based on a litany of proper names: Lenin, Taylor, Ford, Edison – and more often than not, Griffith, Fairbanks, Pickford, Keaton, and most of all, with references in texts of the periods rivalling perhaps only Taylor in their frequency – Chaplin.[33] Americanism was a modernity not only of technological advancement, advanced tempos and Taylorist regimentation of the worker's body, but also of an unprecedented engagement on the part of those allegedly representing 'high art' – experimental, 'leftist' film-makers, designers, theoreticians – with 'popular' forms of art, whether it was the imported 'vulgar' comic cinema, the circus, the burlesque or jazz. In all of these, the body's mechanisation is the generator of pleasure, not merely a conduit to the increased production of pig iron.

However, there is very little in English on the obsession with comedy on the part of the Modernists of the 1920s. Nor is there any serious discussion of why Chaplin was such an

obsession for the avant-garde – for everyone from Adorno to Brecht, from Meyerhold to Tretiakov – or of what his example, and attempts to emulate, adapt or mutate it did to art and aesthetics in the period;[34] not to mention the other American comedians such as Buster Keaton or Harold Lloyd, who can also be found as objects for intense dialectical argument at that time. This is absent from even the most intelligent, least Cold War-tainted works which touch on the conjunction of Socialism and Americanism. Richard Stites' *Revolutionary Dreams* has a wealth of hugely important, fascinating information on Americanism as Taylorism, as Fordism, or as earnest science fiction, but absolutely nothing on Americanism as comedy, either in the sense of popular consumption or avant-garde fixation and adaptation; and Susan Buck-Morss' *Dreamworld and Catastrophe*, even while discussing the motif of the Circus in the mass art of the 1930s as a mass ornament common to Busby Berkeley and the Stalinist musicals of Alexandrov, fails to notice the far more disruptive, far more emancipatory (in the sense of being both individualistic and egalitarian) uses of exactly the same form in the early 1920s. Chaplin only features as a minor walk-on part in the biography of Sergei Eisenstein.[35]

This makes it easier to dismiss or patronise the conjunction of Socialism and Americanism as a merely positivist, technocratic phenomenon, driven by Russian industrial immaturity or a cultural fixation on hygiene and the aestheticisation of technology and, by association, politics. A particularly fine example of this argument can be found in the criticism of Peter Wollen, specifically in the collection *Raiding the Icebox*. The most extensive treatment is in the essay 'Modern Times: Cinema/Americanism/The Robot'. Wollen is undoubtedly erudite on the subject, referencing Alexei Gastev's Proletkult-Taylorist

experiments and some Soviet experiments in slapstick, so giving at least some attention to the other Americanism. However, it is merely as a cursory mention in amongst a parade of quickly dismissed Fordists, describing and then dismissing as bounded by a limited technocratic notion of rationality first 'Gramsci, the Vienna Circle and the Stalinist productivists',[36] and later Benjamin and Brecht. The argument runs that Americanism leads to Taylorism, which leads to automation, all of which leads to a fixation on what is not only a superseded form of capitalism, but one which merely extended domination. So Chaplin features only as the anti-Fordist of 1936's *Modern Times*, but certainly not as what we will argue he was to the 1920s' avant-garde: a mechanised exemplar of the new forms and new spaces enabled by the new American technologies, and one who promised a liberation that was decidedly machinic in form. Where Wollen does discuss the avant-garde's actual engagement with popular forms, for him it somehow still remains technocratic positivism. So, for instance, on jazz, in an essay titled 'Into the Future: Tourism, Language and Art', he writes:

Constructivism was closely linked to the Americanism that swept Europe in the twenties, the so-called jazz age. Jazz was perceived as both stereotypically primitive and ultra-modern, machine-like [. . .] as Le Corbusier put it, with shameless projection [. . .] 'the popularity of tap-dancers shows that the old rhythmic instinct of the virgin African forest has learned the lesson of the machine and that in America the rigour of exactitude is a pleasure' – and the jazz orchestra in Harlem 'is the equivalent of a beautiful turbine' playing a music that 'echoes the pounding of machines in factories'(!) [. . .] in this racist vision, black America was taken to be a fascinating

synthesis of the 'primitive', and the 'futuristic', the body and the machine.[37]

Popular form is inevitably exoticised, patronised and mythologised when the Constructivists attempt to engage with it. Perhaps it would be better left alone. But irrespective of the patronising hauteur and hint of colonial fantasy in Le Corbusier's argument, he appears to have had a far more insightful take on black music of the twentieth century as actually described by its practitioners, than does Wollen. Not only are there the innumerable records that describe the jazz, rock and roll or funk band as a machine (unsurprisingly, most often a train), or phenomena such as the video to Martha and the Vandellas' 'Nowhere to Run', where the clang of the beat is synchronised with the machines in the Ford factory in Detroit, there is also James Brown's definitive coinage, which essentially reduces Corbusier's florid prose to two words: 'Sex Machine'.[38] The central problem of the dialectical tension between Chaplinism and Fordism, or Slapstick and Biomechanics, is exactly the one Wollen haughtily considers racist. That is: what happens to 'popular' forms when they become mechanised? What in the advanced mass-produced culture of the present can possibly presage the culture of the communist future, if anything? Can anything be learned from these phenomena, or are those ideas and forms so scarred by the brutalities of the society that produced them that they could not possibly be useful for a better society? Specifically in this case, does any of it promise a world in which the machine can be reconciled with a pleasure in excitement, movement, and participation, or is such a reconciliation impossible?

## The Americanist Surplus

In strictly political and historical terms, the conception of
'America' in the 1910s–1920s, and especially in terms of
Taylorism and Fordism, was predicated on a fiction, a kind of
productive misunderstanding, and a susceptibility to industrial
public relations. Few serious analyses of Ford and the period he
named concur with the idea held by some in the avant-garde
that Fordism was part of the same emancipatory movement as
socialism and Chaplinism. On one level, this was a matter of
simple invention; John Kenneth Galbraith pointed out that, with
respect to Ford's self-lauding writings, 'immodesty should not be
hinted, as [Ford's books] were written to the last paragraph by
Samuel Crowther.'[39] The awe his factories elicited in its many
*flâneurs* had more to do with their own inexperience of industrial
production rather than the advancement of the technology itself.

> Authors visited Highland Park, where the moving
> assembly line was born [. . .] and thereafter the vast plant
> on the River Rouge, and their only problem was to find
> adjectives to fit the marvels. For many, the wonder was
> unquestionably heightened by the fact that these were the
> first manufacturing plants they had seen.[40]

But most important, there was a fundamental misunder-
standing about Ford, and the new mass-production economy
he embodied, and its workers. The 'Five-Dollar Day', the high
wages which were the 'carrot' to the assembly line's 'stick', and
the affordable car were highly praised on the European left in
the 1920s. Few noticed how these were achieved and main-
tained, and how this oppression actually increased in parallel
with the intensity of interest in Fordism:

[the price of the Model T] was brought down by taking it out of the men. [The supervisors] were masters of the speed-up. In 1914, the Highland Park plant was no doubt a pleasant and remunerative place to work. By the mid-twenties the River Rouge, by even the most friendly evidence, was a machine-age nightmare.[41]

To a socialist historian such as Mike Davis, in his working-class history *Prisoners of the American Dream*, this misunderstanding had dramatic consequences, largely predicated on the failure to notice how the development of the new productive technologies were combined by a relentless assault on labour:

the new mass production technologies (advanced) side-by-side with the new forms of corporate management and work supervision. The totality of this transformation of the labour process – first 'Taylorism', then 'Fordism' – conferred vastly expanded powers of domination through its systematic decomposition of skills and serialisation of the workforce.[42]

Yet at the same time, it was achieving genuinely remarkable technical feats. He notes that: 'The productivity revolution represented by the new labour processes resulted in an almost 50 per cent increase in industrial production between 1918 and 1928, while the factory workforce actually declined by 6 per cent.'[43] It is this ability to produce on an untold scale that attracted those who were considering how to organise a post-capitalist economy.

It was at the same time the very thing which caused, eventually, militant opposition and resistance. Davis notes that the upsurge in union activity in the 1930s, which fed into

the Committee for Industrial Organization's (CIO) split from the craft and business unionism of the American Federation of Labour (AFL), was predicated on the new technologies of production and control themselves.

> When the industrial uprising finally began in 1933, it was not primarily concerned with wages or even working hours [. . .] in a majority of cases the fundamental grievance was the petty despotism of the workplace incarnated in the capricious power of the foremen and the inhuman pressures of mechanical production lines.[44]

Fordism meant not just monotony, machinic repetition and the elimination of thought in labour, but also a physically violent regime of enforcement.

> It must be recalled that in 1933 the typical American factory was a miniature feudal state where streamlined technologies were combined with a naked brutality that was the envy of fascist labour ministers. In Ford's immense citadels at Dearborn and River Rouge, for example, security chief Harry Bennett's 'servicemen' openly terrorised and beat assembly workers for such transgressions of plant rules as talking to each other on the line.[45]

Yet at the same time, the new unionism of the Committee for Industrial Organization was industrial in nature – unlike the American Federation of Labour, it did not appeal to craft tradition or to the dangers of deskilling, and it was subject early on to marked Communist influence. It accepted mass production in principle, but not its application as a tyrannical system of discipline.

However, when it comes to the travels of this Americanism abroad, certain things are missed in this account. Davis writes that:

> the first crusade to mobilise Americanism as a counter-vailing world ideology was sustained, after the signing of the Dawes Plan, through the brief but extraordinary Weimar boom of 1925–9, which prefigured many of the ideological and political relationships of the 1950s. As American loans put German workers back to work, there was a naïve and euphoric celebration of Henry Ford's Brave New World across the Atlantic. However, with the collapse of the American economy in 1929 – largely as a result of the all-too-successful anti-labour drive of 1919–23, which halved the AFL's membership and froze mass incomes – the temporary honeymoon of German social democracy and the export sector of German industry also broke down. In the wake of Americanism's failed promise, brutal homegrown idylls replaced the flirtation with jazz and the Model T.[46]

This is true enough, but it misses the sheer breadth of the enthusiasm for this Brave New World, which encompassed the Second and Third Internationals and even more libertarian left circles, and actually predates the Weimar boom. Soviet Taylorism begins as early as 1919, with Lenin and Gastev's first attempts to 'adapt' it; and in Germany, it coincides, in the same year, with the moment of Expressionist, Spartacist fervour. The Berlin architect Bruno Taut's magazine *Frühlicht* imagined that the crystal cities on mountains serving a new working-class community might be built with an adaptation of the Taylor system. The architect and trade unionist Martin Wagner

even envisaged Taylorism being implemented by the workers' councils that emerged in the aftermath of the November 1918 revolution.[47] Why did this occur? Why was a system of evident capitalist domination so popular among Marxists and a Marxian avant-garde?

Here, we'll come up with two explanations for this apparent paradox. First, the political and aesthetic avant-garde were dedicated to taking whatever was the most advanced technical form – what was producing the most advanced machines, what was achieving feats of mass production – and assessing it and finding out how it worked; and this was then melded with an appreciation of American popular culture, all of it linked in some manner to the new industrial methods, whether skyscrapers or slapstick. Second, it most often involved a form of *anticipatory* thinking. In short, this can be summed up by the rhetorical question – in the light of the proletarian revolution, what can we, the dictatorship of the proletariat, do with artefact or method 'x' of advanced capitalism? As a result, their works created a socialist surplus, through the dreaming that the Americanist form of domination unintentionally created. The intention was to take America and make it better, make it more equal, make it socialist. This was not a naive or unworldly project, but a serious and revolutionary one.

It is in this sense that we should read what two of the more famous sympathetic analyses of Americanism from the Marxist left – both from observers who were also sympathetic to modernist aesthetics – have to say about where 'America' does not go far enough. Antonio Gramsci's 'Americanism and Fordism', for instance, makes a link that is central to this thesis, between Trotskyism, Americanism and the transformation of everyday life. But he then goes on to write something that embodies the practically limitless tensions, the potentials and

threats, in any socialist adaptation of these American models. Gramsci argues that the new mass-production American capitalism represented 'the biggest collective effort to date to create, with unprecedented speed, and with a consciousness of purpose unmatched in history, a new type of worker and of man'. He can clearly tell how outrageous this might sound to an active fighter against the 'rationalisation' imposed by business – for instance at the Fiat plant where Gramsci was embroiled in a near- insurrection in 1920, which took place in the most complete example of American industrial architecture in Europe.[48] So he continues,

> the expression 'consciousness of purpose' might appear humorous to say the least to anyone who recalls Taylor's phrase about the 'trained gorilla'. Taylor is in fact expressing with brutal cynicism the purpose of American society – developing in the worker to the highest degree automatic and mechanised attitudes, breaking up the old psycho-physical nexus of qualified professional work, which demands a certain active participation of intelligence, fantasy and initiative on the part of the worker, and reducing productive operations exclusively to the mechanical, physical aspect.[49]

What he is saying here is strikingly counter-intuitive: what is of value in the new productive forms is precisely the obliteration of craft and thought in work, in favour of literally machine-like labour. Why does he argue this?

> These things, in reality, are not original or novel: they represent simply the most recent phase of a long process which began with industrialism itself. This phase is more

intense than preceding phases, and manifests itself in more brutal forms, but it is a phase which will itself be superseded by the creation of a psycho-physical nexus of a new type, both different from its predecessor and undeniably *superior*. A forced selection will undoubtedly take place; a part of the old working class will be pitilessly eliminated from the world of labour, and perhaps from the world *tout court*.[50]

The 'new kind of man', which generations of Cold War or post-89 triumphalist commentators have posited as the malevolent innovation of Bolshevism, is for Gramsci an American, not a Soviet product; he even welcomes its 'elimination' from the proletariat of its older elements, the ballast left to it by history. And he agrees that this man is better, because he is more precise, because the archaisms of craft have been eliminated, because he is capable of an 'equilibrium' and organisation that gives him a clarity that will be the element of a new society, when he begins to utilise it in his own interest. This is an extreme position, and accordingly, it couches itself as anti-humanist, even to the point of subscribing to the Fordist regulation of sexual and personal life. Like Martin Wagner, he imagines this somehow combining with workers' control.

This equilibrium can only be something purely external and mechanical, but it can become internalised if it is proposed by the worker himself and not imposed from the outside, if it is proposed by a new form of society, with appropriate and original methods.[51]

Gramsci does not believe that capitalism will create this by itself, but imagines it becoming useful to a proletarian regime.

One suspects that if the example of the autoworkers revolting against scientific management was produced, he would see in industrial unionism something which was as founded in mass production and seriality as the tyranny they were revolting against.

However, Americanism and its European satellites are incapable of using their 'rationalism' to genuinely rational ends. The major statement of this position is still Siegfried Kracauer's *The Mass Ornament*, where in 1927 he notes that the new, fast, precise process masks something more fundamental.

> The *ratio* of the capitalist economic system is not reason itself but a murky reason. Once past a certain point, it abandons the truth in which it participates. *It does not encompass man.* The operation of the production process is not regulated according to man's need, and man does not serve as the foundation for the structure of the socio-economic organisation.[52]

This emphatically does not mean calling for a return, for an abolition of the ratio, of mass production, rationalisation, technology and the landscapes it creates. Rather, the incredible things that the system has brought carelessly, accidentally into being, the dreams it has both inadvertently created as a utopian surplus and those it has specifically manufactured, must be used, taken hold of, *made conscious.*

> The 'basis of man': this does not mean that capitalist thinking should cultivate man as a historically produced form such that it ought to allow him to go unchallenged as a personality and should satisfy the demands made by his nature. The adherents of this position reproach

capitalism's rationalism for raping man, and yearn for
the return of a community that would be capable of
preserving this allegedly human element much better
than capitalism. Leaving aside the stultifying effect of
such regressive stances, they fail to grasp capitalism's core
defect: it rationalises not too much but rather too little.
The thinking promoted by capitalism resists culminating
in that reason which arises from the basis of man.[53]

The Constructivists' America was exactly such an attempt; to
take the Ratio and make it genuinely rational, to consciously
use, manipulate, adapt and when necessary *oppose* the forms
that it has brought into being. Here we will see them at the
cinema, wondering how to create a Communist Chaplin; we
watch them trying to Bolshevise the architecture of industrial
America; and finally we find them immolating themselves in the
contradictions of trying to serve a Soviet state which somehow
managed to replicate in even more brutal form the American
combination of archaism and futurism. The notion of 'surplus'
is key to this partly because it denotes the unintended products
of artefacts and techniques intended merely to make profit as
quickly and efficiently as possible; it indicates that technology
and industry created a supplementary dreamlife, an inadvertent
proliferation of fantasy that was enriching, developing tech-
nologies beyond utilitarian horizons. It also indicates that the
avant-garde itself was surplus to politics, no matter how much
it threw itself into everyday life and agitation. They could not
change this by themselves, even in those cases where they were
fully conscious of and committed to the redress of these contra-
dictions. They constantly negotiated an unstable, fissile dialectic
of opposition and identification. Both of these poles would
become far less productive when separated, losing their electric

charge. They looked at the world around them and willingly subjected themselves to – enjoyed, even – the bad new things, whether art forms, technologies or industrial techniques. They submerged themselves in early forms of pop culture and aimed to turn it to communist ends; they gazed at, then forensically investigated, a landscape of industrial domination, pondering what of it could be useful after they had destroyed it. They did so not because they thought that the society capitalism had created in the United States of America represented the peak of human achievement – they did so because they knew full well that they could better it.

## Making America Strange

This book attempts to highlight these arguments, questions and contradictions, giving fair due to the too often expunged elements of Socialist Americanism. We will frequently return to the problem, formulated most persistently by Viktor Shklovsky, of defamiliarisation, ideas which would underpin Sergei Eisenstein's 'Montage of Attractions',[54] and later (via Sergei Tretiakov) come to provide the foundation of Brecht's *Verfremdungseffekt*. Defamiliarisation – or making strange, *ostranenie* – is commonly thought to be a solely avant-gardist technique, one in which the spectator has their (usually political) certainties thrown into confusion and dispute. However, the earliest formulations of this idea by Shklovsky – who had no particular political intent for them – derive precisely from attempts to theorise popular forms: film, comedy, circus. However, the principal difference between the two versions of making-strange lies in their particular attitude towards what is on the stage, or in the ring. The spectacles of the Epic Theatre

intended to use shock and disjunction in order to make the audience think in ways to which they were not accustomed. The circus, meanwhile, uses shocks, tricks, disjunctions (in size, in species, etc.) for the purposes of – indeed – a total spectacle, one by which the spectator is merely to be awed, no matter how much that awe might be expressed through close attention to detail and veracity.

The risks of the use of the cinema and the circus by the avant-garde are alternately the cult of the body and the spectacularisation of the mass, in which the audience's role is always delimited by the stage or the screen. In this sense, the processes of making-strange and making-popular could perhaps have been said to serve an anti-socialist purpose, but the diversity and complexity of the strategies employed in the period make any glib dismissal seem driven principally by the smugness of postmodernist, post-historical distance. This book is as disjointed as the montages it charts, going from a discussion of Chaplin as seen through the eyes of the avant-garde, to a critical examination of American comedy of the late 1910s and early 1920s, to readings of the various attempts at syntheses by (mostly Soviet[55]) theoreticians, directors, film-makers, designers and architects. Our first encounter will be with the figure who always lurks, with his hat, cane and bandy legs, behind all these discussions: Charlie Chaplin.

# Constructing The Chaplin Machine:
## The Constructivist International Encounters
## the American Comedians

*If one considers the dangerous tensions which technology and
its consequences have engendered in the masses at large –
tendencies which at critical stages take on a psychotic character
– one also has to recognise that the same technologisation has
created the possibility of psychic immunisation against such
psychoses. It does so by means of certain films in which the
forced development of sadistic fantasies or masochistic delu-
sions can prevent their natural and dangerous maturation in
the masses. Collective laughter is one such pre-emptive and
healing outbreak of mass psychosis. The countless grotesque
events consumed in films are a graphic indication of the
dangers threatening mankind from the repressions implicit
in civilisation. American slapstick comedies and Disney films
trigger a therapeutic release of unconscious energies. Their
forerunner was the figure of the eccentric. He was the first to
inhabit the new fields of action opened up by film – the first
occupant of the newly built house. This is the context in which
Chaplin takes on historical significance.*

Walter Benjamin, 'The Work of Art in the Age of its
Technological Reproducibility', 1936[1]

For Walter Benjamin, the new landscape of the 'Second
Industrial Revolution', with its mass production factories,
new means of transport and communication, and its increased
geographical spread and its concentration of population and

labour, is incarnated as a 'newly built house' – but a newly built house which, we can expect, resembles the theatrical constructions of Vesnin and Popova, or, as we shall soon see, of Buster Keaton – a house full of trapdoors, mass-produced, jerry-built or prefabricated, but with a new spatial potential, where its multiple pitfalls can be faced without incurring real pain, real physical damage – traversed, if not transcended. The person that can live in it is the Soviet figure of the Eccentric, who has adapted himself to the precipitous new landscape, and has learned to laugh at it; in turn the audience, who may well live in these new houses too, learn to live in them in turn. To get some notion of what the newly built house is like, we could turn to the one in Buster Keaton's *One Week* (1920): a prefabricated house whose pieces are assembled in the wrong order, which is alternately dragged along a road and knocked down by a train, but which in between provides a series of vivid and joyous surprises for its inhabitants and the audience. Alternatively, it could be like the house in Lev Kuleshov's Americanist gold-rush melodrama *By The Law* (1926), another minimal, wooden construction placed in the barren Western expanse, which begins as a sweet petit-bourgeois homestead but soon becomes consecutively an execution chamber and a flooded, marooned wreck, left desolate and hopelessly bleak.

## Comic Anti-Humanism

According to Benjamin, the Eccentric is Chaplin. But what sort of a man can live in this new house? Is Chaplin a man at all? In *Movies for the Millions*, a 1937 study of the popular consumption of cinema, the critic Gilbert Seldes made the observation, in the context of a discussion of the comic film, that there was

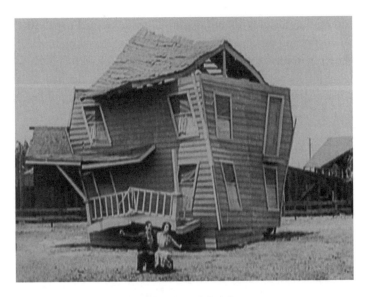

*Buster Keaton's newly built house*

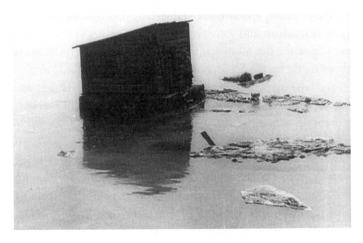

*A house stranded, in Lev Kuleshov's* By The Law

something uncanny about Charles Chaplin. Several pages after an encomium to Chaplin's genius (as 'the universal man of our time') he remarks, almost as an aside, '(W.C.) Fields is human. Chaplin is not'. Chaplin's inhumanity is then defined as a consequence of this universalism, combined with a resemblance to a doll, an automaton.

> He is not [human] because perfection is not human and Chaplin achieves perfection. A French critic has said that in his early works Chaplin presented a marionette and in his later masterpieces endowed that marionette with a soul. That is one way of putting it. It is also true that he created a figure of folklore – and such figures, while they sum up many human attributes, are far beyond humanity themselves.[2]

This provides an interesting contrast with the more familiar idea of Chaplin as a mawkish sentimentalist. 'Chaplin' is not a human being, and is not a realistically depicted subject – he is both machine and archetype. In this he serves as an obvious paradigm for the avant-garde. In his earlier films (principally those made for the Essanay, Mutual and First National studios in the late 1910s, before the character of the 'little Tramp' was finalised, humanised) 'Chaplin' is involved, largely, in everyday situations, albeit in dramatic versions. He is a cleaner in a bank, he is a stroller in a park, he is a petty criminal, he is pawning all his possessions. This universal everyday is made strange, through use of the accoutrements of the everyday for purposes other than those intended, and through the peculiarly anti-naturalistic movements of Chaplin's own body. Chaplin wrote the preface to *Movies for the Millions* (where he uses the opportunity to denounce the Hays code), so we can assume

he had no particular problem with being branded inhuman (or sur-human). Yet however odd they seem in this relatively mainstream study, Seldes' observations were not new. Here we will turn to the avant-garde takes on Chaplin. The field is huge, ranging from El Lissitzky and Ilya Ehrenburg's *Veshch-Gegenstand-Objet* to Iwan Goll, from Erwin Blumenfeld to Fernand Léger; but here we will concentrate on the accounts of Viktor Shklovsky, Oskar Schlemmer, the Soviet magazine *Kino-Fot* and Karel Teige.

The reception of Chaplin by the Soviet and Weimar avant-garde from the early 1920s onwards[3] hinges precisely on a dialectic of the universal and the machinic. Viktor Shklovsky edited a collection of essays on Chaplin in Berlin in 1922, and in *Literature and Cinematography*, published in the USSR the following year, he devotes a chapter to Chaplin; in fact, he is the only 'cinematographer' mentioned by name in this dual study of literature and film. Shklovsky describes this early use of multiple identities as 'a manifestation of the need to create disparities, which compels a fiction writer to turn one of his images into a permanent paragon (a yardstick of comparison) for the entire work of art.'[4] In this sense, then, Chaplin's universalism would seem to be a means of enabling the other characters, or the events in the film, to take place, giving them centre stage. This doesn't at all tally with the idea of Chaplin as unique 'star', and clearly suggests Shklovsky was only familiar with the short films preceding the feature *The Kid* (1921), where the tramp character emerged fully developed. The remarks that follow, however, are more insightful:

Chaplin is undoubtedly the most cinematic actor of all. His scripts are not written: they are created during the shooting [. . .] Chaplin's gestures and films are conceived

not in the word, nor in the drawing, but in the flicker
of the gray-and-black shadow [. . .] he works with the
cinematic material instead of translating himself from
theatrical to film language.[5]

Chaplin is immanent to cinema, and this is what makes him
interesting for Shklovsky's purposes: formulating a theory
unique to film as an art form, disdaining the 'psychological,
high society film'[6] which merely imposes theatre upon a new,
radically different art. Chaplin moves in a new way, through a
new space.

Shklovsky's short discussion of Chaplin includes two
observations which, as we will see, are common in the avant-
garde's reception of his work, which are to do with how the
body of the Chaplin-machine moves through cinematic space.
First, again, we have Chaplin as machine, something about
which Shklovsky is initially rather tentative: 'I cannot define
right now what makes Chaplin's movement comical – perhaps
the fact that it is mechanised.' Similarly, this movement –
mechanised or not – is something which immediately sets him
apart from the other protagonists in the films, which marks him
out from the ordinary run of humanity. 'Chaplin's ensemble
moves differently than its leader.' Shklovsky claims also that
Chaplin is an artist who bares his devices, something that
would be picked up over a decade later in Brecht's 'V-Effects
of Chaplin'.[7] More specifically, a baring of the 'purely cinematic
essence of all the constituents in his films' occurs. This is done
partly through the avoidance of intertitles (and, he notes, one
never sees Chaplin move his lips to simulate speech), and partly
through a series of devices physical or technical: 'falling down a
manhole, knocking down objects, being kicked in the rear'. So,
in Shklovsky's brief, early discussion of Chaplin we find three

principal elements which are usually ascribed to the products of the avant-garde: a sort of impersonal universalism, a human being who isn't a 'subject', and an alien element thrown into the everyday; a mechanisation of movement; and the baring of technical devices.

An instructive example of this correspondence being put to use, although not a cinematic one, can be found in the Bauhaus master Oskar Schlemmer's *Triadic Ballet*, which shows the influence of these three elements: figures which, as in the *Commedia dell'arte*, are (to put it in Eisenstein's terms) 'types', not subjects; a focus on mechanisation (here taken much further, with the costumes seemingly borrowing from the forms of ball-bearings, lathes, spinning tops and other toys); and an acting style which makes the construction of gesture obvious, rather than concealed. It is unsurprising, then, that Schlemmer can be found making similar remarks about Chaplin. In a Diary entry of September 1922, written while formulating the *Triadic Ballet*, he writes of a preference for 'aesthetic mummery' as opposed to the 'cultic soul dance' of communitarian, ritualistic forms of dance. Schlemmer argues for an aesthetic of artifice and mechanised movement:

> The theatre, the world of appearances, is digging its own grave when it tries for verisimilitude: the same applies to the mime, who forgets that his chief characteristic is his artificiality. The medium of every art is artificial, and every art gains from recognition and acceptance of its medium. Heinrich Kleist's essay *Uber das Marionettentheater* offers a convincing reminder of this artificiality, as do ETA Hoffmann's *Fantasiestücke* (the perfect machinist, the automata). Chaplin performs wonders when he equates complete inhumanity with artistic perfection.[8]

The automaton, the machine, artifice: Chaplin is seen as a culmination of a Romantic tendency to create strange, uncanny, inhuman machines that *resemble* human beings. Mechanisation is accordingly seen as something linked as much with dance and comedy as with factory work – or more specifically, dance and comedy provide a means of coming to terms with the effects of factory work and the attendant proliferation of machines. Schlemmer continues: 'life has become so mechanised, thanks to machines and a technology which our senses cannot possibly ignore, that we are intensely aware of man as a machine and the body as a mechanism.' Schlemmer claims that this then leads to two only seemingly competing impulses: a search for the 'original, primordial impulses' that apparently lie behind artistic creativity on the one hand, and an accentuation of 'man as a machine' on the other. By merging the 'Dionysian' dance with 'Apollonian' geometries, Schlemmer claims the *Triadic Ballet* will provide some sort of yearned-for synthesis between the two. Although he does not acknowledge this, it is possible that Chaplin's combination of mechanisation and sentiment provides a similar synthesis. Chaplin is the machine that cries.

This has a great deal in common with Walter Benjamin's anatomy of the 'Chaplin-machine' in his notes for a review of *The Circus* (1928), where Chaplin is both an implement and a marionette, noting both that he 'greets people by taking off his bowler, and it looks like the lid rising from the kettle when the lid boils over'; and that 'the mask of non-involvement turns him into a fairground marionette'.[9] Benjamin implies something deeper here, that this is a 'mask' of sanguine inhumanity, under which something more poignant and sophisticated is at work. Another of Benjamin's observations merges Shklovsky's positing of something immanently cinematic about Chaplin with the notion that his movement is machinic – in fact,

his motion is that of the cinema itself. In a 1935 fragment he notes that the film is based on a succession of discontinuous images, in which the assembly line itself is represented. Chaplin incarnates this process.

> He dissects the expressive movements of human beings into a series of minute innervations. Each single movement he makes is composed of a series of staccato bits of movement. Whether it is his walk, the way he handles his cane, or the way he raises his hat – always the same jerky sequence of tiny movements applies the law of the cinematic image sequence to human motorial functions. Now, what is it about such behaviour that is distinctively comic?[10]

Shklovsky suggests tentatively that it is this machinic movement itself which is comic, that Chaplin is funny precisely because he is mechanised, in which perhaps the audience detects the process at work in the film in the actions onscreen, or perhaps recognise their own increasing integration in the factories where most of them work into an ever-more mechanised capitalism, and are made to laugh at it to dispel resentment and tension. The tension, trite as it may sound, appears to be between machinic movement and personal pathos – but in the process the pathos itself may become machinic.

Meanwhile, Schlemmer's brand of Romantic-inflected artistic syntheses is entirely absent in another avant-garde celebration of Chaplin: a 1922 cover story for the Constructivist film journal *Kino-Fot*, edited by Alexei Gan, a publication described at the time by hostile critics as 'cheap, American-like'.[11] This is a collaboration between Aleksandr Rodchenko (as writer, of a strange prose-poem eulogising the actor-director) and Varvara

Stepanova (as illustrator, providing woodcuts interspersed with the text) titled 'Charlot', the name of Chaplin's 'character' in France. Here, again, there is a stress on the ordinary and everyday, and Chaplin's universalisation thereof, as well as on technology. However, there is an acknowledgement of the 'affecting' nature of the performance, something ascribed to the humility of the Chaplin character, and a certain ingenuousness.

> He pretends to be no one,
> Never worries at all,
> Rarely changes his costume,
> wears no make-up,
> remains true to himself, never mocks a soul.
> He simply knows how to reveal himself so fully and auda-
> ciously that he affects the viewer more than others do.[12]

Aside from the bizarre failure of Rodchenko to notice the layers of kohl and foundation applied for even the more naturalistic Chaplin performances, this is curious as it suggests that precisely in his otherness, his strangeness in his context ('his movement contrasts with the movement of his partner', something also noted by Shklovsky), Chaplin becomes more emotionally involving for the viewer. This 'revealing himself' however is not a dropping of the mask for the purpose of pathos – indeed, Rodchenko claims that 'he has no pathos'. There is a certain smallness to Chaplin in Rodchenko's text. While he avoids the accoutrements of the 'psychological, high-society film', what Rodchenko calls 'the old tinsel of the stage', Chaplin also effaces the machine monumentalism of the period ('dynamo, aero, radio station, cranes and so on'). The machine is transferred to a human scale, as 'next to a mountain or a dirigible a human being is nothing, but next to a screw and one

surface – he is Master.' Machine life is on a human scale here: it is everyday, not grandiose. Chaplin then, is something ordinary and alien. The text's conclusion is that 'simply nothing – the ordinary – is higher than the pompousness and muddleheadedness of speculative ideologies. Charlot is always himself – the one and only, the ordinary Charlie Chaplin.'

Chaplin as everyman and as 'master' is conflated, an unstable and unresolved contradiction. Yet what marks out Rodchenko's Chaplin-machine from Shklovsky or Schlemmer's marionette is a political dimension, something too often overlooked in even the earliest of his films. Nonetheless, Chaplin here takes the place more commonly assigned to Ford or Taylor in terms of providing a bridge between Bolshevism and Americanism.

> (Chaplin's) colossal rise is precisely and clearly – the result of a keen sense of the present day: of war, revolution, Communism.
> Every master-inventor is inspired to invent by new events or demands.
> Who is it today?
> Lenin and technology.
> The one and the other are the foundation of his work.
> This is the new man designed – a master of details, that is, the future anyman [. . .]
> The masters of the masses –
> Are Lenin and Edison.[13]

This elliptical text offers few clues as to *why* exactly Communism should be one of the foundations of Chaplin's rise – although we will suggest a few possibilities presently – but another element has been added to those of the avant-garde Chaplin. He is a *new man*, and a potentially Socialist one. Stepanova's

illustrations, however, have little to do with this extra element. Here, we have a depiction of the Chaplin-machine as montage, in a more casual, rough, representational version of Suprematist abstraction, but sharing the alignment of discrete shapes. He is made up of clashing, patterned rectangles and a circle for a head, poised as if about to leap. The only elements about him that aren't drawn from the Suprematist vocabulary are the fetish objects mentioned in Rodchenko's text: the bowler hat, the cane and the arse. Her illustration for the cover of the issue of *Kino-Fot*, meanwhile, features the famous moustache, in a dynamic, symmetrical composition in which Chaplin swings from his cane towards the spectator, flat feet first. The mono-chrome palette of the magazine cover is exploited to give Chaplin's legs a sharp stylisation, his pinstripes futuristically thrusting forwards. Stepanova's Chaplin-machine is fiercer than Rodchenko's, it seems. Still a 'new man', he displays fewer traces of the human scale.

There is a question, however, of whether or not there is a Chaplinism of practice, rather than of spectatorship. Can Charlot alone be the universal man-machine, or can the audience that he is habituating to the 'newly built house' them-selves live in this manner? Is Chaplin the only alien element in the everyday, or could the everyday itself be transformed? A possible answer to this could be found with the avant-garde group Devetsil in Czechoslovakia, a country whose tensions between Americanised rationalised industry and an active labour movement and Communist Party were similar to those of Weimar Germany. Devetsil's goal was 'Poetism', as defined in Karel Teige's 1924 Manifesto. Teige defines this as a kind of complement to Constructivism in the plastic arts ('poetism is the crown of life; constructivism is its basis [. . .] not only the opposite but the necessary complement of

constructivism [...] based on its layout'[14]), as a kind of practice of life-as-play, rejecting the 'professionalism of art', 'aesthetic speculation', 'cathedrals and galleries' and the other institutions ritually lambasted in the avant-garde manifesto. Poetism is 'not a worldview – for us, this is Marxism – but an ambiance of life [...] it speaks only to those who belong to the new world.' It combines the Constructivism derived no doubt from 'Lenin and Edison' with what an 'aesthetic skepticism' learned from 'clowns and Dadaists'. Those clowns are listed, in what marks an interesting contention given the prevalent received idea of 'high' Modernism, or an aloof, puritan avant-garde:

> it is axiomatic that man has invented art, like everything else, for his own pleasure, entertainment and happiness. A work of art that fails to make us happy and to entertain is dead, even if its author were to be Homer himself. Chaplin, Harold Lloyd, Burian, a director of fireworks, a champion boxer, an inventive or skilful cook, a record breaking mountain climber – are they not even greater poets?
> 
> Poetism is, above all, a way of life.[15]

In the Poetist conception, the avant-garde's place for Chaplinism is in life. Americanism in technology, Bolshevism in politics, slapstick in everyday life. This puts a rather different spin on the idea of the utopian 'new man' of the 1920s – not a Taylorist 'trained gorilla' so much as a self-propelling marionette.

Teige expounds on this at length in the 1928 book *World of Laughter*, a text on humour, divided between sections on 'Hyperdada' and on 'Clowns and Comedians'. The Teige-designed cover is dominated by an image of Chaplin in *The Circus*, peering out inscrutably. Interspersed with the text are

47

sharp, strong-lined drawings, either taken from the cultural industry itself (a guffawing Felix the Cat)[16] or from satirical protest (various George Grosz images of the grotesque bourgeoisie) and, unsurprisingly, Fernand Léger's Chaplin sketches for Blaise Cendrars' Chaplinade.[17] Teige's final gallery of glossier photogravure prints follows a Van Doesburg painting, with its bare, precise abstraction, with an image of Josephine Baker, looking sardonic with her skirt of bananas; circus images by Man Ray and others; and iconic photographs of American comic actor-directors, all of them performing their own specific character. Buster Keaton looks melancholic and effeminate, wanly holding a hand of cards; Harold Lloyd appears as the muscular embodiment of technocratic Americanism, balancing on the girders of a skyscraper's steel frame; and Chaplin, again taken from *The Circus*, by contrast sits looking desperately poor and harried. These images between them situate Chaplin in a context of Modernist reduction (De Stijl), comic over-abundance (Baker) and the abnormal personas of his filmic contemporaries. The book itself argues from a similar perspective as the Poetist manifesto published four years earlier – Dada and clowning as a praxis of life, with the technological environment catered for by Constructivism. There is an open, unanswered question in Teige's inclusion of Chaplin as a Poetist, as in Rodchenko's poem's conception of a mass modernity ruled over by technology and mass politics. If Chaplin is 'outside' of Constructivism, a phenomenon not part of the faceless mass that is 'mastered' by Lenin and Edison, then could he be actively hostile to it? Could he start breaking Edison's machines, or break ranks with Lenin's politics? Could his own versions of machines and politics promise something different from, or complementary with, Bolshevism and American technology?

This survey of various exponents of Chaplinism is taken from a wide range of protagonists of the leftist avant-garde. We have Shklovsky's politically non-committed but aesthetically more disruptive conceptions, most notably *ostranenie*, and the bared device; Schlemmer's Germanic, technocratic-Romantic synthesis; Rodchenko's Bolshevised proclamation of the abolition of art; and Teige's ideas of avant-garde praxis. Drawing on all of them, certain almost always present features are noticeable. First of all, the notion of Chaplin as a marionette and a machine, his movement somehow new and uncanny, and differentiated from that of his co-stars; second, Chaplin as a universal figure, both in his unassuming, faux-humble posture, and in an (early) ability to play all manner of roles, albeit usually as a subordinate figure in a class sense; third, an employer of avant-garde techniques of estrangement and bared devices; and fourth, Chaplin as a product of the age of 'Lenin and Edison', responding to the former in his cinematic representation of the (lumpen)proletariat and the latter in his mechanised movement. This can be seen, then, as not purely an idolatry of an ultra-famous icon of the new mass culture, but as a recognition of a fellow traveller *with* the leftist avant-garde.[18] With that in mind, we will move on to an examination of whether this stands up in the case of his films and those of his less valorised, but still highly important contemporaries, and then analyse the various responses (by the Soviet avant-garde in particular) to these works and their techniques.

### Let Me Show You Another Device

*I love the theatre, and sometimes feel sad because leadership in the art of acting is beginning to be taken over by the movie actors. I won't speak of Chaplin, who by some magic*

*premonition we loved before we even saw him. But remember Buster Keaton! When it comes to subtlety of interpretation, clarity of acting, tactful characterisation, and stylistically unique gesture, he was an absolutely unique phenomenon.*

Vsevolod Meyerhold, mid-1930s[19]

Before we turn to the particular forms that Chaplinism took in the 1920s work of Kuleshov, FEKS *et al.*, a selection of films from the period should be analysed in terms of the three major obsessions of Soviet Chaplinists discussed earlier. First, in terms of their presentation of technology as a comic foil, or as a mechanisation of the productions themselves; second, in terms of their devices, their particularly filmic, as opposed to theatrical qualities, the way in which they draw attention to the film form itself and, frequently, mock their 'high-society, psychological' competitors; and third, the class relations in the film – specifically, whether or not the claims made by Rodchenko that Chaplin's work is in some way brought into being by Communism are in any way tenable. We will focus on the short films of the period, both because this allows the opportunity for a cross-section of typical works, and because the frequent time lag between the completion of the films and their likely showing in Germany (and even more so, the USSR) makes it likely that it is these works that were those initially seen by continental Modernists, rather than the more famous features (*City Lights* [1931], *The General* [1926], and so forth).

In some of these, you can see exactly what Rodchenko or Shklovsky were talking about. In *The Adventurer* (1917), Chaplin is an escaped criminal who charms his way through a high-society party, through such ruses as transforming into inanimate objects, such as a lampshade. Another fairly typical short complicates Rodchenko's contentions: *The Bank*, which

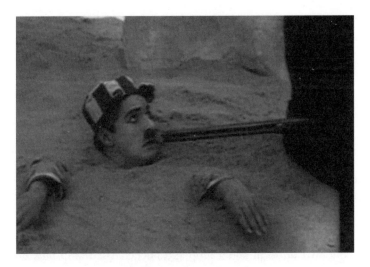

*Chaplin as criminal* – The Adventurer

*Chaplin as object* – The Adventurer

Chaplin directed for Essanay Studios in 1915. In terms of the comic use of technology, Chaplin's films are generally more subtle than those of his two major competitors, and notably here the gestures, rather than the props themselves, are mechanical, or in this particular instance, bureaucratic, and the film takes place in a particularly corporate space. The first few minutes of the film, however, are most interesting for their bitterly ironic satire on class collaboration. Chaplin, in tramp costume, waddles into a bank one morning, spins through the revolving doors several times, then insouciantly follows the complex combination on the doors to the vault, which he casually opens. The assumption that he is going to steal the reserves that are no doubt kept inside is dispelled when the vault is shown to also contain a uniform and a mop and bucket. The tramp puts on the former, picks up his implements, and goes to work, seemingly without noticing that his obviously parlous predicament could be easily solved by means of the vault's other contents.

No doubt he is considered too harmless and stupid – another phlegmatic 'trained gorilla', like F.W. Taylor's 'Schmidt' – to be under suspicion. He clearly, however, has some designs on advancing to the level of clerk, at least. In a movement that supports Shklovsky's contentions on Chaplin's mechanised movement very neatly, he treats his janitorial colleague's arse like a desk drawer, neatly sliding it under the table in a precise, parodic moment. A similar moment comes near the end of the film, during a dream sequence where the tramp foils a robbery (again, co-operating with his superiors[20]) – using the moustache-topped mouth of a banker as a slot, a receptacle, miming putting paper into it as if it is a postbox. Throughout, the tramp is aggressive to his fellow janitor, who is regularly kicked up the arse and hit with the mop, and seemingly obsequious to the clerks and bosses upstairs. However (as has often been

pointed out in studies of the violence in Chaplin's films), the mop usually fulfils the role of Charlie's unconscious, 'accidentally' hitting the people he is too polite to deliberately strike. It is striking, though, given the relatively benign figure the tramp becomes, how malevolent the earlier Chaplin is, even if this malevolence is mostly presented as being accidental.[21]

Here, we can see that the familiar melancholic, put-upon Chaplin emerged gradually. You can find him in 1915's titular *The Tramp*, and perhaps most fully in *Easy Street* (1917), a film which combines unusually bleak social criticism for its period with unashamed sentimentality. The opening scenes, with the Tramp crushed and crumpled, crouching in the shadow of the workhouse, are typical examples of this – the marionette gone winsome. The film hinges on him becoming a policeman and defeating the local criminals – something which he manages after an accidental dose of some sort of stimulant from a drug addict's needle.

*Chaplin as tramp* – Easy Street

The earlier *His New Job* (1914) gives more justification to Shklovsky's theories on Chaplin, what with its baring of various cinematic conventions and devices. Made earlier in 1915, it similarly shows a much more aggressive, and most notably, *annoyed* figure than the Chaplin of the features, always ready to strike the arses of his adversaries with the ever-present cane. The key element in *His New Job* is a mocking of the theatrical pretensions of (respectable, non-comic) cinema. The plot hinges on the tramp's attempt to become a film actor, which he eventually will, by luck and accident. Another auditioning actor reels off his learned speeches from *Hamlet*, no doubt oblivious to their irrelevance to the silent film, something mocked in a moment where Chaplin with 'monocle' mimes a typical thespian. In the feature (which appears to be set in the Napoleonic wars, judging by the costumes, but regardless is clearly an opulent, high-society affair) that is being filmed it becomes obvious that the tramp is unable (despite his best efforts) to remotely convince as a romantic actor. The sword he is given is held in much the same way as the wooden planks he is seen with earlier on, when he is forced to help out the studio's carpenter, resulting in various of the crew being clouted; and he knocks over, and is trapped by, a large Doric column, smashing up the neoclassical stage accoutrements. Finally, he manages to tear a large (and for the time, revealing) strip off the lead actress' dress, which he subsequently uses as a handkerchief after he is, inevitably, sacked (although, like almost all his co-stars, she appears to find him sexually irresistible). In this short, much of the comedy is aimed directly at the film-as-theatre, the object of a decade of Constructivist scorn. The acting is inappropriate, the decor anachronistic, the carefully simulated period costumes are torn up – the entire simulated space of the late-Victorian drawing room is gleefully desecrated. Meanwhile, the process

of film-making itself is shown as being ad hoc, cheap, and riven with petty hierarchies and stratifications. However, a laugh at high culture, even in this attenuated form, is often an easy laugh – and it is notable that the target is the culture of the bourgeois rather than the place they occupy in the social scale.[22]

As an explicit baring of cinematic devices, *His New Job* is far less extensive than Buster Keaton's 1924 *Sherlock Jr.*, a 45-minute film somewhere between a short and a feature. It acknowledges the disparities in everyday life that film, as a dreamlike space outside of social reality, creates, but does so in a far from schematic manner. Keaton's protagonist is a film projectionist and porter (and a desperately poor one; an early set piece shows him picking through the rubbish remaining after the spectators have left, finding dollar bills which are invariably then claimed by returning movie-goers) who has daydreams both of courting a woman above his station, and of becoming a detective. After failing miserably in both, he falls asleep, during the projection of another high-toned melodrama set inside a mock-Tudor mansion, with the symptomatic title *Hearts and Pearls*, its soporific, narcotic function neatly signalled by the name of the production company that appears on screen: 'Veronal Films Ltd'. The stars morph into Keaton's previous love interest and her other suitor. Aggrieved, Keaton walks into the film, and is promptly thrown back out of it.

The film itself then takes revenge on this transgression of boundaries by subjecting him to a life-threatening montage. In a sequence that bares the centrality of fast-cutting and montage to film as a medium, while at the same time providing a (remystifying) series of baffling tricks, Keaton is subjected, while staying in the same place, to a change of scene (in rapid succession) from the middle of a road, to the edge of a cliff, to a lion's den. Then a hyperactive detective film with Keaton

*Buster Keaton's daydreams, in* Sherlock Jr.

in the leading role forcibly replaces the previous melodrama on screen, with a panoply of mechanical devices – Keaton traversing practically every kind of motorised vehicle, with a super-Taylorist precision in timing, as in the moment where a broken bridge is linked by two passing trucks just in time for him to get across. Keaton's own movement, as Meyerhold rightly points out, is constantly precise and restrained, letting the machines and the tricks take centre stage. Here, the mechanical is both revealed and concealed: there is some clear speeding and reversing of the film, alongside actual stunt work. In the film's final sequences, where Keaton, now safely out of the film and his dream, gets the girl, the gulf is still present

– he watches the screen studiously to find out exactly what to do with his new love, attempting to simulate their heroic gestures. This is in turn thrown back, when the screen blanks out, only to return with the couple holding young children. The last shot shows Keaton looking distinctly unimpressed. Over the course of *Sherlock Jr.* there is a combination of an assault on (other kinds of) cinematic genre combined with an ambiguous presentation of the social function of cinema (as dream, as educator, as ideologist) which has clear affinities with the Modernist film. *Sherlock Jr.*'s use both of technological tricks, which need no particular physical gifts, and of acrobatic stunts, is also the key to the Soviet avant-garde's comic dialectic – a tension between accessibility and artifice on the one hand, and the cultivation of the authentic body on the other; it is a contradiction which would not be resolved.

Another affinity with the Constructivists is in a shared fixation on, and involvement in, engineering, as a mechanical basis for filmic experiment and as a joy in machines.[23] Like Eisenstein, Keaton had a functional ability in civil engineering, something that is most relevant in two early shorts, *One Week* (1920), which centres on the prefabrication of housing, and *The Electric House* (1922). The latter centres on a mix-up of degrees, in which a Buster who is qualified in botany finds himself in possession of a diploma in electrical engineering. He is immediately put to work by the father of the obligatory pretty young woman, in electrifying his entire house. Before the inventions of Edison became prosaic this had far wider implications than lightbulbs and sockets, and the film shares with Russian Futurism a romanticism of electricity (cf. the famous formulation of its egalitarian promise 'socialism equals Soviet power plus electrification'). So the electric house necessitates every possible area of everyday life being electrified. With an

*Buster Keaton flicks the switch on* The Electric House

*Keaton shows another device*

intertitle of 'let me show you another device', we are introduced to an automated dining system where food approaches on electrified train tracks, and where the chairs themselves retract from the table mechanically, and cupboards have similar rail systems to get boxes inside and out. The actual engineer, hiding in the generator room, then sets the entire house against the inhabitants, with the gadgets menacing the family to the point where Keaton is eventually flushed out of the house, ending up at the wrong end of the drainage system. Although electricity and engineering are here placed at the service of servility for a decidedly affluent family, its potential is clear both as driver of impossible technologies and as creator of new spaces.

The use of the new space opened up by the technology of the Second Industrial Revolution is the fundamental innovation in the films of Harold Lloyd, who is otherwise ostensibly the most conservative of the three major silent comedians, although this didn't stop the RSFSR publishing a short tract on his work in 1926, featuring an introduction by Viktor Shkhlovsky, where he contrasts Lloyd with Chaplin, with the former needing to acquire new characteristics, new devices in order to differentiate himself from the English actor-director:

> Chaplin fashioned his image by employing the type of the hapless clerk.
> Lloyd chose different material as his permanent mask. On screen, he is a young, well-dressed man in glasses.
> The glasses saved Lloyd from the fate of being Chaplin's shadow.
> The whole trick of Lloyd's screen image has to do with a particular shift: he is a **comedian** with the outward appearance of a girl's first lover.

*Viktor Shklovsky celebrates 'Garold Lloyd'*

Lloyd altered the old character types, the customary conditions of the role. He performed the bit in a different tone. And the bit, as they say in the cinema, got through to the public.[24]

Lloyd, for Shklovsky, merely uses alternative inanimate objects to differentiate himself; the choice of glasses and neat, Ivy League clothes is largely what distinguishes him from Chaplin's crumpled suits and bowler hat, enabling the creation of another approach, a new persona, without any psychological interiority necessary, any new 'personality'. What he does, in fact, is portray a middle-class rather than working-class character, a slapstick comedian you could take to meet your parents. *Grandma's Boy* (1923), for instance, showcases a character who is the class antipode of Chaplin's shabbily dressed chancer or Keaton's depressive, faintly sinister little man. The entire film hinges on the capture of a tramp who is menacing a small town, albeit a less humble tramp than Charlie's. However, there is still the fascination with objects, which seem to revolt against Lloyd, as in a fascinating, brief scene where his grandmother's dresser becomes an obstacle course, with a distorting mirror and a potentially lethal candle, while a central plot device is very uncommon: a false flashback. Nonetheless, this is a tale of a bullied man who triumphs over his tormentors by becoming a better fighter than them, immediately assuming their worldview.

What makes Lloyd relevant for the purposes of this discussion is his use of urban space as a jarring, perilous and fantastical abstraction and absence, in which the skeletal frames of buildings without façades are apt to drop the unwary protagonist into lethally empty space. *Never Weaken* (1921) is the first of two films (the other being the more famous *Safety Last*) in

which the space of the American city becomes the star. And here too, there is the same mocking of the theatrical we find in Keaton and Chaplin ('Shakespeare couldn't have asked for more', notes the opening intertitle, while literary conventions are also mocked in the painstakingly ornate prose of a suicide note). This skyscraper romance, focused on a couple who work on adjoining blocks, ends in a ballet of girders in which Lloyd, after failing in (that seemingly frequent slapstick event) a farcical suicide attempt via a gun wired up to the door of an office, is lifted in his Thonet chair onto part of the steel frame of a skeletal skyscraper. Blindfolded, he immediately assumes he has been lifted up to heaven, as when he opens his eyes the first sight is the stone angel carved onto the corner of his office block. The next ten minutes or so are a remarkably abstract play of mechanical parts in which the stunts are the only 'human' element, albeit in a particularly superhuman form. By the end, he still thinks he's in this vertiginous girder-space even when he is lifted onto the ground, reaching for a policeman's leg as if it were the next girder along.

On this brief assessment, Chaplin's films often seem less mechanically striking than those of his immediate contemporaries, although it is only Chaplin who actually convincingly mimes a machine, taking the machine as a measure of human interaction.[25] Lloyd and Keaton are always fundamentally untouched by their encounters with malevolent technologies. With Chaplin the machine becomes something immanent. In that case, it is telling that he becomes the principal model for the new techniques of film-making and acting introduced in the Soviet Union. Absurd as a Taylorised Chaplin might appear (in the context of his later parody of scientific management in *Modern Times*), it is surely this which makes him more appealing to Soviet Taylorists. The place we can find

this merging of Taylor and Chaplin is in the discipline of 'Biomechanics', developed by the theatre director Vsevolod Meyerhold.

*Harold Lloyd walks the steel frames in* Never Weaken

# Red Clowns to the Rescue:
# Biomechanics in Film, Factory and Circus

*I got the chance to see a few other productions, on nights off, and afternoons when I had no matinee. Soviet vaudeville was heavy on acrobats, wire walkers, kozatski dancers, jugglers and trained animals. Actually, the People's Vaudeville was a watered-down stage version of the People's Circus. The circus was by far the most popular form of entertainment.*

Harpo Marx, on a tour of the Soviet Union in 1933[1]

*Most people are still unaware that many of the successes of our leftist cinema originate from the circus and acrobatics.*

Sergei Tretiakov, 'Our Cinema', 1928[2]

Proletcult. *This theatre developed on acrobatic lines and its methods began to approximate to those of the circus. This phase is now passing. The theatre has its headquarters at the Colusseum, Christy Prood. Its scenery and stage apparatus are so designed as to be readily converted, and at the same time to give opportunities for acting on several different levels. This portable property equals performances to be given at the Workers' Clubs three nights a week.*

Teachers' Labour League, *Schools, Teachers and Scholars in Soviet Russia* (1929)[3]

## Joyous Rationalisation

The most notorious depiction of the Soviet enthusiasm for
the industrial scientific management usually summarised as
'Taylorism' is in Yevgeny Zamyatin's 1920 novel *We*, unpub-
lished in the USSR until the 1980s, although the author gave
public readings from it in 1923. It shares its name with a play
by the Constructivist theorist and designer Alexei Gan, and
the similarity of title is in no way coincidental. *We* is a novel
of Soviet Taylorism taken to its illogical conclusion. Set in the
twenty-sixth century, it purports to be the diaries of D-503,
an inhabitant of a giant city where the population live in glass
skyscrapers and adhere to a 'table of hourly commands'. He is
an engineer by profession, builder of the 'Integral', a spacecraft
designed to take the new rationalist society to other worlds
altogether. Zamyatin conceives of this 'One-State' as a vast,
beautiful *ballet mécanique*. D-503 writes:

> this morning I was at the launching site where the Integral
> is under construction – and I suddenly caught sight of
> the work benches. Sightlessly, in self-oblivion, the globes
> of the regulators rotated: the cranks, glimmering, bent
> to right and left; a balanced beam swayed its shoulders
> proudly; the blade of a gouging lathe was doing a squat-
> ting dance in time to unheard music. I suddenly perceived
> all the beauty of this grandiose mechanical ballet, flood-
> lighted by the ethereal, azure-surrounded sun.[4]

Taylorism has here achieved the status of a kind of official state
philosophy. D-503 is amused at the philosophical myopia of
the nineteenth and twentieth centuries, stating – 'Taylor was,
beyond doubt, the greatest genius the ancients had', although

'he had not attained the final concept of extending his method until it took in the entire life-span, every step and both night and day.'[5] He watches and participates in collective exercises, or rather, cells of rhythmic Taylorised happiness. All beauty in the One-State is based on the eroticism of geometry, on the intersections of planes, on discrete colours and shapes in conflict and alignment. Physical desirability is based on abstraction. A woman whom our diarist is attracted to is described as being 'made up entirely of circumferences'.[6] Collective work and collective action is the highest form of beauty, a merging into one technologised organism, with no divisions, no labour hierarchy. The designer of the Integral, our protagonist, joins in the building work, struck by the beauty of the labour process:

> the workers below, in conformance with Taylor, regularly and rapidly, all keeping time, were bending, straightening up, turning like the levers of a single enormous machine [. . .] I was shoulder to shoulder with them, caught up in a steel rhythm.[7]

This is surely satire aimed at Proletcult and Constructivism, at Gastev, Meyerhold, Gan, Rodchenko, Stepanova and their circle, and Zamyatin is able to convey the sheer excitement they found in the industrial process, and their intent to make of it a new form of art. What he adds, however, is the central dictatorial figure, The Benefactor, a cultic element the Constructivists would resist, but one which D-503 seems unconcerned by. The Benefactor is 'a certain something derived from the ancient religions, something purifying like a thunderstorm or tempest'.[8] The Constructivists, like the One-State, certainly did attempt to transfer Taylorism into the aesthetic sphere. We will find, however, that in the process they created something that did

not evoke the Platonic, frozen world described in *We*, but rather proposed something rough, changeable and comic.

Some observers of the early Soviet Union were horrified by the manner in which it tried to extend American industrial methodologies, taking them out of the factory into everyday life and into art. A well-informed, if politically typical, observer, René Fülöp-Miller, writes of how,

> in spite of all this fantastic veneration for Chicago and 'Chicagoism', the Bolsheviks have many faults to find with their model; the chief defect being the lack of the true political form, the dictatorship of the proletariat, which alone is able to develop society into the longed-for 'complete automaton'. Only Bolshevism can give the final perfection to this technical wonderworld. For even in America mechanization is still confined to economic life, limited to the factories. [...] The American, it is true, was the first to create the mechanistic-technical spirit, but he is trying to sneak away from its social consequences, and aims at continuing to preserve outwardly the soulful face of the good-natured, honest man.[9]

In an account which anticipates both Cold War and post-89 paradigms, the use of cybernetic techniques outside of the immediate production process portends the elimination of the conception of the 'human' itself.

Yet if biomechanics, the form of mechanised, Taylorised acting developed in the theatre of Vsevolod Meyerhold from the early 1920s onwards, is an imposition of industrial domination to the point where it conspires to bleakly mechanise even entertainment, why is it that accounts of biomechanical studios seem to present something so enjoyable, almost idyllic? The American

artist Louis Lozowick, for instance, presents his visit as follows:

> The first place we came to was a middle-sized room, rather dimly lighted and full of young people noisy with talk and laughter. Most of them seemed to be engaged in what appeared to be physical exercises of all kinds – swinging over bars, leaping over obstacles, doing acrobatic stunts on a ladder, making somersaults, and suddenly exploding with laughter when something did not seem to go right. Was this a gymnasium? I asked. No, it was a class for young actors in biomechanics, the discipline invented by Meyerhold and very popular among the young. Briefly, biomechanics required of the actor that he be complete master of his 'biologic machine' in all its faculties and functions. The actor should have such perfect control of his body that he could pass instantly from motion to repose, from fencing to the dance, from gesture to panto-mime, and from walking to acrobatics.[10]

This doesn't appear to be the Taylorist learning of small, exact movements requiring little effort and less skill, but a peculiar combination of sport and circus. Lozowick clearly has no American referent for such a thing, yet the young actors seem to assume that he must. 'When they learned that there was an American in their midst,' he recalls, 'they surrounded me and showered me with questions. "What kind of training do the actors get in America? How do they make their living? Do they know about biomechanics?"' They do not, of course – this is another Soviet 'American' invention.[11]

Biomechanics is a comedy of technology, and hence is a fusion of Taylorism and what Meyerhold himself would codify in 1936 as 'Chaplinism'. It is, not without reason, the former of

those two who has been privileged in readings of biomechanics. Trotsky, for instance, in his remarks on Meyerhold in *Literature and Revolution*, considered this a symptom of the contradictory over-reaching of the 'Futurists' due to Russia's combined and uneven development, a strange accident, whereby the deployment of a strictly industrial system in art achieves an 'abortive' effect. Others, while not so harsh, have also noted only the Taylorist element of the biomechanical system. Richard Stites' otherwise comprehensive *Revolutionary Dreams*, for instance, doesn't spot that American comedy was a source of biomechanical ideas, and that slapstick acrobatics were perhaps a greater element than the incipient militarism he notes. Stites does however rightly record that Meyerhold was a committed Taylorist, and a member of the League of Time, one of two quasi-Taylorist groups active in the early Soviet 1920s, and the affinity of his theories with the leader of the other, Alexei Gastev of the Central Institute of Labour. Similarly, he writes, biomechanics is a regime of:

> alertness, rhythmic motion, scientific control over the body, exercises and gymnastics, rigorous physical lessons in precision movement and co-ordination – in short, 'organised movement', designed to create the 'new high-velocity man'.[12]

The new high-velocity man (who will live in the 'newly-built house') could be the Taylorised worker, or he could just as easily be Harold Lloyd. A retrospective argument can help illuminate the claim that biomechanics is a form of technological comedy. In 1936 Meyerhold wrote a lecture titled 'Chaplin and Chaplinism'. This article is overshadowed by the beleaguered director's need to justify himself against the orthodoxies of

Socialist Realism, which he does by accepting them in part, and then refusing them with the next argument (an approach which evidently did him no favours, given his eventual murder by the state). In this essay he compares his own earlier work – the biomechanical productions of the 1920s, from *The Magnanimous Cuckold* (1922) to *The Bed Bug* (1929) – to the early silent comedies of Chaplin, in that they both share a particularly mechanical bent. The early films – Meyerhold mentions *His New Job* – were considered to 'rely on tricks alone'; but, like the repentant Meyerhold looking over his shoulder at the NKVD, Chaplin then repudiated such frippery with the pathos of *The Gold Rush*. 'He condemned his own formalist period, rather as Meyerhold condemned Meyerholditis.'[13] Yet earlier in the same argument he has intimately linked his development of biomechanics with Chaplin's privileging of movement over the inherited devices of the conservative theatre. After noting that Chaplin began to reject 'acrobatics' and 'tricks' from around 1916, he writes:

> As a teacher I began by employing many means of expression which had been rejected by the theatre; one of them was acrobatic training, which I revived in the system known as 'biomechanics'. That is why I so enjoy following the course of Chaplin's career: in discovering the means he employed to develop his monumental art, I find that he, too, realised the necessity for acrobatic training in the actor's education.[14]

So while he is making a highly ambiguous and guarded repudiation of biomechanics, he essentially defends it by aligning it with the comic acrobatics of the early Chaplin and the Mack Sennett Keystone comedies. This can also be seen in

his employment throughout the 1920s of Igor Ilinsky, an actor whom Walter Benjamin (in the *Moscow Diary*) rather unfairly considered to be an extremely poor Chaplin impersonator, as a means of introducing some kind of Chaplinism to the Soviet stage; but there is an implication there too in the original theoretical justifications of biomechanics. In this, and in many other pronouncements on the affinities between comedy and technics, the comic element is mediated through the circus (which, as we will see, was regarded by Eisenstein and Tretiakov as a proto-cinematic form).

This is perhaps encapsulated in the distinction Meyerhold establishes between 'ecstasy' and 'excitability', with the former standing for all that is mystical, religiose and of dubious revolutionary value, and the latter standing in for dynamism, movement, comedy.[15] More to the point, his conception of biomechanical labour, both inside and outside the theatre, is actually quite far from Taylorist in its conception, something critically but correctly noted by Ippolit Sokolov, who according to Edward Braun regarded biomechanics as '"anti-Taylorist" [...] rehashed circus clowning'.[16] Similarly, actual Fordists were unimpressed with Gastev's attempt to conjure up an entire system of life out of their industrial management techniques, precisely because it had comic elements, because in some ways it was not serious; when emissaries from the Ford Motor Company visited his Institute, they found 'a circus, a comedy, a crazy house' and a 'pitiful waste of young people's time'.[17] Following this precedent, biomechanics is a complete revaluation of Taylorism to the point where it attains the quality of circus clowning. To illustrate this point, we could compare Meyerhold's conception of work with that of Taylor himself, and of Henry Ford, that great proponent of the scientific management of labour and Soviet icon.[18]

Fordist labour is predicated on the near-total elimination of thought in work; something which some, such as Gramsci, regarded as freeing up potential for revolutionary organisation, but which undoubtedly created bleak, relentless work environments. An account of Fordist labour from the worker's perspective, such as Huw Beynon's *Working for Ford*, for instance, stresses precisely this aspect.

> Working in a car plant involves coming to terms with the assembly line. 'The line never stops you are told. Why not? . . . Don't ask. It *never* stops. When I'm here my mind's a blank. I *make* it go blank.' They all say that. They all tell the story about the man who left Ford to work in a sweet factory where he had to divide up the reds from the blues, but left because he couldn't take the decision making. Or the country lad who couldn't believe that he had to work on *every* car: 'oh no. I've done my car. That one down there. A green one it was.'[19]

Sokolov and the Ford delegation were right – this doesn't bear much resemblance to the biomechanical studio.

In the 1922 lecture 'The Actor of the Future and Biomechanics', Meyerhold clearly regards work as something that has to be completely transformed in a socialist society, eliminating drudgery and fatigue and reinstating thought. Rather tellingly, by contrast with Taylor or Ford, his model is the *skilled* worker. This can be seen even in the most seemingly Taylorist statements.

> However, apart from the correct utilisation of rest periods, *it is equally essential to discover those movements in work which facilitate the maximum use of work time.* If we observe

a skilled worker in action, we notice the following in his movements: (1) an absence of superfluous, unproductive movements; (2) rhythm; (3) the correct positioning of the body's centre of gravity; (4) stability. Movements based on those principles are distinguished by their dance-like quality: a skilled worker at work invariably reminds one of a dancer; thus work borders on art. This spectacle of a man working efficiently affords positive pleasure. This applies equally to the work of the actor of the future.[20]

While an American Taylorist might agree with these four points, the use to which they are put, and the aesthetic pleasure that it produces in both the worker and the spectator, would be wholly alien to him.

Taylorism essentially rests in the rationalisation of drudgery, and the implementation of precise rules for unskilled work. This is no doubt why Taylor's *Principles of Scientific Management* centres on pig-iron handling as its main example, in that it proves that even the most thoughtless work, based purely on brute strength, idiotic work – *especially* this kind of work – can be made 'scientific', that is, reduced to a series of speeded-up, physically amenable and repetitious movements, that which can be performed by, in Taylor's admirably unromantic phrase, an 'intelligent gorilla'. Meyerhold argues for the worker as something complete, who rationalises his work to the point where his work becomes an aesthetic phenomenon. Taylor and Ford are, quite unashamedly, interested in the unthinking worker.[21]

In *My Life and Work* (which went into several Soviet editions in 1925 alone, Stites notes) Ford (or rather his ghost-writer) is candid about his own horror of the labour which takes place on his assembly lines:

> Repetitive labour – the doing of one thing over and over
> again and always in the same way – is a terrifying prospect
> to a certain kind of mind. It is terrifying to me. I could
> not possibly do the same thing day in and day out, but
> to other minds, perhaps I might say to the majority of
> minds, repetitive operations hold no terrors.[22]

So there are some who are made for the life of the mind,
and some for a life of labour; any attempt to bridge the two
is unimaginable, and merely breaks up the worker's other-
wise contented existence, as with those agitators who 'extend
quite unwarranted sympathy to the labouring man who day
in and day out performs almost exactly the same operation'.[23]
There isn't any attempt to romanticise this pattern of work,
however – merely a repeated claim that first, there are people
who are 'made' for this kind of labour, and second, that those
who do it have no objection to it (and those who do object
can easily be put to work in the more creative areas of the
Ford Motor Company). The vast difference between this and
Meyerhold's skilled, balletic worker, in perfect control of mind
and body, should be obvious. Ford reiterates that he employs
all manner of disabled workers in his factories, because skill
is fundamentally irrelevant. 'No muscular energy is required,
no intelligence is required.'[24] 'Taylorisation of the theatre'
shares with actual Taylorism in the factory a fixation with the
precise mapping of movement, the speeding up of that move-
ment, and the elimination of the extraneous – but it comes
at this from an entirely opposed position, for all Meyerhold's
protestations.

## Making-Difficult

The Circus, however, which is the foundation of the theories of 'attractions' developed under Meyerhold's influence by Tretiakov and Eisenstein, is far closer to the biomechanical theory than is Taylorist practice. They are both forms of work based on a remarkably regimented control of the body, and on spectacle. This is after all a theatre based on 'physical elements', rejecting both 'inspiration' and 'the method of "authentic emotions"'. Rather than the Stanislavskian method, we have as potential aids to biomechanical acting 'physical culture, acrobatics, dance, rhythmics, boxing and fencing'.[25] All of these forms, like the circus, or the intricate mesh of engineering and acrobatics that makes up the comedies of Buster Keaton, are based (just as is pre-industrial craftsmanship) on what Shklovsky calls *difficulty*, on physical feats, as much as they are on the regimented, precisely controlled motion of Taylorism. In his discussion of 'The Art of the Circus', he notes that 'plot' and 'beauty' are irrelevant to the circus, and that its particular device is in this difficulty, in the very fact that 'it is difficult to lift weights; it is difficult to bend like a snake; it is horrible, that is, also difficult, to put your head in a lion's jaws.'[26] So this, again, is skilled work, something which cannot be emulated easily. Its appeal rests on the spectacle of 'horrible' feats being performed, and on the veracity of those feats.

Making it difficult – that is the circus device. Therefore, if in the theatre artificial things – cardboard chains and balls – were routine, the spectator would be justifiably indignant if it turned out that the weights being lifted by the strong man weighed less than what was written

> on the poster [...] the Circus is all about difficulty [...]
> most of all, the circus device is about 'difficulty' and
> 'strangeness'.[27]

This difficulty and strangeness is implied to be similar to the
difficulty and strangeness of Futurism, something which is
then wholly taken up by Meyerhold's students, Tretiakov and
Eisenstein, although the former comes to have doubts about
its political efficacy other than as a sort of shaming of the
unfit audience who are incapable of undertaking such feats.
It is this, as already noted, which is the crux of the problems
in Constructivism's comic Americanism. There is the trick,
the baring of the device, the impossible geographies and
improbable movements created purely via the mechanical
means internal to the cinema and to montage; and there is the
'difficult' circus trick, which is reliant on the particular physical
training of the actor or circus performer, which relies on the
perfection of the real physical body. In this case, if the audience
are not able to perform these feats, they may be able to enjoy
the spectacle of someone else living in the 'newly built house',
but they themselves will still not be able to occupy it.

An interesting defence of the 'difficult' form of trick as
a kind of dialectical reversal of reification, or an 'anticipa-
tory memory' of a world without reification, can be found in
Herbert Marcuse's 1937 essay 'The Affirmative Character of
Culture'. Marcuse claims that:

> when the body has completely become an object, a
> beautiful thing, it can foreshadow a new happiness. In
> suffering the most extreme reification man triumphs over
> reification. The artistry of the beautiful body, in effortless
> agility and relaxation, which can be displayed today only

in the circus, vaudeville, and burlesque, herald the joy to which man will attain in being liberated from the ideal, once mankind, having become a true subject, succeeds in the mastery of matter.[28]

This seems closest of all to Meyerhold's conception of machinic movement – the treatment of the body as an object to the point where objectification becomes reversed. This is a tentative, and perhaps unsuccessful attempt to fuse the apparent industrial rationality of Taylorism with the production of movements based on joy rather than on eight hours of the same movement for the purposes of an unusually high pay cheque. On another level, what Marcuse describes, this 'artistry of the beautiful body', could be seen around the same time in the aestheticised, classical cinema of Leni Riefenstahl's *Olympia* (1938), whose smoothness and humourlessness is otherwise very far from Meyerhold's conceptions; the concentration on the deliberately farcical, 'low' form of the circus, rather than Riefenstahl's lofty Hellenism. Yet as long as it remained something based on 'circus tricks', despite the organic connection with proletarian culture this might provide,[29] biomechanics remained something outside of everyday life, based on spectacle and amazement, at a safe distance. The truly utopian implication of biomechanics lies elsewhere – in the possibility that it would make the factory more like the circus and the circus (and the associated popular forms – vaudeville, cinema) more like the factory, thus closing this gap. Yet work still remains the common thread linking the two, despite the possibility that Taylorism could actually *reduce* labour.[30]

The circus elements of biomechanics would be emphasised by Eisenstein in 1923's 'The Montage of Attractions', an essay so extensively analysed that another discussion of it here

would be fairly superfluous.[31] Eisenstein's ideas on 'attractions' – moments of 'emotional shocks' – were developed in collaboration with Sergei Tretiakov on plays like 1923's *Gasmasks* and *Enough Stupidity in Every Wise Man*, but Tretiakov's own version of the ideas has not been given anything like the same attention. 'The Theatre of Attractions' (1924) has an intense focus on the attraction's utility in the class struggle, noting that 'despite the tremendous importance of biomechanics as a new and purposive method of constructing movement, it far from resolves the problem of theatre as an instrument for class influence';[32] the response to this appears to be a move away from the Constructivist slapstick of *Magnanimous Cuckold* or the Eisenstein collaborations, in favour of the 'precise social tasks' of instilling particular agitational effects in the audience via the attractions.

So while montage is derived from 'the music hall, the variety show, and the circus program', Tretiakov notes that in that form 'they are directed towards a self-indulgent and aesthetic form of emotion', irrespective of the disjunctive effects of their difficulty and strangeness. The movements in *Enough Stupidity in Every Wise Man* are 'based on acrobatic tricks and stunts and on parodies of canonical theatrical constructions from the circus and the musical'. This can provide part of the intended agitational effect, provoking 'audience reflexes that are almost entirely objective and that are connected to motor structures that are difficult or unfamiliar for the spectator', while he claims that individual attractions 'operate as partial agit-tasks'. The flaw, however, appears to be precisely in the audience reaction to the very difficulty of the attractions, in their inability to perform them, as 'expressed in statements such as "what a shame that I can't control my movements like that", "if only I could do cartwheels" and so on.' The result of this is then claimed to be

much the same as that produced by a performance of Ibsen's *Brand*, the spectator 'depressed from all Brand's thrashing about'. Although Tretiakov evidently thinks that the audience will be ruing 'their own existing physical shortcomings', he acknowledges that it is precisely the emphasis on the spectacle of difficulty that is the problem with inspiring an *active* response in the audience.[33]

Boris Arvatov had claimed in *LEF* in 1924 that the new theatre had a political effect through its exemplary effect on the audience:

> the theatre must be reconstructed on the foundations of an overall social, extra-aesthetic science and technology (physical culture, psycho-techniques and so on) with aesthetic formalism expelled from it. Only those artists who have grown up in this new 'life-infused' theatre will be able to give us a strictly utilitarian, Taylorised *shaping of life*, instead of the *theatricalisation of life*. [my italics].[34]

Tretiakov seems to argue that this has been a failure. For all the defamiliarisation produced by circus Taylorism, the effect is much the same as produced by, for instance, the stunts of Harold Lloyd or Buster Keaton. The world may seem momentarily different, may have been made momentarily strange and exciting, yet the everyday is still untouched, and the mere reaction of thrill or awe is not enough. This prefigures Tretiakov's subsequent development of the more active 'operative' theories of the later 1920s, where spectacle decreases in importance to the avant-garde, in favour of participation, wall-newspapers and worker-correspondents.

## FEX as Engineers of Spectacle

*The Technique=Circus, the Psychology=Head over Heels*
  The Factory of the Eccentric Actor (FEX),
  'Eccentrism' (1922)[35]

*We wanted to create a show in which a series of tricks would unite the elements of circus, jazz, sport and cinema. Our ideal actor was Chaplin. We considered that Eccentrism was the surest way to 'Americanise' theatre, to give the theatrical action the dynamics required by the 20th century – the century of unheard-of velocities.*
  Leonid Trauberg of FEX[36]

The actual use of biomechanics, derived as it is from a form of popular art, when used in conjunction with popular Americanism, seems to have become inadvertently politically contradictory. The reports of the production of *D.E. – Give Us Europe*, for instance, seem to suggest that, like *One Sixth of the World*, the play sets up an opposition between the decadence of the United States, represented by jazz and the foxtrot,[37] and the nobly marching Komsomol, in a play where the USA and the USSR fight over Europe. So the 'West' then had the monopoly on dance in an erotic, as opposed to acrobatic sense, with the biomechanical movements of the young communists appearing merely militaristic. Edward Braun, drawing on contemporary accounts, claimed that 'the scenes in "foxtrotting Europe" [were] far more energetic and diverting' than those of the Red Fleet and the young biomechanists.[38] Mayakovsky was particularly scathing about the onstage juxtaposition of an (actual) jazz band and the (actual) Red Fleet, mocking its military pretensions as 'some kind of theatre institute for playing

at soldiers'.[39] The promise of the Theatre of the Eccentric Actor was, in part, that they could perform a synthesis – one whereby the Reds would not necessarily have to be the incursion of order and power; the link between the biomechanist and the foxtrotter.

Eccentrism was an amalgam of jarring techniques, modernist disorientation, Keystone Kops slapstick and Taylorist mechanisation, albeit stressing their disruptive elements rather than the nascent sobriety of biomechanics. Published by Grigori Kozintsev, Leonid Trauberg, Sergei Yutkevich and Georgi Kryzhitsky while still in their teens, and thrown at Petrograd passers-by from a moving car, the 1922 Manifesto of the Eccentric Actor is a playful counterpoint to Constructivist hardness: self-referential and witty, undercutting its violence with a wilful absurdism. Importantly, the Eccentric Manifesto serves as a major corrective to the still depressingly prevalent view of the 1920s avant-garde as haughtily aloof from 'popular culture', wherein the artistic 'vanguard' in a parody of Leninism attempts to 'improve' its audience. Regardless, the hostility of Eccentrism to 'high' art forms is surely not in doubt. Eccentrism, as employed by the acting studio-film collective The Factory of the Eccentric Actor (FEX) first of all abolished the theatre's preoccupation with subjectivity, with the depiction of a character's inner torments. In the Manifesto this is best expressed by a comparison between an actual theatrical review ('captures all the fine psychological nuances of fading passion with great sensitivity') and an imaginary one of one of their revues ('after four false starts Tamara tears off into the distance').[40]

The Manifesto, with its innumerable references to Chaplin and the circus, is also notable for its unconcealed infatuation with the imagined USA and its unambiguous Proletkult-influenced Communism where revolution and revolutionary art 'spills

into the streets' rather than being limited to legislation and regulation of industry. This is then accompanied by a love for the ephemeral products of base capitalism.

> WE VALUE ART AS AN INEXHAUSTIBLE BATTERING RAM SHATTERING THE WALLS OF CUSTOM AND DOGMA. But we also have our forerunners! THEY ARE: The geniuses who created the posters for cinema, circus and variety theatres, the unknown authors of dust-jackets for adventure stories about kings, detectives and adventurers; like the clown's grimace, we spurn Your High Art as if it were an elasticated trampoline in order to perfect our own intrepid salto of Eccentrism![41]

The theoretical preoccupations of the other proponents of a Chaplinist-Taylorism are here, but it's clear that the emphasis is on a kind of cultural revaluation of popular art and 'trash' to the point where, rather than revolutionary art drawing from it while mechanising it, calming it down, it accelerates the process, taking the cultural forms of Americanised capitalism in the context of the NEP's mixed economy as something which, like the 'socialist' elements of the economy, is hostile to the restoration of bourgeois values exemplified by the psycho-logical, high-society play/picture as the cultural form enjoyed by the NEP man.

Given their evident preoccupation with the poster, it would be instructive to look at the poster for their first (of two) theat-rical production, of Gogol's *The Marriage*.[42] The typography is obviously circus influenced, as is the style – a crowding of declarations and promises (or disclaimers, such as explaining that the production was 'not according to Gogol'), with certain stretches of text in large print. Most interesting for our

*Original Poster for the FEX-MUSIC-HALL*

purposes is that there were various sections of text in a dubious English. One area declares the 'FEX-MUSIC-HALL' (Chaplin's old school), while one of the areas of the grid is filled with the Taylorist exhortation 'TIMES IS MONEY!', which both promises a few stereotypes of Americanism, an oblique joke at NEP capital, and the accelerated pace the Eccentrist borrows both from the speed, violence and cynical humour of the American comic film, and from the accelerated mode of production – something also indicated by Kozintsev and Trauberg spurning the title of 'directors' in favour of 'Engineers of the Spectacle'. The play itself, as if to declare that the eventual intention of the FEX was to branch out into film production, included projected excerpts from American comedies. Katerina Clark's list of the attractions (taken from her translation of reminiscences by Kozintsev) suggests biomechanical theatre becoming an organised chaos:

Figures dressed in garish clothing exchanged shouts and reprises about topical issues; they sang couplets and acted out strange pantomimes with dances and acrobatic feats. The affianced pair from Gogol (in conventional theatrical guise) were mixed in with constructions moving about on wheels. Then, in a flash, the backdrop was changed into a screen onto which was projected a clip of Charlie Chaplin fleeing from the cops. Actors dressed and made up in the same way as those on screen burst onto the stage to act in parallel play with the movie. A circus clown shrieking hysterically turned on a salto mortale right through the canvas of the backdrop, while 'Gogol' bounced around on a platform with springs from which he was propelled to the ceiling.[43]

So here we have circus-as-defamiliarisation in an extreme form, where the procession of jarring attractions is adapted to political agitation and to a technologised burlesque on the Russian classics; we also have a return of cinema to its original place as just such an attraction, something that would have accompanied the clowns and lion-tamers. The fixed nature of cinema, as a discrete object of contemplation, flickering out from the dark, is disrupted by combining it with the actual movement of figures on stage, so that – as in the circus itself – falling into a trance is impossible, in populist prefiguring of the Epic Theatre. Nonetheless, it would seem that the theatre was only a stage on the way to the more genuinely proletarian entertainment of the cinema, and in the 1924 article 'The Red Clown to the Rescue!'[44] Trauberg quite specifically called for the film studios to allow the FEX to make a film.

The earliest surviving example of the FEX's foray into film-making (the debut, *The Adventures of Oktyabrina* [1924], is lost),

and the most clearly 'Eccentrist' in its conception, is *The Devil's Wheel* (1926), a cut-up comedy of the Leningrad lumpenpro-letariat, centring on an amusement park and the descent into the dissolute of a Red Army man (hence the early title *Sailor from the Aurora*, the cruiser used in the October Revolution). It establishes a tension from the very start between its socially redeeming aims and the joy with which the caricatured criminal underworld is depicted – and it does this through the depiction of a very particular kind of urban space. The first scene shows a Leningrad apartment block, surrounded by rubble, with blasted -out windows which are suddenly filled with people dancing, fighting and kissing. While, no doubt, this is intended at one level as a depiction of squalor and poverty, it also serves as a celebration of teeming urban life, and the fantastical delinea-tion of a new multi-storey architecture of clarity, visibility and play. There is a deliberate dialectic set up between the everyday, and what on paper sounds like a conventional love story, and

*The sailor from the Aurora is tempted in* The Devil's Wheel

the montage of attractions themselves, which present the everyday via the defamiliarisations of jump-cuts and cheap but effective tricks, described by Jay Leyda as a deliberate 'clash' between realism and an 'eccentric treatment'.[45] Nothing is too crass for the FEX in this film – and so circus crassness is taken to the level of non-objectivity.[46] While many of its tricks rely on such obvious props as sticking fireworks in the background, having its characters walk through halls of mirrors, filming the spinning wheels to the point where they become abstract, or focusing on the abstraction of the patterns on the heroine's dress, the use of an amusement park as a setting provides a ready-made series of attractions to exploit.

The contradiction in Eccentrism between its Bolshevism and its fixation on the socially dubious comes out in certain moments in *The Devil's Wheel*. At one point the hoodlums, led by a circus magician named 'Mr Question', go to attack a Workers' Club, and one briefly wonders which side Kozintsev and Trauberg would want to win in that particular fight, such is the intrigue and excitement with which the underworld is portrayed. The suggestion is that the world inhabited by these characters, with their obsession with thrill and sensation for its own sake, is the true and correct way of experiencing technologised everyday life. The manifesto itself hails 'the cult of the amusement park, the big wheel and the switchback, teaching the younger generation the BASIC TEMPO of the Epoch'. These settings are described by Barbara Leaming as a kind of New Space – which we might suggest is of a different but analogous kind to the abstract grids of the Harold Lloyd films - the creation of 'an alternate world, an eccentric locus of playful subversion. In the amusement park, the logic and meaning of the everyday world are suspended.'[47] So what does it mean for the veteran of the October insurrection to be dropped into this

space? It is not treated with moralistic disgust, but it is clear that it is something that must be destroyed, albeit, it would seem, with some regret, and perhaps utilising some its features afterwards (hence the carnivalesque depiction of the Paris Commune in *The New Babylon* three years later). Appropriately, the destruction of fairground underworld is itself given a strange, acrobatic treatment, where the gangsters fall out of the windows of the cramped apartment block we see at the start of the film, 'like a swarm of clowns descending to the sawdust'.[48] After their fall, something is lost.

## The New Stupidity

*I do not know whether the stage needs biomechanics at the present time, that is, whether there is a historical necessity for it. But I have no doubt at all – if I may speak my own point of view – that our theatre is terribly in need of a new realistic revolutionary repertory, and above all, of a Soviet comedy [. . .] we need simply a Soviet comedy of manners, one of laughter and indignation [. . .] a new class, a new life, new vices and new stupidity, need to be released from silence, and when this will happen we will have a new dramatic art, for it is impossible to reproduce the new stupidity without new methods.*

Leon Trotsky, *Literature and Revolution* (1924)[49]

Meyerhold's biomechanical works tend to either be revolutionary celebrations such as *D.E.*, or peculiar adaptations of the classics such as *The Magnanimous Cuckold*; and when, at the end of the 1920s, he moves into social satire with Mayakovsky's *Bed Bug* and Tretiakov's eventually unproduced *I Want A Child*, he faces harsh opposition from state critics. So could the new

American-Soviet forms really be used to critique the 'new vices and new stupidities' of the bureaucratic, unfinished revolution? The first major Soviet film comedies do not quite conform to Trotsky's prescriptions – the stupidities portrayed are almost entirely those of the Western perception of Bolshevism, as opposed to the indigenous stupidities of bureaucracy and NEP. Lev Kuleshov's *Extraordinary Adventures of Mr West in the Land of the Bolsheviks* (1924) was the fruit of several years of experimentation on the part of a 'Collective of Failed Actors' who had all been rejected at their examinations (hence Kuleshov's later claim that the film was motivated by a climate where 'everyone defended the theatricalisation of the cinema, the Moscow Art Theatre was law, and only in it could be seen future production possibilities[50]), and is a feature-length farce concerning the titular American visitor, who, visiting the USSR and assuming from the Western press that he will be faced with ruthless, bloodthirsty Bolsheviks, brings with him a cowboy relative (played by the boxer Boris Barnet) but is kidnapped by the same sort of charismatic, eccentric underground troupe that would feature two years later in the FEX's *Devil's Wheel*.

The film contains a multitude of tricks and stunts, most of which are indebted to the 'American montage' that Kuleshov consistently argued for. Mr West's Ivy League haplessness and round spectacles are immediately reminiscent of Harold Lloyd, his clothes appear as a kind of engineer's garb, and a car is fixed in the first few minutes (that American technological expertise), while high-wire acts evoke both Lloyd and the circus. The overwhelming impression of Mr West, though, is one of sheer *speed*, from the fast-cutting to the incessant car chases – both of which seem far more indebted to the example of Mack Sennett's pre-1920 Keystone Kops series than the more sophisticated work of Keaton or Chaplin. Other devices

seem to have been arrived at without American example. The montage of intertitles onto the action, as well as speeding up the action and lessening the literary remnants, have a similar effect to Rodchenko's work on Vertov's *Kino-Eye* in the same year, treating the graphic elements of the film as an integral element, creating disruptive, anti-illusionist, defamiliarising parallels with the typographical experiments on the page in *Kino-Fot* or Rodchenko-Mayakovsky's *Pro Eto*. Kuleshov intended at least some of the borrowings and lurid details to have an educational or at least parodic effect, albeit largely at the expense of German expressionism rather than the American comedy, in moments which are intended to be parodies of *The Cabinet of Dr Caligari* (1920) and *Dr Mabuse The Gambler (1922)*:

> in these scenes we wanted to expose the fundamental and essential falsity of psychological fiction cinema and we were trying to show that the regular organisation of acting and montage work will give us the opportunity to get the better of every style and character of production, and in particular the American and German examples.[51]

Regular organisation – so even the seemingly improvisational scenes where the underworld remnants leap around and generally assault the sensibilities of Mr West are created in a mechanically precise manner.

Kuleshov's collective torment Mr West with great relish, with Aleksandra Khoklova as a dubious 'countess' being particularly eccentric and gleeful. Again, the underworld is mostly far more intriguing than the real Bolsheviks who save Mr West at the climax of the film, showing him such marvels as a Red Army parade and the Shabolovka radio tower, a similar unstable dichotomy between the dissolute and the regimented to that

of Meyerhold's *D.E.* Yet one of the most intriguing elements of Kuleshov's work is in the *cohesion of the collective*, both in their role as Mr West's antagonists and in their own work. It reminds that there was one element of the popular cinema which, practically without exception, the directors of the avant-garde refused to attempt to subvert or assimilate, but instead disdained, no doubt as one of the elements which could not be 'useful': the star system. The actors were instead frequently rather odd looking, their charisma not deriving from their beauty. In the case of Aleksandra Khoklova this met with the active opposition of the nationalised film studios, who effectively banned her from appearing in films due to insufficient pulchritude.

Olga Bulgakova, in an essay on Soviet actresses, wrote that there was a specific 'Eccentrist woman' who was usually disdained both by authorities and, apparently, by audiences:

> female 'anti-stars' of the 1920s were distinguished above all by their unattractiveness [. . .] they were reared on hostility to 'the star', 'the beauty', 'the queen of the screen' [. . .] while everyone was delirious with delight at 'Greta Garbo's divine beauty', a reviewer described Elena Kuzmina (of FEX) as a 'hiccoughing monster'.[52]

Bulgakova quotes Eisenstein on this kind of anti-stardom:

> Khoklova is no 'Soviet Pickford'. America is well acquainted with the image of the petty bourgeoisie and the 'bathing girl'. The very existence of Khoklova destroys this image. Her bared teeth rip up the stencil of the formula 'women of the screen', 'women of the alcove' – Khoklova is the first Eccentric woman of the screen.[53]

Bulgakova notes that this was written at the exact point, in 1926, that Kuleshov was told he would only be permitted to make films without Khoklova being allowed a starring role. This side of filmic populism has been described by post-modernist historians in an interestingly dispassionate manner, lest they be accused of criticising authentic popular desire.

## Adventures of Ms East

The comedies of Kuleshov's collaborators (many of whom – Komarov, Barnet, Pudovkin – became directors soon after *Mr West*), from 1925–27, are more inclined to fulfil Trotsky's requirements for a specifically Soviet satire.[54] Boris Barnet's *The Girl With the Hatbox* (1927) contains many anti-NEP jibes, for instance, although used in a measured and decidedly Americanist form. Perhaps more than any other, this film resembles a direct Soviet transposition of one of the gentler American comedies, such as Keaton's *Our Hospitality* (1923), with a more realist and slightly more formally experimental bent. The squalor of the period is evoked in the subterfuge and exploitation that the heroine, a shopgirl who lives in the semi-rural outskirts of Moscow, has to undergo at the hands of her boss, who utilises part of her flat, with the constant threat of the sack being held over her. False names, rented spaces, home-lessness, marriages of convenience, workplace bullying and the obvious survival and continued power of the bourgeoisie are all treated as objects for mordant comedy, though not quite agitation. Though it in a sense accomplishes the task of making an efficient comedy with Soviet material, its *deus ex machina* ending, via a lottery ticket, would no doubt have seemed to have dubious political usefulness. Meanwhile, much unlike

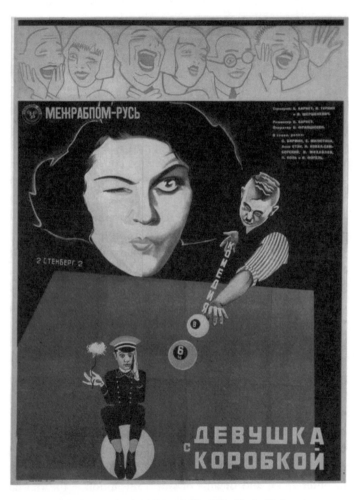

*The Stenberg Brothers's Poster for* The Girl with the Hatbox

Barnet's former partners in the Collective of Failed Actors, its lead actress Anna Sten was conventionally beautiful enough to be picked up and groomed by Samuel Goldwyn in the 1930s.

Another example of the comedy of NEP comes as one of the many ingredients in Yakov Protazanov's 1924 film *Aelita*. Though, directed by a former White émigré from a novel by another former White émigré, it earned the derision of much of the avant-garde, this film still contains significant Constructivist input – from Isaac Rabinovich's abstract sets to Alexandra Exter's costume designs, and not excluding Aleksei Fajko and Fyodor Otsep's Eccentrist, defamiliarising script, constantly frustrating predictable outcomes. Accurately described by Ian Christie as 'polyphonic',[55] the film combines quasi-Constructivist fantasies of revolution on Mars, grim scenes of immediate post-Civil War privation, and Chaplinesque farce from Igor Ilinsky.

Here, there are Red Army men who, after the failure of the world revolution at least manage to create revolution on Mars, alongside Moscow-dwellers who hold parties where they dress and act as they would have done before the revolution as an escape from Bolshevism. The satire here is surprisingly pointed, given the direction by a returned anti-Soviet émigré: revolution is seen as a necessarily unfinished project, and the tension between squalor and fantasy does not end in a ridicule of the latter. *Aelita* presents a world as familiar and as jarringly unfamiliar as the films of the avant-garde; the 'new stupidities' receive a series of well-aimed blows.[56] What is especially notable about *Aelita*, however, is its link between dreams (and this is literally a dream, if an enormously vivid one) of revolution in outer space and dreams of world revolution – the central figure dreams of the former at least in part as a means of escaping the NEP's compromises, as a means of replacing the world revolution's failure to save the Soviet Union from national

backwardness. The dreamer is not mocked, however – it is the mundane world around him that is risible and absurd, not the interstellar revolution that accompanies his sleep.

Eisenstein and Alexandrov's *The General Line*, a film which we will return to at various points below, and which was partly filmed in 1926, before the decline of Eccentrism, can be seen to have certain features which derive from the collision of the montage of attractions and distinctly Soviet satire. The film was aptly described by the critic Robert Barry as looking like 'a Keaton film where the machines all work', and the satire on bureaucracy is dominated by Eccentrist methods of defamiliarisation – stenographers dominated by a huge typing apparatus, the ubiquitous presence of the Lenin cult leading to bureaucrats morphing into their portraits of the sainted leader. These seem closest of all to the 'new methods' that the new idiocies of the 1920s' bureaucratic state capitalism called for, in that they use the very machines and objects of power as comic and belittling. A not dissmilar satire takes place in Abram Room's *Bed and Sofa* (1927), this time based on the claustrophobia of Moscow's urban space and its effects on attempts to conceive of new forms of sexual relation. Shklovsky's script features two men, both construction workers (one skilled, one unskilled), essentially exchanging between them the house's housewife, with the usurped 'man of the house' simply moving to another part of the tiny basement flat, behind a partition. The woman, however, eventually feels stifled by both men, and finds liberation in a train ride out of the city. In the fact that the two men are erecting new buildings to replace these cramped conditions there could be an open-ended element to this attack on an ad hoc, accidental new space – the promise that it will be only temporary. Something darker is hinted at in the set design by Sergei Yutkevich, a signatory to the Eccentric Manifesto – an

*People and objects:* Bed and Sofa

*Joe is already watching you:* Bed and Sofa

assemblage of petit bourgeois kitsch rammed into the tiny space in order to make it 'cosy', and where the characters are constantly framed by wallpaper and doilies, in one of the most persuasive of modernist attacks on the old interior. Among the kitschy artefacts is a 1926 calendar, with an image of a Soviet leader for each month; for much of the film, it is the calendar image of Stalin himself which looms over the characters.[57]

## Slapstick and Instruction

From these films, it would seem that there was a serious attempt to combine a popular form, avant-garde experiment, social satire and explicit socialist commitment in early Soviet comedy. However, accounts, both contemporary and retrospective, tend to be less sanguine. The most detailed study of the films and directors (or rather, studios and stars) who were actually considered 'popular' in the Soviet 1920s is in Denise Youngblood's *Movies for the Masses – Popular Cinema and Soviet Society in the 1920s*. This charts the gradual attempts to reduce the dependence on receipts from the screenings of American films and official programmes to reform popular taste. In profiling the 'Education or Entertainment' debate during NEP (a period when foreign and especially American imports had an overwhelming dominance over the 'market' – she quotes a statistic to the effect that an American film would make a profit of 100 per cent and a Soviet-produced one a loss of 12 per cent), she places the avant-garde on the side of the debate that stands for 'improving' cinema, for the 'dull but worthy'.

Alexei Gan, because of his rages against imported pictures that 'poisoned the masses', is quoted in the same breath as Nicholas 11, although it is pointed out that 'unlike Nicholas

11, (leftists) did believe that 'popular' art (art for the masses) was to be encouraged, albeit via 'social, cultural and political enlightenment'.[58] This is of course the same Alexei Gan whose journal *Kino-Fot* was a focus for the cult of slapstick, and in the issue which was mentioned earlier in the chapter, produced a particularly impressive celebration of the avant-garde's cult of Charlot. Similarly, the self-proclaimed 'Americanitis' of the FEX and Lev Kuleshov, not to mention Eisenstein, is given fairly cursory mentions. It is surely clear that a critical affection for, and a critical engagement with, American cinema was common to practically all 'leftist' directors, with even the irreconcilable opponent of the fiction film, Vertov, owing a debt to the speed of 'American montage'. Meanwhile, the avant-garde affinities of the work that Youngblood considers a genuine engagement with the tastes of working class cinema-goers, that of Boris Barnet and Friedrich Ermler, has in turn clear affinities with the work of the avant-garde in the attention to montage and making-strange. As counters to the avant-garde, Youngblood reproduces from the fan magazine *Soviet Screen*; but as well as a love for stars and glamour, these images also show a huge amount of photomontage and Constructivist typography, as well as drawings evoking the Schlemmer-like work of Alexander Deineka – not to mention a sketch of 'the soul of the American film' which closely resembles the 1910s 'American' drawings of George Grosz.[59]

What this overlooks is that the avant-garde was both obsessed with popular culture and *intent upon changing it*. If Chaplin or Griffith could be critically assimilated into their work, other elements, such as the happy ending, the star system (which, as we have seen, was deeply misogynist in its treatments of unconventional actresses like Khoklova or Kuzmina) and anything that signified 'escapism' were to be expunged. The

argument that this was unpopular with audiences also seems inconclusive. Pudovkin's *Mother* (1926), for instance, was a genuine popular 'hit', while other vanguard works such as FEX's *New Babylon* (1929) or Eisenstein's *October* (1928) were clearly box office failures – although this may be connected with the increasing official hostility to 'formalism' from 1927 onwards. The argument against the cinematic avant-garde is a postmodernist one: the problem with Marxists and Modernists is that they won't accept that popular desire is, and always will be, for what Youngblood calls 'those pictures which appeal to the lowest common denominator (through a combination of action and sentiment)', and while an attempt to create a collision of agitation, defamilarisation and popular art might result in Great Art which can be safely contemplated in MOMA, it will always be unpopular with the audience for whom it was intended, who merely want a bit of escapism after work. The assumption is that this would be as true in the 'new society' as it was in the old; 'choice', meanwhile, should be paramount, so any attempts at education should, presumably, be kept to the schools. What the Red Clowns promised was that this fixed perspective could be broken apart.

## 3
## No Rococo Palace for Buster Keaton: Architectures of Americanism

*Almost everyone evinced immediate interest in America, not, however in its art but in its machines. The two names heard most often in this connection were Ford and Edison.*

*'Ah, America, wonderful machinery, wonderful factories, wonderful buildings, give us time – we'll have as much and more.'*

*One lady put it even more emphatically – 'we'll have it much better'.*

*In view of the critical condition in agriculture, industry, and housing, such a statement would seem wildly optimistic. But it was this wild optimism that brought the country out of its crisis.*

Louis Lozowick on Moscow in 1924[1]

*You can be walking down the street in Chicago today, in 1923, but I can make you bow to the late comrade Volodarsky, who in 1918 is walking along a street in Petrograd, and he will return your bow.*

Dziga Vertov, 'Kinoks: A Revolution', in *LEF*, Vol. 3[2]

In many of the films of this period, the transformation of the built environment itself is the object for comedy. Buster Keaton's *One Week*, for instance, is a 20-minute work on the subject of prefabricated housing. Buster is getting married to a young bathing beauty, and, being a blue-collar sort, is not able to move into an existing property. An exciting alternative is provided by

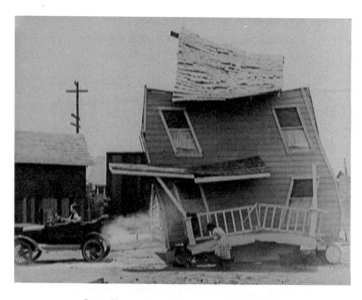

*Buster Keaton drives his house away in* One Week

*No Rococo Palace – the former Universum Cinema, Berlin*

a character who turns out to have been a former suitor of his fiancée, who sells him a build-your-own-house kit which he has, however, mislabelled. So, when Buster clips together this house, on the plot which he has been provided with, it looks freakish, geometrically improbable: all the existing components of a house are there – a roof, a window, walls, doors – but all in the wrong order, at weird angles. This is still a house, but it's a house through a hall of mirrors, and the comforting security of hearth and home has been exploded.

Across the Taylorist working tempo of the *One Week* of the title, a series of mechanical problems gradually beset the house, but the main problem it faces is through the piece of land where it has been erected, which proves to be at the junction of both a railway line and a main road, which proceed to pummel the house into ever more extraordinary shapes. In response, the house spins around, is moved from A to B, and Keaton himself tries to tie it to a car so that he can transport it to a less dangerous place. Most famously, the non-load-bearing wall of the house collapses onto Buster himself, miraculously leaving him unscathed.[3] This film is an early cinematic response to a particular American innovation – the prefabricated home, which can be erected by a non-professional, and placed essentially wherever one wants, or wherever there is a piece of land one can afford, not needing to follow any street lines or enclosed by any class-based districts.

In fact, it's a parody of a film produced promoting house kits, from the cinematic arm of the Ford Motor Company. The film brings together architecture, technology, motorisation and slapstick. Given the interest of Constructivist circles in Buster Keaton, it is worth investigating whether or not an architecture which could reflect all of these things was ever developed, or ever could be. In 1926, the Weimar architect

Erich Mendelsohn declared of his Universum Cinema that there ought to be 'no rococo palace for Buster Keaton'. His solution for housing these fast, unsentimental, high-tech films was a smooth sweep of a building, animating a road junction on Berlin's main commercial street. It is a design rather lacking in pratfalls. Other architects in the 1920s, however, proposed skyscrapers that collapsed and rebuilt themselves, towers for the Comintern that resembled helter-skelters, and did so in a context where the notion of mechanical efficiency had become in itself a farcical dream.

## Practical Utopianism

The 1920s are misread as a 'utopian' period. The totally state-controlled economy of War Communism was dropped in favour of an encouragement of rural capitalism and international trade. Our protagonists here, the artists, film-makers and designers, enjoyed much higher public funding both in the preceding revolutionary period and under Stalinism. Under NEP, to a large degree they had to fend for themselves, much as artists would under capitalism. Industry, though it recovered to the level achieved by the Tsarist Empire, was frequently unmechanised and based on heavy manual labour, particularly in the construction industry, which was largely even pre-Victorian in its technologies. Even here, the adoption of Taylorism as an aim by Soviet industry was in sharp contrast to the world of liberated labour anticipated by the labour movement in 1917. However, the abandonment of revolutionary romanticism instantly produced a surplus in the promise that achievement of a seamless, Americanised modernity was possible.

This, again, is something the unsympathetic critic René Fülöp-Miller was right to notice, even in Lenin's own pronouncements. 'The utterances of the revolutionary,' he writes,

> have a similar ring: 'investigate immediately why the Collegium of the Central Naptha Syndicate have assigned to the workers ten and not thirty arshin per head.' 'Thorough study of the scientific organisation of labour necessary.' 'Care must be taken to make the composition of bills laid before the Ministerial Council clearer and plainer.' 'Investigate how wind-motors could be utilised for lighting the villages with electricity.' This is how Lenin's great utterances look; in these sentences lies the secret of the mysterious way in which Utopias can be created by means of purely practical transactions.[4]

This is very astute. In part, they sound utopian because of the parlous, bitterly impoverished material state of Soviet territory in the early 1920s, where such efficient, precise rhetoric sounds amazing; also, because they promise that the problems can be solved, and moreover, the technological rhetoric takes on an almost incantational, poetic tone. As Buck-Morss points out, it's telling that in the Soviet Union of the early 1920s, Taylorism's most fervent advocate, Alexei Gastev, was a former metalworker and poet rather than a bureaucrat.[5]

Fülöp-Miller defines a territory of almost riotous levels of combined and uneven development, where Russia's existing tension between 'east' and 'west' is exacerbated and accelerated. He sees this, even, as something quintessential to the territory:

> In the Moscow streets, by the side of a house that recalls the Middle Ages, you have an American sky-scraper, and

this curious pair of twins, which couples the Asiatic past with the latest achievements of technology, not only gives the streets a characteristic note, it also represents that feature which recurs in all manifestations of Russian life.[6]

Today, 'Oblomov and the "Time-League" are found side by side.'[7] Rationalisation in America is, as we have seen, merely a means to an end. He cites Rathenau and Ford on their reluctance at their own creation, then finds that:

in Russia, there is scarcely any industry: the factory prole-tariat sinks into insignificance compared with the great masses of the peasantry; in the country, soil is worked with the same primitive tools; everywhere, so far as agricultural and industrial technique is concerned, Asiatic methods of works and organisation prevail. But it is just here that there is continuous talk about 'American mech-anisation', which is regarded as the loftiest expression of human perfection. We can understand how, for the Bolsheviks, industrialised America became the promised land [...] they began to dream of Chicago and direct their efforts towards making Russia a new and more splendid America.[8]

Indeed – and Chicago is the reference that comes up again and again in contemporary accounts, both from observers and those who are deeply involved.

The American novelist Theodore Dreiser, in his travels through the USSR, finds this reaching an almost ludicrous extent. He sees it, at first, in the new forms of Moscow architecture:

while the old palaces and buildings are stained and worn, there are newer things which speak of a brighter day. For the new, if gray and somewhat hygienic, Central Post and Telegraph Building is long and high and wide and suggests in all its features the latest details of a Chicago commercial structure (not a skyscraper), and probably is borrowed in spirit from the Great Lake city which Russia so admires;[9]

something also found in 'the mighty pile that houses *Izvestia*, the official government's newspaper mouthpiece – the great factory in which the world's news is doctored and sent out sufficiently communised for local consumption.' He continues from here to note that 'if there is one would-be Chicago in Russia, there are nine! Chita, Kharkov, Stalin, Novo-Sibirsk, Baku, Vladikafkaz, Perm, a long company'.[10] Chicago, of course, is where the skyscraper first emerges in the 1880s, and whose 'Chicago school' was enormously important for the development of a modern architecture. But at this distance, it could only be a matter for fantasy. For someone like Fülöp-Miller, this is a specifically *Russian* fantasy, but here we will argue something quite different, that it is something specifically socialist – the attempt to use the technologies of an advanced capitalism to produce things that a profit-driven system by itself could never do.

The sheer intensity and unity of this dreaming, and its spread from political and industrial policy to avant-garde and popular culture, necessitates the use of Benjamin's concept of 'the collective dream'. This chapter will constantly keep in mind the dual nature of this collective dream – and finds that one of its most essential conduits is the advertisement. The urban landscape created by capitalism, from

the early nineteenth century onwards, is based on images which make direct appeals to the unconscious. These images are most famously associated with advertising, and Soviet advertising and its close relation, official propaganda,[11] will be discussed here as well as film and architectural design. While the dream may promise utopia, its purpose is *to keep the dreamers asleep*. The dream itself can't offer the possibility of their rousing themselves. So while the culture of abundance and advertisement can provide dream images of utopia in the everyday, something which will be discussed here with reference to skyscraper motifs in the advertising of the New Economic Policy, it does not, contrary to the American boosterism of the time, do so by itself.[12]

### The Tower Has Been Bolshevised

*Come*
*to us*
*Tower*
*Here – you*
*Are far much more needed*
*Steel-shining*
*Smoke piercing*
*We'd greet you*
    Vladimir Mayakovsky, 'Paris' (1923)[13]

In Alexei Gastev's cycle of poems *Poetry of the Factory Floor* can be found one called 'The Tower', which personifies the workers' movement in the vagaries of a vast, endless tower – the suffering undergone in its construction, the bleakness when it was first thought 'finished' (i.e. with the failure of the 1905

Revolution), and its eventual magnificence under socialism, in which it becomes the form of an entire society.

Pierce the heights with your spire
You, our audacious tower-world![14]

The tower here is a lattice-work, iron construction, which would in the American context be covered in masonry and ornament. Its bareness, rather, implies the iron construction which, at the time, was usually hidden in capitalist aesthetics. That bareness does not exclude, but encourages fantasy, for its presentation of the startlingly new, the signs of labour and prefabrication, a nakedness of technology.

A Soviet government poster of 1929 depicts a familiar opposition between socialist politics and the skyscraper, not to mention jazz. On one side figures in bright, artificial colours dance contortedly in front of the jagged, stepped silhouette of a skyscraper. The women's skirts are short, and they look intoxicated, as much as their garb is designed to intoxicate. One of them has strutted towards the poster's foreground. And facing this parade of seductive jazz-age Americana is a single female figure with a red headscarf. Holding her arm up, she points towards the poster's caption – 'STOP!' Although we are in little doubt that the figures being halted are ideologically dubious, with their drunken clinging to lampposts and so forth, their depiction has a hint of the cubo-futurist – the street-lights and the skyscraper are abstracted in a manner similar to the government's ROSTA series of public information posters by avant-garde artists. Officially, the poster warns against prostitution, and it features at the corner, as its ideological content, a poem by the proto-Socialist Realist Demyan Bedny to this effect.

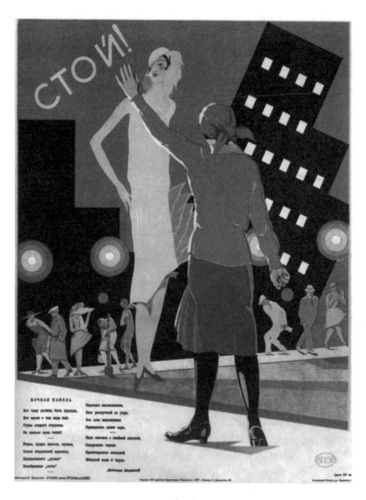

*Stop!*

However, the poster's clearest message seems to be something quite different – a poster against Americanism itself, directed against a landscape of short-skirted flappers, jazz, neon lights and skyscrapers. That this poster was produced at all shows how important America was for the Soviet Union. In a situation of Stalinist autarky there would be no need to implore the workers to resist the blandishments of a culture industry of which they were forcibly oblivious. This poster is a product of the ending of the New Economic Policy – the mixed economy, the temporary compromise with the market that lasted for most of the scope of our study. It tries to close the gates on a decade where there had been a proliferation of jazz, slapstick comedy, adventure films, romantic melodrama and an iconography of extraordinary technological advancement.

Meanwhile, the influence of the New York zoning code on the fantasies of Soviet paper architects (or poster designers) is readily apparent. This 1916 ordnance proscribed, for the purposes of the penetration of light into New York's congested streets, a stepping system, which inadvertently gave the effect, dramatised stunningly in the drawings of Hugh Ferriss,[15] of vaulting skywards to a fine point. In this it not only continues the 'scraping' form ushered in by the Eiffel Tower and other engineering structures, but also, entirely accidentally, evokes a certain atavism – the prehistoric, the pyramidal and pharoanic, just as with the grain silo. The iron pyramid is not, however, an exclusively Americanist archetype – it partly comes from the more recent past, and from French rather than American industrial experiment.

The USSR's earliest, and most famous plan for a skyscraper, Vladimir Tatlin's Monument to the Third International, is somewhat less Americanist in its forms than its immediate successors – the bare steel skeleton evokes the forms of

Eiffel (or indeed his Soviet equivalent, Vladimir Shukhov) rather than Louis Sullivan, although even here there are two Americanist precedents: Coney Island and its spiralling, conical helter-skelters, and the bare steel skeleton of the neo-Gothic skyscraper before its ornament is applied. The elements of primal, Millennarian revolutionary romanticism, reaching back as far as the Samarra El Malwiyya Mosque and Athanasius Kircher's Tower of Babel, combined with the comic aesthetics of the amusement park, are fused inexorably in the tower. This is picked up by Norbert Lynton in his study *Tatlin's Tower*. The tower, for Lynton, is the greatest monument to 'God Building', to the attempt to create a 'religion of socialism', scraping the clouds in order to 'storm heaven', but it is also an object of levity, an intentionally funny building. 'The Tower resembles a helter-skelter, set up on a fairground for people to climb up internally in order to come sliding down an external spiral. Its vast form, at the heart of Petrograd, would counter the city's authoritarian character'[16] – unlike the Eiffel Tower, it is an utterly decentralised structure.

Yet while it is anti-authoritarian, it is still almost mystical. Lynton quotes a letter from Tatlin to Punin of 1919, where he writes of the work in progress 'as a unity of architecture, painting and sculpture', where 'the temple represents the Earth, which returns its dead, and Heaven [. . .] which is being populated by resurrected generations.' Lynton glosses that 'an epoch of human collaboration will come with the advance of science and social understanding, and hence also major technological discoveries, especially in the area of celestial mechanics, celestial physics and other celestial sciences', so that for Tatlin,

> a sturdy structure could be erected – a Temple of the Worlds – which would exist without props or supports,

and would move in infinite space. Such a temple would emancipate all the world from bondage to gravity and from subservience to the blind forces of gravitation, transforming thereby these worlds into a tool for the expression of the mutual feelings and of mutual love of all the generations of mankind. Mankind must become 'sky-mechanics and sky-physicists'; Earth will become a spaceship and mankind its crew.[17]

This captures the sheer density of the dreaming embodied within the Monument to the Third International, the overspill of utopian surplus from something which, in design terms, essentially fuses the Eiffel Tower and Luna Park.

This is predicated on taking to a logical conclusion, or rather on wresting away from it and transforming, one of capitalism's formal accidents. In Sigizmund Krzhizhanovsky's 1927 short story 'The Bookmark', a jobbing Moscow storyteller suddenly begins to tell a tale called 'The Tower Gone Mad', where the Parisian proto-skyscraper leaves its circumscribed bourgeois environs, and becomes international. 'The gigantic four-footed Eiffel Tower, its steel head high over the human hubbubs of Paris, was fed up, you see, fed up with having to listen to that hurly-burly street-entangled life strewn with clangs, lights, and clamour.'[18] It comes to life because it has been plugged into the new telecommunications networks.

As for the muddleheaded creatures swarming at its feet, they had equipped the inside of its pointed crown poking through the clouds with global vibrations and radio signals. The space inside the Tower's needle-like brain now began to vibrate, began to seep down through its muscular steel interlacements into the ground,

whereupon the tower wrenched its iron soles free of the foundation, rocked back, and lunged off.[19]

And to where? 'You and I know, of course, who was calling the lost tower, and from where. And now it knows where to go: due east. The revolutionary will join the revolutionaries. From capital to capital the wires hum with fright. "The tower has been Bolshevised!"' Krzhizhanovsky continues: '"Stop the tower!" [...] ranged cannons again try to bar the fugitive's way: once more, the clanking colossus, battered by blows of steel against steel, breaks into its savage and terrible hymn.' The Tower's attempt to enter the service of Communism ends in tragic failure, however, as it is besieged and near-destroyed:

along the way, at the point where three mountainous borders meet, the tower encounters a waste of water: the stillness and depth of Lake Constance. Passing over that blue mirror, the vanquished giant catches sight of its reflection, inverted and sun-shot, with its spire pointing down. The sonorous steel shivers with disgust and, in a last paroxysm of rage, severs the invisible traces. Then it lifts its leaden paws, stands erect and plunges (can you imagine?) crown-first from the Alpine ledges. Comes the clatter of tumbling rocks and crags torn away, then, echoing from gorge to gorge, the plash of crushed waters: towering above the overflowing lake are the rigid limbs of the steel suicide.[20]

Krzhizhanovsky's allegory is very closely akin to the Monument to the Third International – a claim that the astounding high-tech object 'wants' to become Communist, but that the

capitalist world will encircle and destroy it, much as it had the Bolshevik experiment.

The meanings of the tower need not be so exalted as this. An under-remarked upon element of the Monument to the Third International is that its socialist, technologist, avant-garde synthesis is explicitly in the service of the project for a new *everyday* life. 'The Work Ahead of Us', the accompanying manifesto for the tower's 1921 presentation to the Congress of Soviets, penned by Tatlin and his collective, is quite clear about this.

> The fruits of this work are samples of something new which stimulate us to inventions in the work of creating a new world, and which call upon us to take control of the (physical) forms of the new way of life.[21]

This is perhaps the first call from the Russian avant-garde for the *Novyi Byt* – literally, *new everyday life*, that would have to accompany the annulment of capitalism, and it is significant that it comes as part of a justification for a skyscraper fundamentally unbuildable – pending the world revolution.

## Advertising Construction

*The world in which everything seemed to be arranged so beauti-fully has collapsed. And we want to be the newcomers. We shall lift the curtain from the cities, the streets, the workshops, the bazaars. We shall immediately set our factory of art humming.*
   Alexei Gastev, *Declaration of the Kharkov Art Soviet*, 1919[22]

*The advertisement is the ruse by which the dream forces itself on industry.*
Walter Benjamin, 'Exhibitions, Advertising, Grandville'[23]

The immediate successors of Tatlin's skyscrapers for a new everyday life are those of what is rather deceptively known as the Rationalist movement. This was centred on the researches and teaching of a few architects in the state-sponsored Constructivist debating society INKHUK, and in the VKHUTEMAS school – specifically, the work of Nikolai Ladovsky, Vladimir Krinsky and others who eventually comprised the ASNOVA architects' group. These architects' 'rationalism' lay for the most part on an application of what they called 'psychotechnics' – a variant of industrial psychology. This reminds us that, even in the most intellectually sophisticated circles in the early Soviet Union, Pavlov had precedence over Freud, although the latter was not ignored. The paradigm for this is perhaps Trotsky's discussion of the two as opposed psychological thinkers, pondering their relevance for a Marxist approach to the subject, in *Problems of Everyday Life*. Although, unlike in Stalinism, Freud is taken seriously, his reliance on myth and atavism is seen as less materialist than Pavlov's (decidedly industrial) focus on stimulus-response.[24] However, what the Rationalists do with this is far more based in a certain romanticism and fantasy than on a straightforward instrumentalism. Essentially, a building becomes evaluated for the particular psychological effect it has on the user – and the building in question, once again, is the skyscraper.

The Rationalists' sporadic communiqués and competition entries return obsessively to the skyscraper. The earliest sketches, by Ladovsky from 1919–20, are for expressionist communal towers, which rather than rising centrally in the New York fashion, have a curious variant on this – leaning backwards, and

with each unit differentiated in ostentatiously irregular style.[25] The repetition, the filing cabinet element of the skyscraper, is abandoned in favour of jaggedness and articulation. This short-lived expressionist version is quickly superseded by rectilinearity, and from the start it can be seen that the system they advocate is one derived, even at an oblique remove, from American industrial psychology. From their one publication, *ASNOVA Izvestiia* (1926), we find that:

> the first to have recourse to (psychotechnology) were representatives of the vast industrial and commercial companies of America, for the selection of employees, then business people used it in the advertising field, and then teachers used it in selecting and determining the capabilities of their students.[26]

Ladovsky quotes Hugo Münsterberg, 'who works year by year in his Harvard laboratory', that psychotechnics can both fuse this rationalised approach and the possibility that the 'genius' may create with 'unconscious means'.[27]

Note there the rather uncritical list of bureaucrats and marketing men that make use of this science.[28] At worst, the employment of the 'rationalist' psychotechnical method merely translates this into the nascent bureaucracies of the Soviet Union. Another early Rationalist dream-project was a stepped skyscraper design for Vesenkha, the Soviet industrial commission. In this, it sticks to the distinction made by Charles Jencks between a tower – which can include (usually low-income) housing, or serve as a functional structure (television towers, or Shukhov's radio tower) – and a skyscraper, a more-or-less prestigious vitrine for the making of money or for administration. It is an office block, so if Jencks' distinction

holds, then the Soviet skyscraper is a mere aestheticised version of its American predecessor, and there is, in a version of the later Socialist Realist formula, a structure that is 'socialist in form, capitalist in content'. As imaginary form, the products of Ladovsky's psychotechnical laboratory are far more exemplary as imagery of an advanced technology. The Vesenkha tower fuses a series of cubic forms into a elongated, almost weapon -like *Wolkenkratzer*, which in the perspective is seen from above (where Hood's Chicago Tribune building, for instance, is seen from the ground), suggesting either a demiurgic presence or, more likely given the essentially science fictional nature of the design, some sort of flying vehicle as its vantage point.

This is, then, as far away from *Byt* as possible, but perhaps also from a transformed *Byt* – this might just be another object of awed contemplation, irrespective of the cleaner lines.[29] Nonetheless, Ladovsky consistently related both the fixation on the skyscraper, and the use of a methodology based on perception rather than function, to the political context. Catherine Cooke quotes the Rationalists on how the 'architectural [. . .] spatial system evokes a particular attitude in the ordinary person', something that promises the possibility of a far from liberatory model of psychotechnics. Ladovsky writes: 'The Soviet state, which has put the principle of planning and control at the cornerstone of all its activity, should also utilise architecture as a means of organising the psychology of the masses'[30] – something which she emphasises was the consequence of the nationalisation of land. The psychotechnical appeal would seem to be more to the bureaucracy than the workers that supposedly controlled the state, but even here, the intent is that architecture be tendentious and instrumental in its aims.

What makes the skyscraper problematic in the creation of a *Novyi Byt* is its role, in sum, as advertising itself. The building

is always a vast advertisement, for Chrysler, Woolworth or the Chicago Tribune, as we've already discussed, serving the purposes of dazzlement and dream. The centrality of the advertisement for the avant-garde should not be in any way surprising. In one of its most uncompromising statements, George Grosz and John Heartfield note that:

if he does not want to be an idler, an antiquated dud, the contemporary artist can only choose between technology and propaganda in the class struggle. In either case, he must relinquish 'pure art'. Either by enrolling as an architect, an engineer or an advertising artist in the – unfortunately still highly feudalistically organised – army which develops the industrial forces and exploits the world, or by joining the ranks of the oppressed who are struggling for their fair share in the world's value, for a meaningful social organisation of life, as a recorder and critic reflecting the face of our time, as a propagandist and defender of the revolutionary idea and its supporters.[31]

Except the two were not always mutually exclusive – a figure like Heartfield, or Rodchenko, frequently shifted between the two.

The advertisement can promise utopia, and can, in providing a dreamlike index of impossible forms, provide indicators for its possible realisation – and as a piece of ephemera, as street furniture of little other than speculative value (except to the future collector) it is totally central to the avant-garde's concept of both a new thing-world, and the transcending of the old. It is curious how often advertising has been ignored in the study of the early Soviet Union, particularly considering the widespread popularity of the NEP/First Five Year Plan-era Soviet poster, to the point where their parodying of contemporary advertising

*Mosselprom Building, Moscow (2011 photograph)*

*Mayakovsky and Rodchenko decorations on the Mosselprom Building (2011 photograph)*

has been a cliché ever since the 1980s. The major exception to this is Christina Kiaer's book *Imagine No Possessions*,[32] which concentrates on the 'advertising construction' of Mayakovsky and Rodchenko for the state-run Mosselprom store in the mid-1920s, reading it in terms both of the commodity theories of their comrade Boris Arvatov and Kleinian psychoanalysis. In order not to repeat her work, we'll look instead at how the street, everyday urbanity, is depicted and transfigured in the advertising and street furniture of the period, wherein a fantasy of America takes the form of a particular way of seeing everyday Moscow. This also hinges on Mosselprom, specifically on its building, perhaps one of the most definitive examples of what Adolf Behne called *Reklamarchitektur*.

The Mosselprom building is in a sense a built example of the montage tower envisaged by Vladmir Krinsky. It is not something rising out of the city *ex nihilo*, but a reconstruction and re-imagining of an existing part of the cityscape. The concrete-framed building is usually credited to a relatively young Vkhutemas graduate, David Kogan. Richard Pare writes that: 'this building was developed from an existing apartment block as the headquarters of the Moscow Association of Establishments for Processing Products of the Agricultural Industry; at the time it was one of the tallest structures in Moscow'.[33] The alterations centre on two areas. First, the rear is given over to a display of advertisements by Rodchenko for various consumer goods – chocolates, drinks; and second, the building's corner had added a few extra storeys to the point where it would have been regarded as skyscraping perhaps in Louis Sullivan's time, if certainly not in the 1920s.

This deficiency is covered by re-imagining. The building is always depicted, in the ephemera/iconography of the time, from a corner, again a miming of the quirks of the New York

zoning code – this time, the Flatiron building's geometrically improbable thrust towards the road. Formally, this can then be depicted in varying ways depending on the particular desired effect. A package for Extra cigarettes features it with a central clock, smoothing it into a more Americanist, art deco form and (in the manner of the aforementioned technology companies advertisement) infusing the surrounding cityscape which now becomes a series of tall, brightly-lit blocks.[34] Rodchenko's more famous poster abstracts it, emphasising the frame. But this structural emphasis is undercut by the work Rodchenko did on the building itself, covering it in advertising in Grotesk typography, accentuating the bright colours and the lack of naturalism – while in American skyscraper design the opulence of the materials would be of the essence, here the building is a mere canvas for the application of slogans, a principle easily extended from the sphere of the commodity to the party-political.

An early Mayakovsky poem, 'To Shop Signs' is an embryonic instance of this infatuation with the advertisement. In it, the Taylorist poet Gastev's observation that Futurism is an essentially consumerist aesthetic system[35] is partly confirmed – what interests isn't so much the commodities themselves but the web of images and signs that are woven around them, which seem to generate abundance all by themselves.

> Read those iron books!
> To the flute of the gilded letter
> Will sprout glamorous beetroot
> And smoked sardines and salmon.[36]

This preoccupation with what is added to the building, the extraneous parts added to it to bring it into the commodity-city,

continues in the aesthetics of Soviet modernist architecture. It is customary to consider the architecture of the 1920s as a species of pure aesthetic object, an approach that was certainly favoured by its most influential practitioners (Mies van der Rohe and Le Corbusier). As Kestutis Paul Zygas' *Form Follows Form: Source Imagery of Constructivist Architecture, 1917–1925* extensively demonstrates, such an approach is totally alien to Constructivism, at least until it comes under extensive Corbusian influence. On the contrary, we have an obsession with street furniture, what Zygas calls a 'component fixation', dragged into the building itself – clocks, signs, slogans, a particular fondness for futuristic typography, very few of which can be found in their Western contemporaries. Zygas lists (and shows specific images of) the following typical 'components': 'fixtures retrieved from the modern cityscape: giant clocks, searchlights, advertising signs, propaganda posters.'[37] There is a particular device which is frequently used, even in more conservative projects, which is to place a radio mast at the top of the building, and use the wires and pylons as an integral part of the design – actualising the 'radio-city' promised by advertisers and avant-gardists alike. However, equally important was the straightforward use of typographical self-promotion.

## Demystified Display Cases

For reasons either of historical happenstance or convenience, many of the structures planned were for organisations trading with the West, providing an alibi for the use of Roman script. Accordingly, a design like the Vesnin brothers' ARCOS building, for the English-Russian trading organisation, delights in cosmopolitan, multilingual declarations – ARCOS LIMITED

at the top, lower down HOTEL-RESTAURANT, E WYSS, and in one corner, JARY FRERES MOTEURS. There is only one small area of Cyrillic type in the entire scheme. This goes way past the necessity of acclimatising any foreign delegations, and instead typographically pulls the Moscow street Westwards. This is even more prominent in another Vesnin brothers design, this time for the Central Telegraph Building, designed around the same time. Here, as Zygas points out, a particularly rich panoply of street furniture is affixed to the blueprint, from a prominent clock to large and poster-like lettering and slogans. In the Constructivist journal *Sovremennaia Arkhitektura* the Vesnins explained how the construction and arrangement of the building conformed with the norms of NOT – the scientific management movement headed by Alexei Gastev, dedicated to spreading Taylorism in the Soviet economy.[38] Another particularly fine example is Moisei Ginzburg's design for an Orgmetall headquarters – above the jutting glass volumes is, in the semi-Gothic script of the Chicago newspaper, the words 'Go After Them!' (where exactly this slogan derives from is unclear). This fetish is combined with a form that was in the process of being discarded in the USA.

All of these schemes, using exposed frames and/or an extensive use of glass, recall the 'daylight factories' of the 1900s, which were at that point being phased out in favour of Albert Kahn's more carceral containers for production lines. What makes this particularly extraordinary is the reversal of the schema whereby the architect blandly accepts what the streetscape of capital will do to the work, planning and drafting an eternal object (and then abdicating responsibility for what happens next). Rather, the ephemera is featured into the plan, the draft itself, for the drama, dynamism and noise that it provides. Whether this entirely accords with a society in which, in Gastev's terms, the

*Mostorg Department Store in its current incarnation*

consumer is less privileged than the producer, is an interesting question. Is this just a Futurist evocation of the hectic beauty of capital's urban bustle (especially romantic in a mainly rural context), or a reconception of the capitalist city's devices for an entirely different purpose? One way into this question is via the Gastev quote that begins this section, in which the veil of the city is lifted, in which its forms are seen naked, and in which those previously excluded are suddenly given free rein.[39]

This is certainly what is promised by the application of the 'daylight factory' approach to consumerism. The most frequently cited built version of this is the Mostorg department store in Moscow, again a design of the Vesnin brothers (this time constructed in 1927) which is a structure made up of two things. First, a huge display of futurist lettering, in which Mostorg Univermag (note also how the typically Soviet linguistic compression-neologism is mirrored by the building's compaction) is written in a metallic, attenuated form; second, an enormous plate glass window. Accounts of this, such as

Richard Pare's, have focused on how this consumerist vitrine, suddenly opened up to the workers (never previously considered as potential consumers) has a politicised, emancipatory intent. Everything is on display, as much here as in one of the curtain-walled American stores built ten years earlier, though minus any filigree accoutrement.[40]

Here are the goods, come and take what you need. The gamble of this Constructivist approach to the part-capitalism of NEP is that this sort of *sachlichkeit* (precision) can appeal over and above the irrationalist promises of advertising and its atavistic appeals to myth and instinct. Key in the Constructivist embrace of advertising is that is on their own terms, using the most abstracted forms it provides. It is noteworthy that, for all the components, props and propaganda affixed to the Constructivist building (built and unbuilt) there is no figurative sculpture, or for that matter figurative imagery of any sort, until such things begin to be imposed by Stalinist fiat at the turn of the 1930s.[41]

This isn't to suggest a hard-and-fast distinction between non-figurative advertising, favoured by the avant-garde, and political propaganda, which would incorrectly read them as liberals loath to participate in politics. There is a motif of what, with an appropriate hint of the utopian (in the Blochian, fairy-tale sense) was called 'writing with light' in the Constructivist streetscape, and this would be picked up – to their approval – by the organisers of official events and festivities, at least until the display of military power became the favoured mode. This is partly a take-up of one of the most impressive features of Erich Mendelsohn's photo-essay *Amerika*. This book was regarded with such significance by the Soviet avant-garde that it was reviewed twice in *Sovremennaia Arkhitektura*. This is a (re)discovery of the American cityscape that we will discuss elsewhere, but it is useful for our purposes here in how it uses

light as a way of making strange – specifically, making abstract – the otherwise irrationalist, over-ornamented, tacky city.

The most famous image takes a row of speeding cars, a neon-sign and the lights in an office block and makes out of them an abstract play of lights and planes. This truly creates a phantasmatic space, although not a reactionary phantasmagoria in the sense of a Wrigley palace or the Woolworth building. Rather, the everyday act of walking through the city becomes electrically charged, it is seen anew. In 1927 *Novyi LEF* featured two photographs, in an article titled 'Contemporary Everyday Photography', by R. Karmen.[42] These were of the 10th anniversary celebrations of the October Revolution, and take Mendelsohn's principle to an extreme whereby, with blurring and mirroring, the street is suffused with lit words – Lenin, October, etc. – all of which are not, so is the implication of the article's title, something to be saved for the annual ritual, but an everyday experience – in which Mayakovsky's iron books come loose from their moorings on the shop frontage and float freely around the city.[43]

The city of commodities can be represented as a city literally built out of commodities, in another dream-image that suggests both utopia and myth. It's an under-remarked upon fact that when Hannes Meyer took over the directorship of the Dessau Bauhaus, he introduced into it a department of advertising. In fact, during the reign of this director, usually painted as an intractable Marxist implacably hostile to the status quo, the Bauhaus first turned a profit. Later on we will have occasion to look at how Meyer's Bauhaus embraced its own contradictions. For the moment though, we shall concentrate on an extraordinary project of his from the earlier 1920s, when he worked closely with El Lissitzky and Mart Stam in the ABC Group – the series known as the 'Co-op Vitrines'.

Here Meyer placed under glass a series of objects produced by Germany's co-operative stores – like the 'socialist' elements of NEP, a collectivist element in a mixed economy. The contents of the boxes weren't quite as important as the packages themselves, and the declarations they made about their contents. The arrangements vary, but there is one common factor – the packages become cities. Laid down in rows they appear as streets, piled up they become houses and skyscrapers. The commodity city is turned inside out. The goods under glass, that emblematic form of capitalist urbanism, even in the Vesnin brothers' rationalised, socialist version, become the model for an entire, depopulated city. The commodities don't necessarily have more life than the city's inhabitants, in Marx's terms – rather, their deadness (combined with their garish, communicative and standardised power) is represented in a city of packaged tombstones.[44]

This image is, in a distinctly apposite symmetry, a feature of NEP advertising. A 1925 advertisement, which doesn't appear to be for Mostorg, Mosselprom or one of the more ideologically driven consumerist endeavours, imagines a city made of Ukrainian soap.[45] This might be fairly banal if it were merely piles of unwrapped bars of soap. Instead, the repetition of these soap skyscrapers, which are stepped in true New York style, is reinforced and exacerbated by the recurrence of the pattern of folding, the printed image on the wrapper, the lettering. What appears to be a shadowy crowd has gathered to genuflect in front of the soap-city, dwarfed by the pile-up of commodities. Naturally on one level this is utopian wish fulfilment of the same ilk as that of the futuristic city brought into being by the Mosselprom building and the Shabolovka Tower, but it is also a reminder of the dream of commodity abundance, particularly sharp, no doubt, in a society emerging from seven years of war.

*Skyscrapers of soap*

This abundance creates a city, in this image, one both standard-ised and fantastical.

## The High-Velocity Billboard

The Soviet sky-city as a romantic, dramatic scene for an entirely modernist 'performance of everyday life' (in Alexei Gan's phrase) is prefigured in the film posters of Vladimir and Georgy Stenberg. These have often been dismissed as a back-tracking from their former position as prominent members of Obmokhu, the early Constructivist group, where their designs were seen as potential industrial prototypes. Their return as designers to the figurative, and to painting (the collages on their posters were very seldom actually a result of photomontage) has been categorised as emblematic of a general Constructivist retreat from production into representation.[46] Nonetheless, these posters may not participate in the production of indus-trial objects, but they do serve as a mass-produced indicator of the political aesthetics of NEP in relation to the USA and to the built environment. What happens in these posters is frequently a making-avant-garde or making-Constructivist the American environment (as cinematic construct) and a making-American of the Soviet urban context. One of the two posters they designed for Vertov's *Man with a Movie Camera* (1929) shows this process in the latter case.[47] A well-known image, it shows, from below, at the kind of sharp low-angle seen in Mendelsohn's *Amerika* photos and in Rodchenko, a towering skyscraper landscape, in which the abstracted towers (each a different but equally garish and jarring colour) frame a disembodied female figure who is literally pulled apart, in a grisly mimesis of Vertov's cutting techniques. First of all, these

skyscrapers show a clear knowledge, not only in the setbacks of the New York zoning code, but also of specific recent skyscrapers. One resembles Walker & Gillette's Fuller building, another Howells and Raymond Hood's Daily News building, both of which were already significantly more stripped and abstract than the neo-Gothic of the early 1920s.

What, though, is the reasoning behind depicting this Soviet city-portrait, centred on Moscow and Odessa, as a New York cityscape? Partly this is no doubt for publicity purposes, to excite and attract an America-infatuated audience, but partly it is also a non-literal representation of Vertov's intent to make strange the environments in question by depicting them as fully Americanised, rather than on-the-way-to, aspiring to 'catch up and surpass'. What this does to the person walking the streets, or the spectator (as represented by the central dismembered figure, who with her high heels and bob is already Americanised in the sense of the girls of the 'STOP!' poster), is violent and literally shattering, throwing them into component parts that might not necessarily fit together in the same way again. The sky-city as depicted by the Stenbergs would seem then to have a sexually sadistic undertow, were it not for the fact that the figure mimes their own immersion in the wildness and brutality of an (imaginary and documented) Americanised everyday life. Skyscrapers (always drawing from the 'art deco' minimalism of the late 1920s, with their stripped spandrels providing a vertical equivalent to the Constructivist/ Corbusian ribbon-window) are seemingly at random put into other wholly Soviet pictorial contexts, where they would seem bizarre and inappropriate.

In two posters for the documentary *SEP*, with the unpromising synopsis 'about a training course (SEP) for army personnel, provided by the Soviet Army's film department',

*Stenberg Brothers' poster for* SEP

there is, jutting out of the corner of compositions bursting with latent violence and action (tanks, a girl with a gun), a truncated strip of a Daily News building-style tower.[48] On the other hand, when 'America' itself is the matter for the poster, as in their series of posters for Richard Talmadge, the towers are abstracted even further. In the image for *Daddy's Boy*,[49] a suited, trilbyed figure leaps out of one skyscraper window into a street lined with them, all of which seem far closer to Gropius or

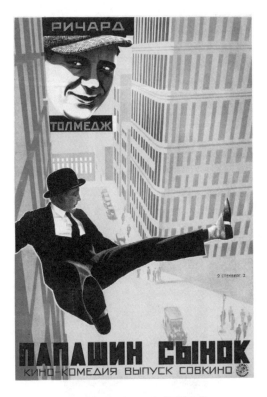

*Stenberg Brothers' poster for* Daddy's Boy

the Vesnin brothers than to the actual landscape of New York. Both are insufficient in the Stenbergs' graphic work: the Soviet Union is too full of remnants of the pre-revolutionary era to be depicted as it is, while the USA is for the most part too pre-revolutionary in its aesthetics to be represented literally. What is imagined here is a dynamic amalgam of the two into a kinetic, heavily sexualised fantasy, one in which dismemberment or hanging from a tall building are the matter of the everyday.

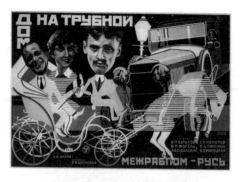

*Above:*
*Prusakov's*
*poster for*
*Boris Barnet's*
House on
Trubnaya

*Right:*
*Prusakov's*
*poster for*
His Career

An equally radical transformation of the environment and the human body can be found in particularly farcical form in the work of the more obscure poster designer Nikolai Prusakov, like the Stenbergs a former abstract artist in Obmokhu. In these, the mechanised city of the Stenberg posters is internalised in the bodies of the films' characters, in a manner which combines caricature, slapstick, montage and sexual

tension. Prusakov used some techniques that were familiar from popular caricature, such as oversized, prominent heads on rudimentary bodies; other parts of Prusakov's style come from Constructivism and Dada, and throughout, his posters are distinctively comic. The 1928 poster for Boris Barnet's *The House on Trubnaya* – like *The Girl with the Hatbox*, a satirical comedy on the new stupidities – is a case in point. Riding on a horse and cart are the film's three protagonists. Film stills of their monochrome heads are montaged onto bodies made up of vertical lines, as if from graph paper, which are then coloured in bright, artificial yellows and reds. Their cart, progressing down an abstracted historic street, is carried by a horse whose body is also transforming into a stylised graph as he leaps forward into the path of a Model T Ford. In the poster for Victor Turin's film *His Career*, from the same year, a drama is represented by a Malevich-like montage made up of the opposed forms of various heads – a bloated cigar-smoking capitalist, a blonde starlet, two bourgeois-looking men – plunged into the painted female protagonist, as if they are plunged into her mind. In the poster for *A Glass Eye* (again, 1928), Prusakov staged a confrontation between what seems to be a scene from the 'high-society film' – an embracing couple, the man in a chic checked suit, the woman in a nightgown. The scale of the characters is made completely farcical, as the woman in the nightie holds aloft her diminutive partner. Meanwhile, a moustachioed, monocled man looks on. His body is a film camera.

These images are among the most violent and extraordinary of the NEP period. In most cases (though not all), they are considerably more radical than the films they advertise. Their blaring colours and disjointed montages were, perhaps, made more acceptable as advertisements because the figures are often quite conventionally glamorous; rather than the heavy

male and female workers you can find on the contemporary political posters of Gustav Klutsis or Valentina Kulagina, the people appearing here look like stars, the men suave, the women vampish. In the process, they make even more sharply apparent the transformations in gender relations then current in Soviet cities, full of sexual tension and the overt suggestion of sexual exploitation. Bodies themselves are fragmented, cut up, mechanised and transformed in their scale. What is especially important is that as posters, these were objects in urban space, part of (urban) everyday life, on which they provided a commentary as dreamlike and unnerving as any of the films of the avant-garde; and unlike them, they are not interested in providing a proletarian 'positive' to counter the NEP negatives they satirise.

## Comrade van Winkle

Many of the Soviet films of this period use – or, more often, distort – the actually constructed modernist architecture of the 1920s as the object for satire or utopian dreaming, or in many cases, both. Most examples that do attempt this use probably the largest Soviet building project of the 1920s, the Derzhprom or Gosprom building in the then-Ukrainian capital, Kharkov. The building's sheer scale and advanced technology made it an obvious propaganda coup, appearing in a special 1933 issue of the fellow-travelling brochure *Soviet Travel* and in innumerable guidebooks and propaganda tracts.[50] The building enters mass-produced dream life in the films of the time in a quite literal sense. Frederick Ermler's 1929 *Fragment of Empire* used it in a Rip van Winkle, *Sleeper Awakes* tale of an overall-clad, bearded worker awaking from a 12-year sleep to the

incomprehensible post-revolutionary world, one which is completely illegible and disorienting. Although the film was set in St Petersburg, the complex was used to symbolise the sheer spatial strangeness to the Tsarist observer of the environment produced by Communism and Constructivism; assuming, perhaps, that the audience across the Soviet expanse would not be too familiar with either city. The building is placeless, able to be geographically indeterminate, a shifting signifier of a baffling future. The sense of something that had suddenly, jarringly appeared while the observer was sleeping actually fits perfectly with Gosprom's status in Soviet urbanism – supposedly emblematic, but in actual fact entirely unparalleled, and in no way representative of the majority of building activity, even in urban centres. So it essentially takes the form of a built promise – the claim that it shows that the new world is being or has been constructed combined with a certain eschatological hope that eventually, even neoclassical St Petersburg will resemble

*Muzhik meets Constructivism:* Fragment of Empire

it. Meanwhile in another film of the same year, this complex similarly exists in a fantasy geography.

In Eisenstein's *The General Line*, the building features in an episode wherein the film's heroine Marfa goes to the city to demand a new tractor for her embattled attempt at a collective farm. Eisenstein includes it first in a montage of urban industry – huge Grotesk letters proclaim 'FROM THE PALACE OF INDUSTRY . . .', yet at least one of the buildings seen alongside it – the MOGES power station by Ivan Zholtovsky – is actually in Moscow. The imaginary geography leads to a bizarre scene of blending later on. Eduard Tisse's camera hurtles down one of the building's towers, intercut with the same camera motion depicting Boris Velikovsky's Gostorg building in Moscow, an almost imperceptible transition; and then Marfa walks out of the revolving doors of the Kharkov building. Eisenstein's interest in architecture is well documented, but his use of these buildings has escaped attention in comparison with, say, the architectural space of *Ivan the Terrible*. The Constructivist architectural spaces of *The General Line* play a complicated dialectical game between the constructed and the imaginary. Some attention has been paid to Andrei Burov's Corbusian mock-up factory farm, an imaginary vision of efficient agriculture and the gleamingly purist war of nature, filmed with lush attention to detail as it goes about its entirely hypothetical production of eggs, meat and so forth.[51] The Kharkov complex is unsubtly used as the symbolic heart of the Stalinist bureaucracy. Within it are ageing administrators morphing into portraits of Lenin, pretentiously ornate signatures, and incredible, industrial machinery (when filmed up close) which turns out to be mere stenographic equipment. There is an explicit political critique here. The modernism of Byt, the daily struggle of the endless, un-electrified countryside is

*Augmented skyscrapers in* The General Line

only Marfa's dream, a Constructivist fantasy extending to the unconscious of a sleeping peasant (regardless of the intertitles proclamation that 'this isn't a dream!').

The modernism of the bureaucracy meanwhile is a constructed, grandiose (in scale if not in ornament) micro-city, and inside it are malingering, obstructive bureaucrats. However, this is undercut by the awe-inducing technique as the building is first shown, fast-cut and then viewed panoramically to depict its enormous scale – when, with a typical gesture of historical disinterest, Eisenstein manipulates the shot in order to make the towers look approximately five storeys taller, more like a 'real' skyscraper.[52] The complex is both the centre of all that is sclerotic and obstructive in the Soviet apparatus, and emblematic of its futuristic appeal. However, for the most part, the environments which the protagonists of 1920s Soviet films walk through are those bequeathed by the pre-revolutionary era, albeit transformed in their content through the new forms of life thrown up by the October Revolution. This would soon change.

# 4

## The Rhythm of Socialist Construction:
## Soviet Sound Film and the Creation
## of an Industrial Economy

*When Vertov attended the presentation of his first sound film,*
Enthusiasm, *to the Film Society of London on November
15, 1931, he insisted on controlling the sound projection.
During the rehearsal he kept it at a normal level, but at the
performance flanked on either side by the sound manager of
the Tivoli theatre and an officer of the Society, he raised the
volume at the climaxes to an ear-splitting level. Begged to
desist, he refused and finished the performance fighting for
possession of the instrument of control, while the building
seemed to tremble with the flood of noise coming from behind
the screen.*

Thorold Dickinson, quoted in Jay Leyda, *Kino*[1]

In 1927, the Left Opposition in the Bolshevik party were
finally humbled and many of its leaders publicly recanted; in
the following two years, a Right Opposition were then defeated
in a more backroom conflict. Beginning in this period, the
USSR shifted towards a 'planned economy', and during the
first Five Year Plan (completed in four years, from 1928–32),
the foundations of a modern industrial state were laid at an
utterly dumbfounding cost in lives, mainly in the devastating
famines inflicted on Ukraine, the Volga region and Kazakhstan,
but also seen in a cavalier approach to industrial safety and the
widespread use of forced labour. This took place with immense
American assistance. Companies which faced falling demand

in a US facing Depression accepted lucrative commissions for the Soviet industrial expansion. American engineers led the construction of the DniproGES dam in Ukraine, the new steel town of Magnitogorsk, and many others; the Ford Motor Company's engineers and architects planned and constructed car and tractor factories in Stalingrad and Chelyabinsk; the Austin company of Cleveland, Ohio, built a new town south of Nizhny Novgorod. During this period, satire and slapstick became less and less prominent in film, design and theatre, but Americanism and the fascination with Fordism only increased.

If there is an art form that attempted the apocalyptic drama of the first Five Year Plan, it is the early sound film. The transformative violence of the Plan and its accompanying 'cultural revolution' became raw material for those using the new synch-sound technologies, who exploited their potential for disorienting audio-visual attack, contrapuntal montage and mechanised rhythm. The content of the films themselves explicitly dramatise, or rather proselytise, the convulsive changes taking place, and accordingly create contradictions as tangled and intractable as the film-makers' montage constructions, in fractured narratives which, for all their attempts to provide 'positive' examples and heroes, are ethically and politically complex in the extreme. In these films German 'deserters' from the class war are hailed as shock-workers in Soviet factories; Soviet hurrah-patriots insist on the noble contributions of American industrial specialists; and the war in the country-side re-emerges onscreen in surreal, disavowed forms. All of the elements of Third Period aesthetics can be found in these early sound films, from dreams of fairy-tale technological transformations to grim industrial toil, from fantasies of mobile architecture to minutiae of sectarianism and betrayal in the international class struggle; and all share a harsh intensity that

helps explain its swift replacement with a lighter, gayer new style – itself heavily based on Hollywood precedent. Most of all, though this era saw a rise in Soviet chauvinism and jingoism, it is very much an international moment. Dutch directors and German composers can be found working in Magnitogorsk, and Soviet montageurs in Hamburg – and the most prominent Soviet director was attempting to find work in Hollywood.

The development of synchronised sound was coincidentally itself contemporary with the commencement of the Plan. Eisenstein, Pudovkin and Alexandrov's famous 'Statement on Sound' was published in response to *The Jazz Singer* in 1928, at a time when films such as *The General Line* began to propagandise the shift in policy. The statement is insistent, first of all, on the geographical derivation of the new technology ('with the invention of a practical sound film, the Americans have placed it on the first step of substantial and rapid realisation'[2]), and determined not to leave it in their hands. The reason for this is not the risk that crass, commercial work would be made with the new technology – in fact, the three signatories seem remarkably unconcerned with this, noting that: 'a first period of sensations does not injure the development of a new art'.[3] Rather, the potential problem is the accepted idea of high cinema itself, which by using 'ADHESION' between sound and image in creating straightforward talking films, destroys the linguistic universalism of the silent film and obliterates the principle of montage, or 'JUXTAPOSITION' (capitals in the original). Eisenstein, Pudovkin and Alexandrov use specifically musical terminology in their call for a 'contrapuntal', 'orchestral' use of sound, via a 'DISTINCT NON-SYNCHRONISATION' – something which may seem perverse given that the main innovation of the sound film was the possibility of synchronisation. It is also notable how the

authors phrase the innovation's potential in terms of added *force* – sound, 'treated as a new montage element (as a factor divorced from the visual image), will inevitably introduce new means of enormous power to the expression and solution of the most complicated tasks that now oppress us', creating an art form at a point of 'unprecedented power and cultural height'.[4] The possibility is not power in the sense of a unified, overwhelming, 'totalising' *gesamtkunstwerk*, but the power of disjunction, conflict and, as the authors put it, 'attack'. What was attacking what, or rather, who was attacking whom, would become clear in one of the earliest Soviet sound films.

## Blast Furnace Music

The most impressive fulfilment of this can be found in the work of the hyper-sectarian director who did not sign the declaration – Dziga Vertov's 1931 *Enthusiasm: Symphony of the Donbas*, a film with an extreme level of aggression and exaltation. Vertov's film is a not particularly analytical presentation of the mech-anisation of the Donets Basin region, a series of mines and steelworks in Ukraine. It begins, not unexpectedly given the period, with a scene of 'Cultural Revolution' – the destruction of a church. Here, and continuing throughout the film, is some fairly anodyne marching music, which is interspersed with a far more intriguing system of contrapuntal recordings, noises and atmospheres. The film's central conceit, a woman at a radio tuning through the Donbas as if it were a radio spectrum, fastens upon blurred images of Orthodox churches, signified and made unsettling rather than spiritually 'uplifting' via murky, distorted chants, atonal counterpoints and morse blips and bleeps. The churchgoers are montaged with drunks, as the

sound of the church itself becomes slurred and indecipherable. If this is comedy, it is of a rather cruel sort.

It is interrupted by a rousing march to herald the arrival of the Komsomol, who stride through the frame at an acute, Suprematist angle. Finally, several minutes in, we hear a clear human voice, addressing the crowd, denouncing the alliance of capital and priesthood. Then the (literal) iconoclasm begins. Vertov tracks at a sharp angle along the skyline of spires, revealing a skyline of factory chimneys and blast furnaces behind it, producing thick, black plumes of smoke. As the church spires are brought down by a celebratory crowd, the chimneys replace them as the focal point of the town's skyline.[5] Vertov then moves into architectural commentary, as we see the church transformed, via animated flags and stars rising into the bell towers without the aid of human hands, into a workers' club;

*The destruction of the old world, the skyline of the new:* Enthusiasm

*Miners perform Taylorist exercises in* Enthusiasm

then we see an earlier and even more drastic transformation of church into club, with a flat architecture of signage and devices that evokes the mid-1920s rather than the Corbusian new architecture of the early 1930s. A new settlement of spaced-out, white buildings is glimpsed through a screen of greenery.

At this point, the inane march is replaced by a mechanical pounding, and Vertov speeds up the image, with clouds rushing past the church-cum-club, and the words 'PLAN' and 'TOWARDS SOCIALISM' appear on screen, along with an animation of tractors and cars carried on conveyor belts. It appears as if the destruction of the old culture has cleared the space for the plan and for socialism, in a fairly straightforward analogy to the specific rationale for the 'cultural revolution'.

The triumphal music now accompanies closer images of the industrial complex seen earlier – flares, furnaces and bright lights outline it as a ferocious, hellish city in its own right. Much of the rest of the film takes place inside this inferno. As we begin, Vertov cannot resist making pointed juxtapositions – a crowd enters a cinema to sit down and watch the film we are in fact watching (one of many moments where the film draws attention to its own processes and apparatus), while at the same time miners trudge to work. A nagging industrial drone runs through the two scenes, and intensifies as a series of ornamental images of advanced industry take over, while a defamiliarising use of doubling, mirroring and fade-outs creates an increasingly abstracted machine movement; the drone becomes a series of notes and rhythms. This is followed by the only sequence of straightforward synch-sound in the film, where shock-workers at the mine make various declarations about their intent to over-fulfil the plan. Their voices are extremely distorted and metallic, over the top of a rhythmic industrial rumble. It is unclear – certainly not made clear by Vertov – whether this is a consequence of the technology or a deliberate making-machinic of the human voice, a conscious transformation of the organic sound into an electronic form of communication to parallel the same process occurring across the Donbas landscape. In this scene, we see uniformed shock-workers performing a sequence of industrial dances, evoking the Taylorist theatre or the training exercises of Gastev's NOT; they mime axing away at blocks of wood, pretend in unison to carry heaps of coal.

This mass ornament has little in common with the labour inside the mine, which is dirty and disordered, although it seems Vertov is merely documenting this as training rather than taking issue with the work's aestheticisation. Yet for a time after

this, human labour is replaced by images of machines, contra-puntally organised along more bangs and rumbles, occasionally mapped clearly onto specific actions but more often creating a generalised atmosphere.[6] The architectural, spatial qualities of the Donbas are emphasised in tracking shots (from a freight train) under iron bridges aligning with the blast furnaces as a dramatic new landscape, or under conveyor belts carrying coal without human interference – Vertov revels in these in particular, speeding them up at the 'crescendo'. At times, the film marvels at automation and lack of human input into the processes it depicts, at others it provides vivid and alarming views of labour.

So, in a subsequent scene we have an astonishing and fright-ening view inside a steelworks. Three men operate an enormous forge, and with every clang, Vertov zooms in closer on the face of the middle of the three workers, focusing on his desperate concentration. This heroic collective labour is montaged along with a lone, rather stooped man poking his forge into a massive, barely controlled open flame. Then, inside we see steel cables being made in conditions that don't remotely resemble the clean daylight factories of Fordist propaganda, but instead a dark, messy, dirty room where the only point of light is that of the molten cables; as these are formed, Vertov organises them into an increasingly abstract and apocalyptic motif, coiling and whipping around the forge; the 'crescendo' this time is an alter-nation between the abstract, fluid play of molten steel cables and the determined, dirty faces of the steelworkers. The sounds of a celebratory crowd are montaged over the process. Vertov, while he is not immune to ornamentalising and aestheticising the process of industrialisation, presents it throughout as dirty and harsh – a pandemonium which must presumably be passed through 'towards socialism'. It is depicted as a fire, the 'furnace

*In the furnace of the Five Year Plan*

of the five year plan' as contemporary slogans had it, through which many of its participants would be lucky to escape.[7] It is an exemplary work of *accelerationism*[8] – its wager is supposedly that by subjecting itself to the most dramatically brutal rigours, through the most painful labour, the working class will be able to create socialism, although unlike in earlier Vertov films there are few images that present a particular 'positive' image of socialism. It seems more likely that it is the inferno itself that is the point, the present of vertiginous and exhilarating industrial landscapes, of uncontrollable fires and unbearable heat. Although Charlie Chaplin himself would specifically praise *Enthusiasm*,[9] it is propaganda without sentimentality or respite, albeit with an atypical self-reflexivity. The enthusiasm is not for the prospect of socialism, with or without any attendant garden

cities; it is for the shocking and defamiliarising process of the Donbas' mechanisation in and of itself.

A comparable, and ostensibly very similar 'symphonic' sound film taking place within the furnace of the Five Year Plan shows a gradual move away from *Enthusiasm*'s tensions, contradictions and its unromantically presented toil. Joris Ivens' 1933 *Komsomol: Song of the Heroes*, on the subject of the construction of the Magnitogorsk steel complex, is one of the most international productions of this alleged period of autarchy and national accumulation, directed by a Dutch film-maker with 'blast furnace music' composed by Hanns Eisler, and lyrics to a climactic song by Sergei Tretiakov. The film was produced under the auspices of Willi Münzenberg's Comintern film corporation, Mezhrabpom. The film is clearly intended for an international audience (it was released in German as *Die Jugend hat das Wort*), as it begins with a montage showing gigantic industrial complexes in Western Europe in a state of desuetude, with workers walking disconsolately past them; this is then followed by struggles between workers and police in Germany; the film is dedicated to the 'Komsomol of the West', before we see a dramatised map of the telephone networks connecting Moscow with the USSR's industrial centres. That said, the film is not so much propaganda for Moscow as the centre of world revolution as propaganda for the Soviet Union as a country with full employment and an 'enthusiastic' approach to industrial labour. In many ways, the film is less extreme than Vertov's work with similar material. Although made two years later, it is, despite having far clearer and less distorted synch-sound, more primitive – there are still intertitles here, of a fairly leaden nature, needlessly interrupting the montage to equally leaden propagandistic effect ('Ishmakov's Brigade broke the American record with 560 rivets in one day'); but though it shares the use

of rousing, march-like music, Eisler's compositions are far less insipid than those in *Enthusiasm*.

The film still revels in the disruption of previous modes of life by industrialisation, and in the literally explosive disjunctions of the new landscape – an early trick sequence sets up an idyllic steppe, with a man playing a pipe in this rural scene. Then a hill explodes, and we notice that he is playing in front of a freight train packed with coal. Ivens and Eisler clearly want to induce a pleasure at that unexpected explosion. The use of industrial sound, meanwhile, is notably more 'composed' – at one point, the sound of metal on metal is almost gamelan-like in its organisation.[10] The parallels are many, aside from the subject matter – there is even another scene where models move, untouched, as a representation of industrial transport networks, like the toy tractors on conveyor belts in the earlier film, which here is actually more dramatic, a stop-motion animation of elevated railroads in an automated model Magnitka careering in all possible directions. There is also a similar defamiliarising, rather than ethnographic, use of folk song, in the scene where the blast furnaces echo with an only supposedly more 'authentic' music which is actually as contra-puntal, jagged and frantic as Eisler's own contributions. In the location filming, there is a greater *sachlichkeit*, a precision, to the depiction of the industrial maelstrom, less obvious instability and extremity than in Vertov's film, but a maelstrom it remains, a dirty, messy process; Ivens' camera angles may be calmer, but there is a similar sense of exaltation and horror as it pans over a river surrounded by blast furnaces, steaming and almost boiling. *Komsomol* is certainly more clearly 'documentary' in the John Grierson sense: it tells a clear story, with explanatory, educational intertitles of the 'now the coal has to be turned into coke' variety; the precision and stability of the filming in scenes

of panic and emergency suggests that some of it is staged; and there is none of Vertov's baring of cinematic and aural devices.

*Enthusiasm* has no clear ending, no obvious resolution. This appears to be deliberate – Vertov could clearly shape a dramatic ending, as the various 'crescendos' of *Enthusiasm* or the spiralling climax of *Man With a Movie Camera* attest – stressing that the film is an episode from the unfinished mechanisation of the Donbas, with no particular finality. This is where the two Five Year Plan symphonies depart most radically from each other, through the practically orgiastic final scenes of *Komsomol*. We have been following labourers working overtime to complete a second blast furnace so as to produce a certain amount of tons of steel as centrally required. This occurs as an 'attack' on the night shift, with a fleet of Komsomol members leaping onto a truck, holding aloft flaming torches. Eisler's music suddenly shifts into a roaring, almost screaming 'song of the heroes' with the insistent refrain *Ural, Ural*, which in this martian landscape suggests *War of the Worlds'* *Ull-aa*, a literally 'agitated' music

*Destination: Magnitogorsk, in Joris Ivens's* Komsomol – Song of the Heroes

of shocking violence. Tretiakov's lyrics manage to revel in the fulfilment of Party decrees ('the Party asks "give us iron!" and the Komsomol says "we will!"') and the war on nature. The 'Ural' is not being hymned, it is being threatened, taunted, with the prospect of victory in the war against nature, the project outlined in Trotsky's *Literature and Revolution* to reshape the natural landscape according to man's will – the singers yell triumphantly 'Ural! Ural! We've made you submit'. In the darkness, meanwhile, we watch the Komsomol with their burning torches work amidst rivers of lava, amidst sparks and flames; as if the infernal connection is not obvious, the intertitles interject with 'we will fight like devils!' At the climax of this industrial paroxysm is a surely comic image of the phallic furnaces becalmed, giving off steam, with the red flag lifted at its head – the Five Year Plan equivalent of the post-coital cigarette, and here we see in gratuitous detail the consummation that precedes it. It is all very anti-Taylorist. If, as Gramsci puts it, Fordism and Taylorism put limits on passion and enthusiasm in favour of precision and a severe sexual morality – 'the exaltation of passion cannot be reconciled with the timed movements of productive motions connected with the most timed automatism'[11] – then here it is brought back in, which may not be the most sensible way to construct a steelworks.

The film is keen, as an intertitle quoting Stalin attests, to make clear the success of Russia's attempts to transcend its historical backwardness. What is less clear is what, other than the availability of employment, makes this relevant to the concerns of the Western workers the film is aimed at and dedicated to. And given that Magnitogorsk was intended to be a socialist town planned on entirely novel lines by a group of German socialist architects, it is striking how the workers' city is of no interest whatsoever to Ivens and Eisler, the only allusion to workers'

living conditions being the wooden barracks we see in the background when workers line up to enlist in the production brigades. Even more than in *Enthusiasm*, this is not presented as production for the sake of the glorious socialist future, but, in Marx's phrase, 'production for production's sake' (although the use of that production for the Soviet Union's industrialisation is patently obvious). The utopia of Magnitogorsk as Sotsgorod is far less important than the mesmerising but apparently point-less transportation, distribution and production of steel and coal, and the heroic feats of labour behind them. As Galbraith pointed out about the visitors to River Rouge in Detroit, the amazement, awe and thrill they make out of industrial construction may not be unrelated to the far from proletarian backgrounds of many of these directors and composers.

The construction of socialism is not the subject of the film's construction, the subject *is* construction. It fits well with an early 1930s Intourist poster, which features a colourised, tilted photograph of a worker in front of the Magnitka blast furnaces (subtitled 'an Udarnik [shock-worker] at the Magnitogorsk steel mills'), it cries 'SEE USSR' – offering up the promise of heavy industry as a spectacle, a theatre of astonishing feats to be enjoyed by the visitor, tourist or Friend of the USSR. The strange transfiguration of this American archetype is complete. Visitors from places with plenty of steelworks and hard labour of their own – people who would seldom think to visit Gary, Indiana or the Ruhr – consume what in their own countries would be considered mechanised oppression, now sold back to them as 'socialism'. The dream of the USSR occludes both the nightmarish carnage of its gigantic construction projects and the possibility of a meaningful solidarity across the industrial countries.

## Shock-Workers – Hip Hip Hooray!

A less terrifying approach to the themes of industrialisation, toil and 'socialist construction' can be found in Esfir Shub's 1932 documentary *K-Sh-E: Komsomol, Patron of Electrification*; and here, an explicit Americanist spin on the genre is developed. The film charts the early stages in construction of the DniproGES, the Dnieprostroi construction project, like Magnitogorsk then the largest project of its kind in the world. Much as with Magnitogorsk, the precedents were American, but here the involvement was even more clear: the General Electric Company of the USA essentially built the dam directly, using Russian labour. Alan M. Ball writes that:

> not only most of the major construction techniques were American but also most of the technical equipment – roughly 70 per cent, according to an estimate in 1929 – came from the United States. The General Electric Company (GE) had as many as sixty technicians and engineers at work on Dnieprostroi and supplied such crucial components as the nine generators for the power plant. Five of these generators, the biggest in the world, were built at General Electric's plant in Schenactady, while the remaining four were assembled in Leningrad from GE parts and with the assistance of GE engineers.[12]

Ball notes that Soviet leaders were not always inclined to stress the American contribution to the USSR's grand industrialisation projects, but *K-Sh-E* has little compunction.

*K-Sh-E* is also a modernist film, in a very 1920s sense, displaying a relatively innocent delight in abstraction and the strange, and lacking the onset of Stalinist heaviness that can

be detected in *Enthusiasm* and *Komsomol*; the introductory sequence shows a play of three-dimensional shapes redolent of Moholy-Nagy's 'Light-Space-Modulator', while the following orchestral prelude centres on that early electronic instrument, the theremin. As in Vertov's work, the film is pervaded with self-reflexivity – as the orchestra and the theremin play, we see sound waves, reels and the camera, and a slightly later scene shows recording inside the Moscow Radio studio, with announcers in English and German, repeating Comintern slogans. The synch-sound takes the artificiality towards the unearthly, montaging seemingly disparate elements due to their semi-musical properties, from Kremlin bells to the chatter of women working in the telephone exchange. When the scene moves to the manufacture of electrical components of Dnieprostroi, the multilingual movement is united in its approbation of the factory's engineers – 'the equipment was built by the Americans', says one worker proudly – but there is also the ritual declaration that the USSR will accelerate past them; 'the American engineers helped to eliminate defects, but Komsomol plans to catch up and overtake America!' says another.

Following this is one of the more convincingly joyous sequences of collective labour in the period, in a factory construction landscape that is frequently speeded-up and manipulated by Shub. In the lovingly shot electrical factory, women workers construct components in a mechanical waltz-time, lingering especially over the automated aspects of the process; throughout the surviving 25 minutes of the film, the music avoids the numbing hurrah-patriotic march that trudges through so much of *Enthusiasm*. There are even moments of laughter. For that, production still appears to be carried out with the organisation and ferocity of a war – Shub's focus is often

on giant objects, carried through an open-framed Ford-like shed, with large glass surfaces making the space appear both metallic and ethereal. The effect is both controlled and cataclysmic. This is often presented as being in direct response to the Americanist command. At one point, the foreman informs the workers that 'the American says' that a certain quantity of machinery is needed by a certain time – and one of the women workers replies in Slavic-accented English 'alright, we will do as you say!' – at which point the factory springs into deafening, awe-inspiring life. At one point, workers crowd round in the factory to watch what appears to be an impromptu circus-like entertainment, part music hall, part slapstick, with dancing and general clowning. The impression is of speed, lightness, automation and at this time unforced enthusiasm, mirrored perhaps in this enjoyment of non-propagandising leisure (shown, of course, as part of a propaganda film).

Another film made on the same construction site just over a year later depicts a rather different tempo.

Alexander Macheret's *Men and Jobs* (1932) is a fiction film, although one filmed on the Dnieprostroi site itself, rather than in a studio. It hinges on the friendly rivalry between two foremen – one Soviet, one American.[13] We are first introduced to the American, in Harold Lloyd glasses with pipe in mouth and Taylorist stopwatch usually in hand. He is in his quarters, listening to a jazz record, making clear his homesickness on the construction site; we hear, in English, 'I'll soon come back my darling, then we'll love and caress'. He writes postcards, then opens the window – and jazz is replaced with the noise of strain and movement, in a cut which is an implicit link as much as a contrast. The relative ineptitude of the Soviet hosts is made clear in the next scene, when a vaguely Constructivist theatre meeting/concert sees the delegates call for electric

*Comedy of efficiency:* Men and Jobs

light (the production of electricity being the purpose of the entire project, after all), which promptly disappears when the speaker takes the stand. Meanwhile, the American foreman has 'socialist competition' explained to him by a young interpreter, and a series of embarrassed misunderstandings ensue. 'No, I don't mean *competition*', she says in Russian. He replies in English 'I understand [. . .] people here don't know how to work'. The Russian foreman is mortified at this slur, and shouts 'Go!' to make the whole construction site suddenly start up from a previous torpor. The American opens his jacket to reveal a postcard of a skyscraper, and takes off his hat and glasses, revealing a large, proletarian frame. To his own workers, he issues Taylorite commands – 'you take nine minutes to do what should be done in three!' – and times them by his stopwatch.

In *Men and Jobs* an opposition is set up between Taylorist precision and Russian machismo. In the former work is timed and rationalised, in the latter, long periods of sloth are suddenly interrupted by manic shock-work. Initially, the latter approach seems risible to the American, and he roars with laughter at the idea of being caught up and overtaken. The film's propagandist purpose (and this is a gently propagandistic film, low on exhortation and exaltation) is to shame the Russian workers, to some degree, to embarrass them out of 'peasant' working habits. In a particularly tragicomic scene, workers enjoying a quiet moment hear stories of forced labour in Soviet camps in an English edition of *The Times* that is being translated for them. 'The English bourgeoisie won't even let us enjoy a cup of tea in peace!' In this context, the American quickly creates a humming mechanised workforce. Meanwhile the Russian workers' work-tempos – indolence followed by panic, a wartime pace – is also the pace of the film itself, where *longueurs* are interrupted with flurries of industrial activity. There are few montage sequences, and the possibilities of synch-sound as a contrapuntal method are deliberately unused, with dialogue paramount throughout. This partial rebellion against the new tempo can be encapsulated in a moment where a Russian worker is told 'The American takes three minutes with each', and replies derisively 'this is not America, it's Russia!'

Yet that embarrassment in front of the American foreman, after lives are put at risk by the Russians' inefficient working methods, leads to a final spasm of shock-work that pulls the site out of its torpor. The shamed workers become enthusiastic, and they express this enthusiasm by mouthing party slogans. 'There are no fortresses the Bolsheviks cannot storm' says one, the Russian foreman replies 'no, there are not! So we must overtake the American!' and they do so, 'laying down concrete

equal to the Americans'. Nikolai Okhlopkov's performance as the Russian foreman is full of gestures of 'peasant' sluggishness and slowness, a frankly poignant contrast to the inhuman efficiency being demanded on the construction site; he is a deeply unlikely rationaliser. The dreaming collective is particularly slumberous in *Men and Jobs*, needing to be humiliated and forcibly awakened before it can accomplish its work. In the concluding sequences, the last-minute shock-work has served its purpose, and the American has been overtaken, somewhat improbably. Partly this is because 'we began employing Mr K's rationalisation to our site', but partly because they, in an exact Stalin quote from *Foundations of Leninism*, 'combined American efficiency and Russian revolutionary sweep',[14] although the efficiency is hard to imagine. The American concedes, and in broken Russian hails 'udarniky' (shock-workers), 'stroi' (construction) and finishes with 'hip hip hooray!'. He is seen at the end throwing away his jazz record and writing to his girlfriend 'I won't be back soon [...] the Bolsheviks seem to me to be gentlemen'. Aside from its attempt to tidy up the mess it has admirably presented, *Men and Jobs* depicts fairly accurately the problems of Soviet industry, a chaotic succession of sloth and forced rush.

This also accords with Isaac Deutscher's account of Soviet Taylorism as a species of the oxymoronic 'Socialist Competition', or rather the *failure* to create a Soviet version of Scientific Management. After noting the fierce opposition to rationalisation on the part of the American Federation of Labour and most trade unions elsewhere (where 'the defence of the worker's interests and the fear that scientific organisation of labour would result in an increase of redundant labour have inevitably been blended with an instinctively conservative attitude towards technological progress'[15]), Deutscher follows

Trotsky's attempts in 1921 to apply Taylorism in a Soviet context where the trade union movement were similarly hostile, with the justification that nationalised industry would avoid the exacerbation of inequalities – which led to an eventual realisation that 'state ownership of production does not turn manure into gold'.[16] However, Deutscher sees the apparently intensified focus on rationalisation at the turn of the 1930s as:

a primitive though broad approach by Soviet industry towards Taylorism and kindred versions of scientific management and organisation of labour [. . .] in most sectors of Soviet industry the rhythm of technological advance was at first too slow and then too uneven and jerky, the labour force too raw and management too much hampered by political and bureaucratic interference for any systematic scientific organisation of labour to be practiced over most of those years.[17]

Interestingly, the elements that he claims hampered these efforts are exactly those which the films of the First Five Year Plan, most straightforwardly in *Men and Jobs*, praise as specifically Soviet, those which enable them to overtake the Americans in fiction: 'too fierce competition between workers', as in the Udarnik or especially the latter Stakhanovite movements, 'is by no means conducive to scientific organisation. Nor does the customary Soviet emphasis on quantity production, so often harmful to quality, agree with either scientific management or the rational planning of labour processes.'[18] Other than the avoidance of competition between firms and the attendant wastage of resources and production of useless goods, it appears that by the early 1930s the innovations the Soviet Union had introduced into their adaptations of American technique

served to make it actually less egalitarian, and less technically efficient. That this can be detected in the unconvincing resolutions of an otherwise conscientious film such as *Men and Jobs* is telling about the early Soviet sound film's ability to hold harshly antagonistic contradictions within it. What has been lost here can be found in Gastev's words to Ernst Toller, when he expressed worries about dehumanisation – that in fact rationalisation would mean 'producing the highest quality for the least expenditure of energy',[19] all with the specific aim of 'arriving at a stage when a worker who formerly worked eight hours on a particular job will only need to work two or three.'[20] What happens in these films is that work, the struggle and alleged nobility of work, becomes an end in itself, and heroic efforts and prodigious feats replace the once-terrifying ratio, with results that were as impressive as they were bloodily wasteful. The Five Year Plan films, with their occasional moments of joyous automation, retain a memory of the earlier paradigm, but also conspire to replace it. However, they're also a strange recurrence of the theory of 'making difficult', the notion that particularly arduous and unusual physical actions would be an 'attraction' in the Constructivist theatre. Certainly these actions too are rendered as something to be watched and appreciated in films like *Enthusiasm* and *Komsomol*, but the grimness of this particular kind of difficulty – the heat, the stench, the smoke – is all too visible in Vertov's film.

## National–International

The film which confronts the early Stalinism in the Comintern most directly, and which also shows to the fullest one of the 'Statement on Sound's signatories implementing those

recommendations, is Vsevolod Pudovkin's *Deserter* (1933). The film was commenced as a commission from Münzenburg's Mezhrabpom studio in Hamburg in 1931. It was originally intended to be shot in Russian and German, but Hitler came to power before its completion, meaning that it is largely in Russian, though still partly bilingual, and includes much location footage from Hamburg and Berlin – the introductory street scenes montage road accidents, workers on the verge of starvation and mass unemployment, with the neon lights of the Kurfürstendamm, in a fairly common class-struggle contrast. That is as simple as politics gets in *Deserter*, however, which is otherwise as complex and contradictory as the policies that inspired it. It even begins with a propagandistic account of a Hamburg dock strike broken by Communists in order to aid Soviet freight using the port; an act of scabbing described in Jan Valtin's book *Out of the Night* as the height of betrayal is here recast as heroic solidarity with the Five Year Plan. What occurs in *Deserter* is the attempt of a director who specialised in convincing, non-Stalinist depictions of revolution from below (in *Mother* [1926] and *The End of St Petersburg* [1927]) attempting to celebrate the dishonesties, occlusions, compromises and horrific defeats of the early 1930s, while retaining political and intellectual integrity. It is, to adapt the hoary Trotskyist phrase, a deformed revolutionary film – as overspilling with ideas, conflicts and audio-visual intelligence as anything made by the pre-Stalinist avant-garde, refusing to lull, mollycoddle or hector its viewers with a simple chauvinistic message, still with the insurgent crowd rather than the leader as its hero, it is also an unambiguous work of support towards Stalinism's remaking of international Communism in its own image.

*Deserter*, despite its coherent narrative and identifiable 'heroes', still partakes of the formal extremes of *Enthusiasm*;

more so, if anything, with the larger budget and superior tech-
nology enabling greater feats of disjunction and attack. A
scene of shipbuilding in Hamburg presages the 1980s work of
Einstürzende Neubauten in its transformation of industry into
angular syncopations. Sound and image remain in constant,
dynamic, rhythmic disjunction, with the use of long periods
of silence or slow motion clashing with deafening noise and
teeming crowd scenes. In a later strike scene, the Communist
and Social Democrat unions clash; the camera delves right
into the crowd, getting into workers' faces; the metallic music
is interrupted with one worker's prediction of imminent defeat
('the bosses will beat us just the same'), and then the music
resumes, as if a comment on that defeatism's interruption of the
strike's tempo.

The metal-on-metal jazz taken over from the shipbuilding
scene becomes parodic, and industrial-militaristic for the entry
of the Social Democratic unions. The scene ends with the noise
of an incoming train, appearing before we see the train itself;
then another scene of the neon of the bourgeois city; the adver-
tisements on the boulevards are accompanied by scrolling news
stories. One of them is about rationalisation, about Taylorism,
where it promises 'one child can do the work of ten adults'; the
techniques celebrated elsewhere in Soviet culture here in their
other role as destroyer of solidarity and eliminator of the worker.
When the intra-proletarian conflict is resumed, we watch an
industrial lift shaft descend in a manner which closely evokes
*Metropolis* (1927); science fiction here as grim reality, and as the
camera tracks along a crepuscular railroad, the Gothic potential
of industry is fully utilised – perhaps in a way that it couldn't be
in the USSR, where its role in 'building socialism' was too sacro-
sanct. These subterranean scenes alternate with lightning-flash
montages of the strike outside; and strike-breakers and strikers

alike are attacked by the Reichswehr, while a strike-breaker is felled by a practically robotic tank. The cries and groans of pain continue into the intertitles announcing the next scene, and continue, now underlying the workers' forced return to work, overseen by their bosses and the army. Lines of the dead are seen behind them.

After the battle in Hamburg, delegates of the KPD are chosen to go to the USSR; a young proletarian, Karl Renn, goes there, along with older workers. In the next scene, in Leningrad – the first thing we see is a street parade on Nevsky Prospekt, with planes flying overhead. The complexity of the metallic music in the German scene is replaced with a patriotic march, although it is partly overtaken by more metal banging, cheers and car noise. Already, this is the era of the grand sports parade. The Russian proletariat is not however a regimented crowd, yet – faces loom right into the camera, and the mass is not yet drilled into the ornamental patterns that would mark the later 1930s. After this introduction, Renn becomes a 'specialist' in a factory; inside it, a tannoy names those who cannot 'reorganise themselves', and the inquisitorial side of the Plan is clear as the workers give their reasons and excuses for tardiness to the microphone. There is Rationalisation here too, and it seems to have some things in common with shipbuilding in Hamburg; here too, the factory's work is montaged into a pounding rhythm, perfectly synchronised, with the machines in 4/4 time. The obligatory shock-work task, meanwhile, is to complete 36 days' production in only 30. This feat is 'our duty to the world proletariat', 'from the victory of one socialist factory to the world revolution', maybe in unspoken recompense for the strike-breaking in Hamburg. The two halves of the film are still distinct, however, the chauvinistic sloganeering is as uncharacteristic of Pudovkin's earlier films as it is of *Deserter*'s Weimar Republic segments.

At the end of the film, back in Germany after self-criticism for earlier co-operation with SPD 'Social Fascists' and awards for heroic shock-working in the Leningrad factory, Renn now takes part in another battle, this time between KPD strikers and the police. The scene is dominated by strident marching music, with a relentless forward motion. This seems at first like more hurrah-chauvinism, but it soon gives the scene a horrifying tension, as the strikers quickly lose the fight against their better-armed opponents. The montage goes on, the music is uninterrupted, our heroes fall, elegantly, but the struggle, in the form of the march, continues despite everything. But in the process, the music's glory and pride sounds grotesque. Pudovkin, who was accepted as a candidate member of the CPSU during the making of *Deserter*, wrote of this last scene that:

> Marxists know that in every defeat of the workers lies hidden a further step towards victory. The historical inevitability of constantly recurring class battles is bound up with the historic equal inevitability of the growth of the strength of the proletariat and the decline of the bourgeoisie. It was this thought that led us to the line of firm growth towards inevitable victory which we follow in the music through all the complications and contradictions of the events shown in the image.[21]

This was the Comintern's line during the rise of Hitler in a nutshell – that what looks like defeat, what appears to be the disarming and murder of the workers' movement, is in fact only a scuffle on the way to the inevitable final victory; accordingly, nothing need be learned from defeat, as the forward march still overrides all. This also helps explain the remarkable absence from *Deserter* of the National Socialist movement, an absence

shared by Slatan Dudow and Bertolt Brecht's similarly formally innovative *Kuhle Wampe* (1932). It is not even dismissed as a threat, the NSDAP simply doesn't exist; the only enemies are the Reichswehr, the police and the Social Democrats. Even after the Nazi takeover of power forced the director to finish the film in the USSR, Fascism, as opposed to 'Social Fascism', is never acknowledged. In *Deserter*, the Soviet Union's industrialisation is presented as unspoken consolation for the destruction of the Communist movement in Germany.

## The End of the Village

The most notorious brutalities of the Third Period occurred in the Soviet countryside, where violently forced collectivisation directly caused famine on a huge scale, in Ukraine, the Volga region in western Russia, the North Caucasus and Kazakhstan; throughout, grain continued to be exported, and there was no serious attempt at famine relief; the famine was hushed up, both locally and internationally.[22] Unsurprisingly, given this official oblivion, these events do not feature in the propaganda films of the period, but there are two films which present a haunting, ambiguous and uncanny account of the transformed country-side, that is not so much celebratory as unnerving. An animated short from 1933 directed by Nikolai Khodataev (director of the joyous Eccentrist short *Interplanetary Revolution* [1924]), *The Little Music Box*, is a particularly unusual example of this contrapuntal montage as applied to the Soviet rural film. It is not a film of construction in the manner of the Ivens and Vertov films, but a surreal vignette of the progression from the imperial bureaucracy to the new. It begins with a series of imperial grotesques, as various worthies audition for the job

*The Tsarist horseman chased through the New World:* The Little Music Box

*Saluting the Tsarist horseman:* The Little Music Box

of governor for a small town, with the main targets being a general hurrah-patriotism, as the various contenders compete via increasingly enthusiastic sheep-like bleats and cries.

The protagonists' actions are determined by the titular music box, which has 'a clever mechanism that replaces the faculty of human reasoning' – intertitles show the puffed-up general who bleats loud enough to become governor setting about to 'zealously eliminate free thinking' as his programme. His first act is to torch a library – the books literally run out of it, escaping the flames before it burns to the ground. The soundtrack, here as throughout, is an atonal collection of imperial marches, animalistic cries and squeaks, a patriotic burlesque. Then the architectural setting, provincial neoclassicism, becomes rural, as the governor launches an assault with an army of toy soldiers as retinue on a village. The emaciated peasants are bombarded with cannon until they pay their tribute, after which they cross themselves. In celebration, the governor stages a banquet, where young women in uniform perform 'the dance of the patriotic constables'.

Abruptly, the general gallops out at speed with horse and retinue, though at such speed that he suddenly emerges in the modernist city of Communism. In place of the peasants' shacks arise gigantic, unornamented and clearly Constructivist buildings with asymmetrical balconies, abstract geometries and ribbon windows, some of skyscraper proportions – they literally shoot up out of the ground at speed. The general is unsurprisingly alarmed, and is soon chased in and out of the village-cum-Sotsgorod by cars, until he keels over and dies. The film ends, however, on a cautionary note – 'a museum keeps the music box with its special mechanism'. It is presumably this implication of continuity in bureaucratic, militaristic philistinism and bombastic patriotism, and the depiction of a

starving and servile peasantry, that led to the film being banned on completion, 'considered a satire on social relations and collective farms'.[23] It seems more a satire of the bureaucracy's continuation of imperial methods, and its farcical, grotesque and disturbing use of physical caricature, its nightmarish imperial parades, were no doubt 'formalist'. Although modernism appears to chase Tsarism out of the village, it survives through the museum.

There is a similar architectural ambiguity in Alexander Medvedkin's *Happiness* (1934), a now famous, bizarre (and silent) remnant of Eccentrism at its most anti-realist and deliberately facetious, adrift in the year that the Soviet Writers' Congress issued the official declaration of 'socialist realism'. It was inspired directly by the experience of the ravaged countryside which the film's makers had acquired on a film-train that traversed the collectivised landscape in the early 1930s. Here, there is little political ambiguity. An (emaciated) peasant and his (significantly less emaciated) wife attempt to find happiness in a blasted, featureless rural moonscape. Initially, their dreams are conventional – money and power, particularly in a dream sequence where the two live like medieval kings, consuming huge quantities of meat and wine. Eventually the peasant is arrested after a kulak (rich peasant) tricks him into setting a village store on fire – upon release he finds his wife working joyously in a kolkhoz (collective farm), and is taken to the city, his thin, half-starved frame is measured, he is dressed in a suit and a proletarian cap, and at the end he desperately tries to drop his peasant baggage, his old clothes and all they represent, in a neoclassical city, only for the militia to make sure he takes his bundles with him.

What makes *Happiness* so intriguing as a depiction of the consequences of the socialist offensive's most brutal front, the

Soviet countryside, is the use of Eccentrist, slapstick devices and motifs. The structure of the film may have been partly based on Harold Lloyd's *Grandma's Boy*.[24] The acting is greatly indebted to the tradition that extends from Mack Sennett through Chaplin and Keaton to the Theatre of the Eccentric Actor – gestural, anti-naturalist, machine and marionette-like, farcical, and eroticised, either in the wholesomely bountiful form of the protagonist's wife, or via a notorious scene where nuns in see-through vestments parade through the village. The rural environment, though, is not abundant in the same manner, but a grim, blasted heath, far from the verdant motherland of a fully Stalinist film like Alexandrov's *Volga-Volga* (1938). Yet the simple buildings in it are as mobile as any Constructivist dream; the autonomously active architecture of Keaton's *One Week* and *Steamboat Bill Jr* is taken to genuinely surrealist levels. In an early scene, the couple's disputatious horse carries a barn on his back to spite his owners; and later, an entire house is lifted from its foundations by kulaks involved in sabotage, now escaping from the villagers and the Red Army.

*A house flees collectivisation:* Happiness

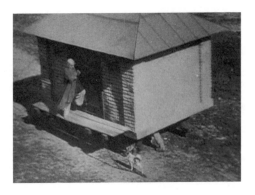

Medvedkin tracks the house along the fields, with the shot making it look as if the house has grown legs, running away from the kolkhoz to somewhere else altogether. Although the film ends with an attempt at resolution, where the dreamy village idiot becomes a neat proletarian in the colonnades of an imperial city, the most memorable architectural image is of the dying petit-bourgeois peasantry (embodied in the semi-mythical figure of the kulak) creating, by accident, the new form of mobile architecture envisaged by the Constructivists. Partly inspired by the Russian folk tale of Baba Yaga, a witch who lives in a house carried on chicken legs,[25] it also merges with the hostile reaction to the free-floating Pilotis of modernist buildings. Vladimir Paperny's account of the critiques of Le Corbusier's Tsentrosoyuz office block in Moscow claims, via the same folk tale, that 'a structure that stands on legs is not simply something that has come from far away; it is also hostile'. The dream of mobility, then, is now a kulak fantasy. Medvedkin's sympathies, at least on aesthetic grounds, appear to be with this free-wheeling mobility, but it is of necessity consigned to a farcical past.

## Conclusion
## Life is Getting Jollier, Comrades!

*Sub-Mack Sennett director, sub-Max Linder actor, Stavisky of the tears of unwed mothers and the little orphans of Auteuil, you are Chaplin, emotional blackmailer, master-singer of misfortune. The cameraman needed his Delly. It's only to him that you've given your works, and your good works: your charities.*

*Because you've identified yourself with the weak and the oppressed, to attack you has been to attack the weak and oppressed – but in the shadow of your rattan cane some could already see the nightstick of a cop.*

*You are 'he-who-turns-the-other-cheek' – the other cheek of the buttock – but for us, the young and beautiful, the only answer to suffering is revolution.*

Bernau, Brau, Debord, Wolman, 'No More Flat Feet!' (1952)[1]

### Gulag and Circus

In the David King collection there is an extremely rare photograph, taken surreptitiously on the 19th anniversary of the October Revolution, of a Gulag, the Svirlag labour camp in the Leningrad region. From familiarity with the surviving buildings of the concentration and extermination camps of Nazi Germany, we might assume some lonely wooden or brick barracks, a minimal and functional vernacular non-architecture. It is striking how much this anonymous photograph contradicts that notion. Although the basic buildings – traditional wooden constructions, albeit arranged with a less

than traditional asymmetry – are not especially dramatic, the paraphernalia around them certainly is.

The entire apparatus of Constructivist architecture in its pre-Corbusian phase – the 'component fixation' noted in the work of Kestutis Paul Zygas[2] – is used to decorate the building. Here we have a glass observatory, a strip of advertisement culminating in two clocks (the lettering for which reads 'NKVD'), a sign reading 'Club' in Constructivist lettering used in the Workers' Clubs of the 1920s, a succession of slogan billboards celebrating the anniversary of the revolution, and, alongside the more expected portraits (Molotov, Kalinin, a gigantic Stalin overlooking the entrance to the camp at the top) are several childlike, cartoonish figures embedded in the structure, Red Army men and women looking decidedly cheerful. Along with red flags blowing in the wind, there appears to even be tinsel draped across the buildings. Given the sheer amount of public celebrations in the Soviet calendar, it is unlikely that this was an atypical scene. It shares in the radical, blaring aesthetics of the avant-garde, but for very different purposes. Rather than the insertion of an ad hoc propaganda apparatus into the historical city, a disruption of the everyday in order to jar the pedestrian, to shock them into thinking, the apparatus here is designed to exhort production from slave labourers, to cajole and nag them into working harder, to convince them that the regime that enslaves them is the continuation of an emancipatory movement.

But what this resembles, more than anything else – if you blind yourself to the huddle of hatted and headscarfed people in the foreground, and the sinister ambience they (and the cheap, worn film stock) evoke – is a fair or a circus, with its funfairs, its apparatus of jolly objects, advertisements, billboards, its deliberate marshalling of fear and drama into

crassly exciting entertainment. According to Koolhaas in *Delirious New York*, the funfair at Coney Island is one of the foundations of Manhattanism, which merely translates its innovations into the metropolis itself rather than a peripheral pleasure district. What is so alarming about this photograph is that it shows the Stalinist dictatorship, here just about to enter its most psychotically violent phase, the Great Purge of 1937, as a society of compulsory jollity, where even something so brutal – and, as the clandestine nature of the photograph attests, so secretive – as the system of concentration camps, adheres to an aesthetics of publicity, of compulsory cheerfulness and levity. If, as Stalin claimed around this point, 'life has become more joyous',[3] then this was even to be reflected in the design of labour camps.

There was a widespread view among avant-garde circles after Stalinism, and especially after the Second World War, that this discredited the entire attempt to transform everyday life via the conjunction of Constructivism and mass culture. The most penetrating retrospective critique of the aesthetics of avant-garde Americanism is that of T.W. Adorno, particularly in the remarks on 'variety' and vaudeville in 'The Schema of Mass Culture'. While the montage of attractions that is originally found in the circus as posited by the FEX or Eisenstein is considered to be something jarring and disjunctive, no matter how bound it might be by convention, Adorno posits *boredom* as the main circus device.

What really constitutes the variety act, the thing which strikes any child the first time he sees such a performance, is the fact that on every occasion something happens and nothing happens at the same time. Every variety act, especially that of the clown and the juggler, is really a kind

of expectation. It subsequently transpires that waiting for
the thing in question, which takes place as long as the
juggler manages to keep the balls going, is precisely the
thing itself.[4]

This creates a temporal effect whereby the circus act actually
prefigures the industrial process, hence providing a model for
mass culture: 'the performance becomes the model of mechan-
ical repetition'. That it is repetitious and mechanical is already
included in the theorisations of Meyerhold or Tretiakov,
which is precisely why it is considered to be contiguous with a
Taylorised model of theatrical or cinematic movement.

However, what Adorno denies is precisely that this would
have the effect of excitation (in Meyerhold's terms), or collision
and conflict – more specifically, agitation – that Soviet theo-
rists argued would be produced by the incorporation of both
industrial and circus effects. The very sequential movement
that constitutes the film (with the discontinuous technical root
of this sequence necessarily hidden) erases conflict, although
whether this would have been the case where film was merely
another attraction among many, as in the FEX's *Marriage* or
Eisenstein and Tretiakov's *Enough Stupidity* is another matter.
Precisely what the avant-garde adaptations of circus technique
do is to attempt to resist expectation and familiarity, on one level
through extreme speed and rapidity, and on another, through
the experiment taking place in an unexpected area – on film, in
a factory, or in something like Meyerhold, Vesnin and Popova's
unproduced masque for the Congress of the Comintern in
1921, in the street. Nonetheless, as conflict is precisely the most
valued effect, for it to be negated by its mode of transmission
would destroy the entire argument. Conflict, despite the avant-
garde attempt, as Adorno puts it, to 'play a Chaplin trick' on the

sequential process, is apparently suppressed by the 'experimental time'[5] in which the avant-garde mutation of the variety show (Adorno's example is the epic theatre) sidesteps historical time. As the epic theatre is merely experimental, there is nothing at stake. Similarly, as the space announced by the FEX is, like that of the Marx Brothers, one where anything is allowed to occur, the shock of that 'anything' occurring is radically lessened. There is an alternative to this, however – to move out of this circumscribed, 'anything goes' space into directly lived space.

The argument in this book is that various attempts at producing a disruptive or defamiliarising film, theatre or architecture derived many of their ideas precisely *from the culture industry itself*, including its pre-industrial precursors. This has been mainly as a polemic with the claim that the avant-garde was more fundamentally concerned with industrial rationalism in itself, and intended to impose its own alien conception upon the proletariat for the purposes of dubious technocratic theory or uncomplicated domination. Instead, there was a complex dialectic between technological fetishism, popular 'entertainment' and Modernist aesthetics, which was perhaps never fully resolved. What remains an open question – attempts to dismiss it or resolve it are equally unconvincing – is whether or not it actually *worked*, whether the 'audience' could be radicalised through the production of a mutant form of their mode of evening and weekend escapism, wherein they may recognise the popular forms but be jarred into thought by their re-deployment and conflict with other forms. If this failed, then what happens to the avant-garde in the Soviet Union, Germany, Czechoslovakia and elsewhere afterwards can be seen as a reaction to that failure. Although Boris Groys's claim of total continuity is unconvincing, there is no doubt that certain ideas of the avant-garde do continue after the proscription of artistic

associations in 1932 and the Soviet Writers Congress of 1934, both of which are the usual cut-off dates for Constructivism. Architecture did not merely return to classicism, but incorporated Constructivism into a new, hierarchical baroque; and in cinema, the creation of a truly Stalinist film had direct input from one of the most enthusiastic Eccentrics, Eisenstein's close collaborator Grigory Alexandrov, who adapted these earlier ideas for the new hierarchy.

## Happy, Happy, Happy

The Eccentric period in Soviet cinema was already superseded in the later 1920s by a series of revolutionary epics. There were attempts at combining the historical accounts of workers' struggles and the devices borrowed from slapstick and farce, most notably Eisenstein's *Strike* (1928) and later, the FEX's *New Babylon* (1929), but it was, according to Youngblood and others, an approach considered baffling or at least confusing and inappropriate by audiences and the nationalised film studios. Although Soviet Eccentrism declines to the point where, by 1930, there are no longer any direct traces of it on the screen (bar the very late anomaly of Alexander Medvedkin's *Happiness* in 1934), it leaves traces on screen. Most notably, after the highly modernist aesthetics of the first Five Year Plan, where the obsession with Taylorism leaves Chaplinism behind, unambiguous comedy returns. In fact, it is often much more effective comedy than the works of the 1920s – the films actually made audiences laugh, which was not always the case with the work of the FEX or Lev Kuleshov; they show a mastery of comic timing that was rare in the more ramshackle work of the avant-garde. Hence the huge popularity of (and Stalin's personal affection

for) the series of Busby Berkeley influenced musicals directed by Alexandrov, particularly *Jolly Fellows* (1934), *Circus* (1936) and *Volga-Volga* (1938). As a pointer to what differentiates this Americanism from the making-strange of Eccentrism, there is an instructive anecdote in Harpo Marx's ghosted autobiography. On a visit to the Soviet Union in 1933, he was initially pointed to the Moscow Arts Theatre, Stanislavsky's centre of Method acting, for whom he auditioned much the same inscrutable, disruptive vaudeville act that he had been appearing in on screen since 1928. The response of the Moscow Arts Theatre's directors is fascinating:

> 'Your movements are extraordinary. But please forgive us. We don't know the story. If I may say so, the point eludes us.'
> 'Point?' I said. 'There isn't any point. It's nothing but slapstick. Pure hokum.'
> 'Yes, yes, of course,' he said, as if he understood, which he didn't at all. 'But may I ask why you were compelled to destroy the letters? Why did you drink the ink, knowing it was ink? What was your motive for stealing the knives that belonged to the hotel? [. . .] Perhaps it is different in your American theatre. Here you must tell a story that answers your audience's questions, or your performance will fail.'[6]

The Stanislavskian criteria of story and explicable psychological motivation are applied to the example of the comic approach of the Marx Brothers, who unsurprisingly are found wanting. That a film like *Duck Soup* (released in the year of Harpo's Soviet tour) with its collision of satire and eccentrism, and its remarkably fierce attacks on Imperialism and militarism

('we can't declare peace, I've just put down the ground rent on the battlefield', and so forth) would have been incredibly exciting to the authors of the Eccentric Manifesto is obvious, but this kind of comedy was clearly not circumscribed enough, had too much of a risk of competing interpretation; when it appears briefly as a component in Alexandrov's *Jolly Fellows*, it is actually *less* political than the Marx Brothers' precedent. The connections between the most disruptive and extreme elements in the American culture industry and the Soviet avant-garde had been definitively broken.

Aside from the grand Soviet-patriotic films of the 1930s, beginning with the 1934 *Chapaev* and continuing in the later 1930s and beyond with dozens of hagiographies of Lenin and Stalin, the most successful post-avant-garde genre was the musical comedy. Grigory Alexandrov's were the first and most famous. Alexandrov was Eisenstein's assistant on his major works, and was promoted to co-director on *The General Line*. He was one of the co-signatories of the 'Statement on Sound' in 1928. The first of his musicals, 1934's *Jolly Fellows* was very different in its use of sound from, say, *Enthusiasm* or *Deserter*, but still had a certain contrapuntal nature, and was still experimental in its use of music and sound effects, which was successful to a degree which Eisenstein, then shooting the soon-to-be-banned-and-destroyed *Bezhin Meadow* (1937), must have envied. The musical genre is directly American in inspiration, specifically from the musicals of Busby Berkeley, which, as Buck-Morss notes in *Dreamworld and Catastrophe*, were depictions of the Taylorised mass ornament to a degree which makes Kracauer's Tiller Girls look mild.[7]

In fact, *Jolly Fellows* is in many ways a more complete fulfilment of the demands of the Eccentric Manifesto than the films of the Eccentrists themselves, like *The Overcoat* (1926), or

*New Babylon*, with their shadow-filled irrationality and ornate expressionism. The main point of difference with the filmic avant-garde as it existed in the early 1930s – with films like *Enthusiasm* or *Deserter* – is in an apparent depoliticisation, a toning down of propaganda to accompany the stabilisation of the Stalinist state. In this move, the example of America becomes more, not less important. No longer adapted and warped, Hollywood is for the first time directly emulated. Esfir Shub claimed at the time that *Jolly Fellows*, while 'very interesting and entertaining' was 'nothing to do with us. It comes from America, from revue.'[8] That this was also the place where Tretiakov and Kuleshov had claimed a distinctively Soviet cinema had come from in the first instance is beside the point; they had distorted American models, used them to their own ends, made them unrecognisable. *Jolly Fellows* had no such qualms; it is very closely modelled on the 1931 Hollywood film *The King of Jazz*.[9]

It begins with parody of this heritage. In the film's first seconds, one of several animated sequences, we find captioned caricatures of Charlie Chaplin, Harold Lloyd and Buster Keaton. The next caption: 'these are not the stars of this film'. Given that imports of foreign films declined heavily in the early 1930s, in an attempt to create a filmic autarchy, there is more than a little irony in this opening comic disavowal. The jazz accompaniment, meanwhile, is far more frenetic than the soft balladry we hear in *Men and Jobs*, 'hot' jazz by Soviet standards. This shifts briefly into a more stereotypically Stalinist mode when the scene moves to a joyous collectivised countryside of mass abundance and rosy-cheeked milkmaids, singing an upbeat, slightly martial song about how wonderful life is; a not particularly subtle visualisation of the official claim that life has become more jolly. This is even more apparent,

although in a less Stalinist mode of iconography, when the scene shifts to a seaside resort. A continuous pan runs along the beach, and we see abundance both of bodies and flesh, shot largely at posterior level. People are fed grapes by their lovers in an Arcadian manner. It is a celebration of leisure, ease and pleasure. It is also, it soon becomes clear, both a leisure society and a class society. We shift to a rather bourgeois-seeming luxury hotel, with women in luxuriant hats; in fact, we appear to be back in the era of NEP, without the slightest trace of shock-work and the intensification of the class struggle. This looks a great deal like the ruling class, but no Chekists are shooting at them.

The dichotomy does not pass without comment. *Jolly Fellows* partly centres on the rivalry between the lady of a grand seaside house, who has her heart set on becoming a singer, and her cleaner, played by Lyubov Orlova, who is blessed with a natural voice which she is mostly too shy to use. The opposition is set up as being between purity and decadence, the provocative, indulged but talentless bourgeoise and the talented but downtrodden woman worker; although it is never foregrounded. Instead, this bourgeois environment is ridiculed in a manner which closely evokes the Marx Brothers; by anarchistic accidental pitfalls and by objects and animals acting out the Id of the human characters. A shepherd claiming to be a great conductor accidentally brings his flock into a dinner party, which they smash to pieces; the urbane setting is destroyed by the irruption of the countryside. The shepherd himself is one part satyr and one part Harpo Marx, with his innocent yet malevolent glint and boyish curls. In that, it is perhaps the only Soviet film to pay attention to the American slapstick sound film, where the Marx Brothers intensified Chaplin, Lloyd and Keaton's apparatus of clowning into gigantic, auto-destructive

*1934 poster for* Jolly Fellows,
*aka* Jazz Comedy, *aka* Moscow Laughs

set pieces, causing chain reactions of casual violence and ridicule.

*Jolly Fellows* is in two halves, the first in a seaside resort and the second in Moscow; both are equally imaginary. The 'Moscow' section begins with a glittering Constructivist theatre building, which has evidently been mocked-up, as with the Corbusian collective farm of *The General Line*. Yet this is not the white walls/ribbon windows Weissenhof modernism that was found in the earlier film, but the earlier Constructivism of neon signs, advertisements and 'components', centring on a glass volume that evokes Ilya Golosov's Zuev Workers' Club. It is a glossy, metropolitan architecture designed to let us know

*Eccentric Orlova, in* Jolly Fellows

that we are now in the capital, and typically, it is not a real
Moscow building at all, but a depiction of what the architec-
ture of the Soviet capital 'will be'. It is also hardly avant-garde
in its booking policy – a poster announces Liszt performances,
while the musicians are in tailcoats and bow ties. An imaginary
Constructivist city recurs another time, when a character
looks out of the window prior to a lengthy, Marx Brothers-
like fight scene in a *kommunalka* apartment, where a jazz band
fight each other with their instruments, making a remarkably
formalist noise in the process. Formal distortions are also
used in the fight scene; animated emphases when someone
falls, a hall of mirrors effect on the picture when a man is hit.
At another point, Orlova walks around a rainy Moscow, in
front of a non-existent Americanist-Constructivist building,

visible mainly in the silhouette of its rectilinear frame, near the Kremlin. The imaginary geography is, like the rest of *Jolly Fellows*, fairly unpoliticised; it is merely a signifier of modernity, of big-city metropolitanism, which could easily be replaced with the Haussmannism of the later 1930s without qualitative difference; it merely makes clear that at that point, Moscow modernity was still modernist.

The more interesting modernism in the film is of another sort, however – in the approach to jazz, performance and destruction, where a less propagandistic enthusiasm is at work. When the jazz band accidentally take the stage at the Bolshoi after trudging through heavy rain, their instruments shoot water; the band, and then Orlova herself, start scat-singing to make up for it. There is a demotic jazz modernism in moments like this that are as much an example of the foreclosed possibilities in Soviet aesthetics as anything in the agitational 1920s; anyone, in *Jolly Fellows*, irrespective of their abilities or their class position, can come on stage at the Bolshoi Theatre and produce a joyous, if hardly musical noise, and they can freely burlesque the pomposities of high art. The implicit politics of *Jolly Fellows* don't really emerge until the film's conclusion, when the song about how joyful life will be resumes, and the singers remind us that all this is a reward (to the viewer? to the participant? to the Soviet worker?) for their hard work. At this point, the scene has shifted to a huge neoclassical colonnade. We pan out – seeing the hammer and sickle on the curtain – all the way out into outside of the Bolshoi. After the film finally announces its escapist, consolatory purpose, the film suddenly switches from anarchy to organisation, with a Busby Berkeley tableau in place of the tangle of dancing bodies the film contained before. The violence and disjunction, the attempts to shock the viewer awake are stripped away; the Hollywood-Soviet film is

*Pyramid of pleasure:* Circus

*Pyramid of power:* Circus

now both an organising and pacifying force, offering a dream of better times perpetually just around the corner.

By the time of *Circus* (1936), this has taken over almost entirely. The film is about a young American performer, again played by Orlova, who has fled the United States because she has had a child with a 'negro'.[10] In the Soviet Union, she works as a circus artiste and gradually surmounts various obstacles to become a singer. Whereas *Jolly Fellows* mockingly stated at the start that it was 'not starring Charlie Chaplin', the circus here includes an actual Chaplin impersonator, hat, fringe, moustache and all. Like *Men and Jobs*, the film features a curious linguistic combination of Russian and disjointed English. What changes is that even more than in *Jolly Fellows*, all contradictions and tensions are set up to be resolved. Musically, the film abandons the hot jazz of *Jolly Fellows* in favour of something much more conservative, encapsulated in Orlova's rather schmaltzy, high, tremulous singing style, often interspersed with marching music. The early scenes of the film feature the usual rather antiquated circus tricks – trapeze walkers, a girl shot through a cannon, and so forth, but *Circus* ends with a new form of entertainment, the Mass Ornament. Orlova surmounts a Tiller Girls/Busby Berkeley assemblage, arranged in a tableau of pulsating lights and high-kicking girls. In a rather touching scene, various Soviet nationalities sing a lullaby to Orlova's baby, but this is smothered by the cutting from the circus to the marching of young enthusiasts on Red Square, who are massed in Berkeley-like constructions carried along in front of the assembled Party leaders, as flags of Marx, Lenin and Stalin are waved in the direction of the Kremlin. Here, for the first time in all the films discussed in this book, is a pure image of Stalinist power, the masses arranged in a pyramidal ornament presented at the feet of an absolute ruler.

## The Land of Fairy Tales

*Now Comrade Smirnov declares that he loves Stalin. But love has nothing to do with it. (Kosior: 'Much good love will do him'). The matter has nothing to do with love. Love consists of carrying out the line pursued by the Party headed by Comrade Stalin. [. . .] I would like to speak of one other antiparty method of operation, namely, the so-called jokes (*anekdoty). *What are these jokes? Jokes against the party constitute agitation against the party. Who among us Bolsheviks does not know how we told jokes in order to undermine the authority of the existing system? We know that all factional groups always resorted to such a method of malicious, hostile agitation.*

M.F. Shkiriatov, Speech to the Central Committee Plenum, January 1933[11]

There were some avant-garde works which clearly showed a Chaplinesque approach being used specifically to critique the technological 'rationality' of American capitalism, and most of all Fordism, particularly when it was put into doubt by the depression. Brecht's series of 'Americanist' works from *Mahagonny* to *Happy End* and most of all, *Saint Joan of the Stockyards* show a Meyerholdian approach to montage and farcical comedy as methods for revealing an American capitalism drenched in blood and offal, far from the cold, clean aesthete's reception of Fordism. But the figure who really runs with this is not Brecht, but Chaplin himself. *Modern Times* was released in 1936, the same year as *Circus,* but was also contemporary with the wave of strikes across the United States against speeding-up and 'scientific' management on the part of the Congress of Industrial Organizations. It begins with a famous

parody of the body-warping, panoptic aspirations of Taylorism and Fordism, as Chaplin, the proletarian, is driven insane by an automated feeding machine, and by a spell at the assembly line where he becomes unable to perform any movement other than the scientifically calculated twist of two spanners, which he runs off to inflict on the buttons on the dress of an unsuspecting woman. The sequence in which Chaplin is absorbed into the machine itself, floating between cogs, chains and wheels, which he beatifically adjusts, is a brief fantasy of mechanised labour as a dream, and it's a bitter fantasy. This is how it is not.

Gastev, then about to be arrested in the Great Purge, would presumably not have approved. The fact that Soviet labour practices were at that time moving from the measured precision of Taylorism to the outrageous, athletic feats of the Stakhanov movement would surely not have affected workers' appreciation of the film's portrayal of industrial work. As Raymond Durgnat points out, the film 'attacked the enslavement of man to dogmas of productivity, whether under a profit system or a Stakhanovite one'.[12] It is puzzling in that sense that Guy Debord and Gil Wolman's Lettrist International would publicly attack Chaplin as a representative of romanticised poverty and consolatory sentiment, throwing a leaflet titled 'No More Flat Feet!' at the 1952 French premiere of Chaplin's *Limelight*. No doubt they'd seen him as a consensus figure, loved by the French Communist Party and its intellectuals, at least partly for his fellow-travelling. Charles Chaplin may have had Communist leanings, but the Tramp was more the Situationist.

Sergei Eisenstein shared a certain sceptical response to *Modern Times*, although not to the subsequent *The Great Dictator* (1940), in which 'machine men with machine minds' were safely found only in the Third Reich. In a 1943 retrospective text on Chaplin, 'Charlie the Kid', Eisenstein claims that:

it is precisely the infantilism of humour that makes him the most American of American humourists [. . .] Infantilism is always followed by an escape from reality. [. . .] In a strictly-regulated society, where life follows strictly-defined canons, the urge to escape from the chains of things 'established once and for all' must be felt particularly strongly.[13]

As an example of the processes of such a society, he notes the driving tests he encountered during his time in Hollywood, where a simple 'Yes' or 'No' was the answer to a series of questions, a learning by rote rather than by a process of deduction. This is precisely why *Modern Times* does not make sense in the Soviet context. 'While Chaplin finds a physical way out of the tangles of machinism [. . .] in *Modern Times*, it is in the method of infantilism, providing a 'leap' beyond intellectual machinism, that he finds the intellectual and emotional way out.' You will guess what is coming next.

In the Soviet Union we are not fond of these words. We don't like the notions they express. And we have no sympathy with them.

Why?

Because the Soviet state has brought us in practice a different solution of the problem of freeing man and the human spirit [. . .] At our end of the world, we do not escape from reality to fairy-tale, we make fairy-tales real. For the first time in our country everyone is free to engage in any creative endeavour he or she may wish.[14]

If Eisenstein is not joking here, then he must have believed, like Henry Ford (or his ghost-writer) claimed in *My Life and Work*,

that those who perform industrial labour, with all its boredom and discomfort, did so because they were genuinely not fit for anything else, too slow-witted to take advantage of these fairy-tale opportunities to do absolutely whatever creative tasks they felt like. There was no new stupidity to satirise, no alienation to react against. The dream had been achieved, and there was nothing more to say.

That isn't to say that the Soviet Union in the Stalinist era was not in some respects comic. Raymond Durgnat finds in the Marx Brothers' *Duck Soup* a preview of the mentality of the rigged, farcical spectacle of the Moscow trials. In J. Arch Getty and Oleg Naumov's *The Road to Terror*, an archival work on the 'self-destruction' of the Bolsheviks during the Great Purge, there is a catalogue of shocking farce, where the industrial techniques of precisely-set targets are adapted into the produc-tion of quotas for the amount of people to be arrested in each district. 'These quotas,' they write, 'reflect a focus on sensitive economic areas where the regime believed the concentration of "enemies" to be the greatest [. . .] (and) reflected the regime's inability to specify exactly who was an enemy.'[15] The Five Year Plan's techniques of racing towards arbitrary targets were literally used to specify the amount of people to be arrested for unspecified crimes.

In a reading of *The Road to Terror*, Slavoj Žižek finds an 'eerie laughter' recurring through the Moscow trials and the private hearings that preceded them. In hearings before the Central Committee in 1937, Nikolai Bukharin is 'talking about his possible suicide, and why he will not commit it, since it could hurt the Party, but rather go on with his hunger strike until death.' In the face of this ethical stand, the reaction of Stalin, Voroshilov *et al.* is to giggle at Bukharin's misunderstanding of the situation: 'If this in any way entails any political damage, however minute,

then no question about it, I'll do whatever you say [laughter]. Why are you laughing? There is absolutely nothing funny about any of this.' According to Žižek, 'the discord that provokes laughter' here is based on an 'utter denial of subjectivity'[16] to Bukharin, but equally, it can be read as a Marx Brothers-like malevolence, a scorn for his belief that he can still pose as an ethical human being capable of individual choice, while at the same time accepting the Party's right to purge or even execute him. The greatest laughter is reserved for Bukharin's attempt to secure from Stalin the assurance that he *personally* knows he is innocent, even if it is necessary *publicly* to liquidate him. If Chaplin was funny because he impersonated a thing, Bukharin was funny because he thought he could act as if he wasn't.

Long after the terrifying public farces of the Moscow trials, the Anekdoty, or anti-Soviet jokes, censured by Shkiriatov continued, becoming a famous factor of Soviet life, collected in anthologies even during the Perestroika era; some historians have claimed that they were actually encouraged, and that some jokes were actually planted by Party members to draw attention to some things worth laughing at and draw attention away from others.[17] Another survival is the circus, the Big Top around which the audience watches impossible feats and incredible dangers, which remained an incredibly popular form, much more than it was anywhere in the West, where it was very much superseded by film, television, music festivals and other forms of mass entertainment. The Soviet Union had all of these, but somehow, right up until the 1980s, it continued to build immense circus buildings in every major city. Soviet circuses, like the Moscow State Circus, go on tour around the West, providing a spectacle which becomes a specifically Russian phenomenon due purely to its preservation, lion tamers and all. The circuses are not instantly demountable tents, placed

in parks and then taken away when the fair is over, but heavy, permanent structures. They could be neoclassical, such as the 1950s, Stalin-style Kiev Circus, and they could be modernist, sometimes rather daringly so, flying saucers balanced in the middle of public squares, or the abstracted concrete tent of the Dnepropetrovsk Circus, built in the 1970s. This is where Chaplinism ended, in a spectacle of thrills and spills taken with the utmost seriousness, and treated as if it were permanent.

*A Stalinist circus, Kiev*

*Modernist circus, Dnipropetrovsk*

## Acknowledgements

This book derives from 'The Political Aesthetics of Americanism', a PhD thesis at Birkbeck College, London, that was begun in 2006 and awarded in November 2011. This book basically splits the thesis in half, creating a book on film and discarding as much material on architecture. Those interested in these lost chapters should refer to their partial publication elsewhere: in *The Journal of Architecture* Volume 20 Number 3 (June 2015), *Historical Materialism*, volumes 16.2 (2008) and 18.2 (2010) and the anthology *Skyscraper – Art and Architecture against Gravity* (MCA Chicago, 2012). Thanks to all those who commissioned, and especially, edited these. Parts of this book were delivered as papers at various of the annual *Historical Materialism* conferences in London, and I'm very grateful to those who responded there and then with questions and problems.

Thanks to David Shulman and Emily Orford at Pluto for commissioning and accepting the book, and to David for shockwork on the editing front. For anything that took so long as this to make it to publication the list of people who helped out in the process is too long to recall, but special thanks must be made to Bobby Barry, Gail Day, Matthew Gandy, Benjamin Noys, Agata Pyzik and Jannon Stein. I'm most indebted to the work and the patient supervision of Esther Leslie, for whose lessons in dialectics I am immensely grateful.

Deptford, Greenwich, Woolwich, Mokotów, 2006-2016

# Notes

## Introduction: Americanism and Fordism – and Chaplinism

1. Viktor Shklovsky, *Mayakovsky and his Circle* (London: Pluto Press, 1972), pp. 118–19.
2. Frederick Winslow Taylor, *The Principles of Scientific Management* (New York: Dover, 1998), p. 19.
3. Ibid., p. 21.
4. Ibid.
5. Bernard Doray, *From Taylorism to Fordism: A Rational Madness* (London: Free Association Books, 1988), p. 126.
6. E.H. Carr and R.W. Davies, *Foundations of a Planned Economy, 1926–1929* (Harmondsworth: Penguin, 1974), p. 510.
7. Ibid.
8. This was not entirely idle. In 'Contains Graphic Material – El Lissitzky and the Topography of G', Maria Gough notes that 'like the many other Internationals established in the early 1920s, the Constructivist International adopted its nomenclature in emulation of the mother ship of international socialism founded in Moscow in 1919, the Communist International, or Comintern. El Lissitzky had been a key protagonist in the formation of the Constructivist International in 1922 and had once also claimed to 'have close links with the Comintern', though 'their precise nature remains unclear'; but had also claimed of his transnational activities – 'we are taking not art but Communism to the West'. The 1922–23 period when the 'Constructivist International' briefly came into existence is one still full of revolutionary intensity – the era of the German inflation, and plans for an eventually abortive (except in Hamburg) Communist insurrection. The Constructivist moment is not one of mere consolidation. See Detlef Mertins and Michael W. Jennings (eds), *G – An Avant Garde Journal of Art, Architecture, Design, and Film, 1923–1926* (Santa Monica, CA: Getty Research Institute, 2010), pp. 23–30.
9. That said, there is a link to New York Futurism via Louis Lozowick; see Barnaby Haran's PhD thesis, *The Amerika Machine: Art and Technology between the USA and the USSR, 1926 to 1933* (University College London, 2008) on some under-investigated examples of Americans applying and adapting the ideas of Meyerhold and El Lissitzky.

10. On the ambiguous, difficult slippage between the positive and negative views of America and Americanism in the Soviet press through the period studied, of particular importance are Alan M. Ball, *Imagining America – Influence and Images in Twentieth-Century Russia* (Oxford: Rowman & Littlefield, 2003), Jeffrey Brooks' 'The Press and its Message – Images of America in the 1920s and 1930s', in Sheila Fitzpatrick, Alexander Rabinowitch and Richard Stites (eds), *Russia in the Era of NEP: Explorations in Soviet Society and Culture* (Bloomington, IN: Indiana University Press, 1991) and the interestingly identically-named section 'Imagining America – Fordism and Technology', in Anton Kaes, Martin Jay and Edward Dimendberg (eds), *The Weimar Republic Sourcebook* (Berkeley, CA: University of California Press, 1995), pp. 393–411. The literature on Soviet and Weimar Americanism is extensive, if not always specific. Works of particular importance for this book are: Stephen Kotkin's *Magnetic Mountain: Stalinism as a Civilization* (Berkeley, CA: University of California Press, 1997), Susan Buck-Morss' *Dreamworld and Catastrophe: The Passing of Mass Utopia in East and West* (Cambridge, MA: MIT Press, 2002), René Fülöp-Miller's *The Mind and Face of Bolshevism: An Examination of Cultural Life in Soviet Russia* (New York: A.A. Knopf, 1928), Manfredo Tafuri's *The Sphere and the Labyrinth: Avant-gardes and Architecture from Piranesi to the 1970s* (Cambridge, MA: MIT Press, 1987) and *Architecture and Utopia: Design and Capitalist Development* (Cambridge, MA: MIT Press, 1976), along with contemporary theoretical works such as Antonio Gramsci's 'Americanism and Fordism', in Quintin Hoare and Geoffrey Nowell-Smith (eds), *Selections from the Prison Notebooks* (London: Lawrence & Wishart, 2005), or Siegfried Kracauer's *The Mass Ornament: Weimar Essays*, ed. and trans. Thomas Y. Levin (Cambridge, MA: Harvard University Press, 1995), I found two comparative essays on spatial history in the USA and USSR by Kate Brown exceptionally useful for both their context and contemporary resonance. 'Out of Solitary Confinement', in *Kritika: Explorations in Russian and Eurasian History* 8: 1 (Winter 2007) and 'Gridded Lives: Why Kazakhstan and Montana are Nearly the Same Place', *The American Historical Review* 10: 1 (February 2001).

11. Susan Buck-Morss renders Benjamin's 'dream-images' perhaps even more pointedly as 'wish-images', in *The Dialectics of Seeing: Walter Benjamin and the Arcades Project* (Cambridge, MA: MIT Press, 1999).

12. Richard Stites, *Revolutionary Dreams: Utopian Vision and Experimental Life in the Russian Revolution* (Oxford: Oxford University Press, 1989).

13. The present work uses 'avant-garde' broadly in the terms of Peter Bürger, *Theory of the Avant-Garde*, trans. Michael Shaw (Minneapolis, MN: University of Minnesota Press, 1984), to denote a self-conscious group aiming at the transformation of art through the transformation of everyday life, and vice versa; though it should be noted that such a usage is anachronistic, and the term was never used in the 1920s. 'Left Art' or 'Left Artist', in the definition by Richard Sherwood, is more useful:

    an artist influenced by Futurist, Formalist or Constructivist theories on art, ie a general hostility to imitation of life, in favour of 'creation' or 'construction' of life; hostility to realism in art, or a tendency to utilitarianism; rejection of '*belles-lettres*' in literature, of 'pure' or 'easel art' in painting, and of 'applied art' (in the sense of art 'applied' to a ready-made object).
    Richard Sherwood, 'Introduction to *Lef*, *Screen* (Winter 1971–72), p. 31.

    However, the term is much rarer in the German context. Accordingly, the more precise term *Constructivist* is used whenever possible.

14. For instance. Lily Feiler's Preface to Viktor Shklovsky's 1940 *Mayakovsky and his Circle*, ed. and trans. Lily Feiler (New York: Dodd, Mead & Company, 1972) quotes a contemporary reviewer's criticism:

    that the worldview of the best poet of the Soviet epoch was formed not by the Bolshevik Party with which Mayakovsky had been connected since his youth, not by Lenin's books, which he had read, not by the entire atmosphere of imminent revolution, but by people like Shklovsky, Brik, Khlebnikov . . .
    Feiler, *Mayakovsky and his Circle*, p. xxii.

    This was no doubt extremely unfair; but now the problem is precisely the opposite, with the avant-garde subsumed back into art.

15. Bertolt Brecht, 'No Insight Through Photography', in *Brecht on Film and Radio*, trans. and ed. Marc Silberman (London: Methuen, 2000), p. 144. This precedes the more famous formulation in his *Threepenny Lawsuit* (translated in the same volume), where the named factories are those of Krupp and AEG.

16. One example of this is the work on LEF by Halina Stephan. This does make clear the absolutism of LEF, and the Futurists' occasional (and inconsistent) desire for 'dictatorship' in Soviet arts;

but it does LEF a disservice by considering it largely in terms of a literary movement, see Halina Stephan, *'Lef' and the Left Front of the Arts* (Munich: Verlag Otto Sagner, 1981). This book takes an approach closer to that of Yuri Tsivian, who in an essay on the especially sectarian Kinoks group, warns against considering the avant-garde's often indeed 'totalising' theory separately from their multi-valent practice: the avant-garde's 'self-images were austere and isolationist; their practices, flexible and open. As students of the avant-garde we are sometimes too mesmerised by the former to pay enough attention to the latter [. . .] techniques, ideas and objects easily changed hands'. See Yuri Tsivian, 'Turning Objects, Toppled Pictures: Give and Take between Vertov's Films and Constructivist Art', in *October* 121 (Summer 2007), pp. 92–110.

17. Boris Groys, *The Total Art of Stalinism: Avant-Garde, Aesthetic Dictatorship, and Beyond* (London: Verso, 2011).

18. 'All these "friends" of the USSR approach the problems of the Soviet state from the sidelines, as observers, as sympathisers, and occasionally as *flâneurs*.' Leon Trotsky, *The Struggle Against Fascism in Germany* (New York: Pathfinder Press, 1971), p. 225.

19. Ernst Toller, *Which World: Which Way? Travel Pictures from America and Russia*, trans. Hermon Ould (London: Sampson Low, 1931), p. x.

20. Alan M. Ball reveals that the band, touring the USSR, were 'the Chocolate Kiddies Revue'. *Imagining America: Influence and Images in Twentieth-Century Russia* (Oxford: Rowman & Littlefield, 2003), p. 100.

21. Dziga Vertov, 'Film-Makers, A Revolution', *Screen* (Winter 1971–72), p. 76.

22. Lev Kuleshov, 'Selections from *Art of the Cinema*', (1929) *Screen* (Winter 1971–72), pp. 110–11.

23. Ibid.

24. Ibid., p. 113.

25. Ibid., p. 114.

26. Ibid.

27. Ibid.

28. Ibid., pp. 120–1.

29. Ibid.

30. In the *Pravda* article 'Man's Enslavement to the Machine' in 1914, Lenin describes Taylorism as both a system of sweating and one that could be managed by workers themselves to emancipatory ends.

This is not too different from the later, mooted 'adaptation to our own ends' of elements in the Taylor system in 1918's 'The Immediate Tasks of the Soviet Government', where he refers to it as a system of both 'subtle brutality' and a great 'scientific achievement'. V.I. Lenin, *Collected Works, Vol. 2* (Moscow: Progress Publishers, 1970), p. 663. Similar remarks are made in Trotsky's already quoted 1926 'Culture and Socialism' with reference to Fordism – the key element in Trotsky's partial defence of Fordism is that it would considerably reduce working hours: Leon Trotsky, 'Culture and Socialism' (1926) in *Problems of Everyday Life: Creating the Foundations for a New Society in Revolutionary Russia* (New York: Pathfinder Press, 1973), p. 244. It should not be deduced from this that the Soviet Union was either willing or capable of Taylorising its workforce – in fact, it seems incontrovertible that it was neither. See Daniel A. Wren and Arthur G. Bedeian, 'The Taylorization of Lenin: Rhetoric or Reality?', *International Journal of Social Economics* 31: 3 (2004), pp. 287–99. Similarly, Alan M. Ball finds that Gastev's Central Institute of Labour, although officially sponsored in the 1920s, was marginal-
. ised by the 1930s, with Gastev himself purged in 1938: Ball, *Imagining America*, p. 29.

31. Doray, *From Taylorism to Fordism*, p. 83.
32. Mary Nolan, *Visions of Modernity: American Business and the Modernization of Germany* (New York: Oxford University Press, 1994), p. 82.
33. Of course, Charles Chaplin was not an American. Nonetheless, within a few years of joining Mack Sennett's group in 1914, he was one of the most famous actors and arguably directors in Hollywood, if not the most famous, so a clear exemplar of Americanism; although it is possible that his use of English Music Hall routines, in a morphed, cinematic form made them particularly accessible to Europeans. See Charles Chaplin, *My Autobiography* (Harmondsworth: Penguin, 2003).
34. A recent exception is Paul Flaig's work on 'Weimar Slapstick', such as 'Brecht, Chaplin and the Comic Inheritance of Marxism', in *The Brecht Yearbook* 35 (2010), pp. 39–58. Thanks to David Shulman for the reference.
35. Buck-Morss, *Dreamworld and Catastrophe*, pp. 158–61.
36. Peter Wollen, 'Modern Times: Cinema/Americanism/The Robot', originally published in 1988, in *Raiding the Icebox: Reflections on*

*Twentieth Century Culture* (London: Verso, 2008), p. 40.

37. Peter Wollen, 'Into the Future: Tourism, Language and Art', originally published in 1990, in *Raiding the Icebox: Reflections on Twentieth Century Culture* (London: Verso, 2008), pp. 192–3.

38. Many of the most insightful theorists of popular black music have concentrated on precisely this tension, manifested in the consistent combination of rigid yet 'loose', sexualised syncopation and technological futurism. In particular, Peter Shapiro, 'Automating the Beat: the Robotics of Rhythm', in Rob Young (ed.), *Undercurrents: The Hidden Wiring of Modern Music* (London: Continuum, 2002), and Kodwo Eshun, *More Brilliant than the Sun: Adventures in Sonic Fiction* (London: Quartet, 1997) or the very apposite comparisons between Soviet Constructivist architecture and that most determinedly futuristic black American music – Detroit techno – in Barrett Watten's *The Constructivist Moment: From Material Text to Cultural Poetics* (Middletown, CT: Wesleyan University Press, 2003).

39. J.K. Galbraith, 'Was Ford a Fraud?', in *The Liberal Hour* (Harmondsworth: Penguin Pelican, 1963).

40. Ibid., p. 132.

41. Ibid., p. 140.

42. Mike Davis, *Prisoners of the American Dream: Politics and Economy in the History of the US Working Class* (London: Verso, 1986), p. 51.

43. Ibid.

44. Ibid., pp. 55–6.

45. Ibid.

46. Ibid., p. 186.

47. On this brief 'utopian' Taylorist moment in post-revolutionary Germany, and its replacement with a more grim version of rationalisation, see Nolan, *Visions of Modernity*, p. 90.

48. According to Reyner Banham's *A Concrete Atlantis: U.S. Industrial Building and European Modern Architecture, 1900–1925* (Cambridge, MA: MIT Press, 1989).

49. Gramsci, 'Americanism and Fordism', pp. 302–3.

50. Ibid.

51. Ibid., p. 303.

52. Kracauer, *The Mass Ornament*, p. 81.

53. Ibid.

54. 'The Montage of Attractions', in Sergei Eisenstein, *The Film Sense* (London: Faber & Faber, 1986).

55. Erwin Piscator is, other than Brecht, the main German figure of relevance here, with a similar approach to the montage of attractions. Although he claimed not to have been influenced by Meyerhold, he noted that the emergence of these similar but unconnected methods 'would merely prove that this was no superficial game with technical effects, but a new, emergent form of theatre based on the philosophy of historical materialism which we shared.' However, the comic and circus elements are rather less pronounced. See Erwin Piscator, *The Political Theatre*, ed. and trans. Hugh Rorisson (London: Eyre Methuen, 1980), p. 93.

### 1. Constructing the Chaplin-Machine

1. Second version in *Walter Benjamin: Selected Writings, Volume 3: 1935–1938*, eds Howard Eiland and Michael W. Jennings (Cambridge, MA: Harvard University Press, 2002), p. 118.
2. Gilbert Seldes, *Movies for the Millions: An Account of Motion Pictures, Principally in America* (London: Batsford, 1937), p. 44.
3. It is unclear when Chaplin's films were first shown in both countries, but it is likely to have been after 1918. According to Jay Leyda, the first showing in Russia was of *A Dog's Life*, during the Civil War, though he doesn't specify on which side. Jay Leyda, *Kino: A History of the Russian and Soviet Film* (London: George Allen & Unwin, 1960), p. 145.
4. Viktor Shklovsky, *Literature and Cinematography*, trans. Irina Masinovsky (Champaign, IL and London: Dalkey Archive Press, 2008), p. 64.
5. Ibid., p. 65.
6. 'Let's hope the psychological, high-society film, whose action takes place in a drawing-room, becomes extinct.' Shklovsky, *Literature and Cinematography*, p. 68.
7. The scenes are from *The Gold Rush*:

   Eating the boot (with proper table manners, removing the nail like a chicken bone, the index finger pointing outward). The film's mechanical aids: Chaplin appears to his starving friend as a chicken. Chaplin destroying his rival and at the same time courting him.

   See *Brecht on Film and Radio: A Critical Edition*, ed. Marc Silberman (London: Methuen, 2000), p. 10.

8. Tut Schlemmer (ed.), *The Letters and Diaries of Oskar Schlemmer*, trans. Krishna Winston (Evanston, IL: Northwestern University Press, 1990), pp. 126–7.
9. Walter Benjamin, 'Chaplin', (1929) in Michael W. Jennings, Howard Eiland and Gary Smith (eds), *Walter Benjamin: Selected Writings: Volume 2: Part 1, 1927–1930* (Cambridge, MA: Harvard University Press, 2005), pp. 199–200.
   10. Ibid., p. 94.
11. Ya Braun, 'Bio . . . Fascism (thoughts at the dispute "The Rout of the Left Front")', in *Teatr*, no. 6, 1922, in Aleksey Morozov (ed.), *Constructivism: Annotated Bibliography* (Moscow: Kontakt-Kultura, 2006), p. 10.
12. Aleksandr Rodchenko, *Experiments for the Future: Diaries, Essays, Letters and Other Writings*, ed. Alexander Lavrentiev (New York: Thames & Hudson, 2005), p. 147.
13. Ibid., p. 148. Edison also features in an (unproduced) FEX scenario:

   In *Edison's Woman*, an agitational film scenario written in 1923, Edison creates a robot that comes to Petrograd to 'save the city from the cult of the past', of Petersburg. Once the light of Volkhovstroy (power station) is turned on, the old Petersburg disappears.

   Katerina Clark, *Petersburg: Crucible of Cultural Revolution* (Cambridge, MA: Harvard University Press, 1995), p. 202.
14. Karel Teige, 'Poetism', in Eric Dluhosch *et al.* (eds), *Karel Teige: L'Enfant Terrible of the Czech Modernist Avant-Garde* (Cambridge, MA: MIT Press, 1999), pp. 66–7.
15. Ibid., p. 70.
16. The edition of *World of Laughter* consulted here is a facsimile reprint, published in Prague in 2004 of Karel Teige, *Svet, Ktery Se Smeje* (Prague: Odeon, 1928). The 1930 follow-up, *World of Smells*, features a more Dadaist choice of illustrations.
17. Cendrars and Léger's version of Chaplin is remarkably similar in approach to Schlemmer's, quoted earlier: the schematicised Chaplin sketches that appear in the *Ballet Mécanique* film make the connection between the comedian's movement and that of the products of the Second Industrial Revolution. Léger's Chaplin images are not as 'iconic', or severely Suprematist as Stepanova's, but have more of a chaotic, urban feel to them, fusing the disconnected parts of the marionette's body with fragments of the post-war city.

18. Something that would be reciprocated later, with Chaplin's very public advocacy of Vertov and Eisenstein.

19. Quoted in Aleksandr Gladkov, *Meyerhold Speaks, Meyerhold Rehearses*, written 1934–37, ed. Alma Law (Amsterdam: Overseas Publishers Association, 1997), p. 112.

20. Interestingly, Buster Keaton, usually seen as a less politicised figure than Chaplin, films a far more disruptive and pointed scene set in a bank in *The Haunted House* (1921). As a bank cashier, Keaton accidentally ends up spilling glue over the notes, covering his bourgeois customers in money that they physically can't remove from their bodies, in an impressive making obvious of their pecuniary fixations, a device that fits neatly alongside the stock market sequences in Pudovkin's 1927 *The End of St Petersburg*. However, a comparison of two films in which the actor-directors play convicts (Chaplin's *The Adventurer* [1917] and Keaton's *Convict 13* [1920]) is instructive. Although the humour in the latter is more mordantly cynical, most notably in a farcical execution scene, Keaton is in prison because of a case of mistaken identity. The tramp of *The Adventurer* however actually *is* an escaped criminal, which makes his subsequent charming of an upper-class woman and humiliation of her father all the more threatening. In this sense, Chaplin's sly 'inhumanity' is particularly remarkable, as he is able to elicit pathos to the point where his crime doesn't even need to be explained.

21. It should be noted that more 'conscious' political elements can appear at the edge of the frame; Simon Louvish points out that in 1914's *The Fatal Mallet* a chalked 'ıww' (the Industrial Workers of the World, or 'Wobblies') can be seen in the background of one scene (Simon Louvish, *Chaplin: The Tramp's Odyssey* [London: Faber & Faber, 2009], p. 60). This association of Chaplin and the American libertarian communist union is also made by Hoberman, who finds in Chaplin's 'urban chaos and visceral class awareness' a 'Wobbly esprit de corps'. Jim Hoberman, 'After the Gold Rush: Chaplin at 100', in *Vulgar Modernism: Writing on Movies and Other Media* (Philadelphia, PA: Temple University Press, 1991), p. 121.

22. Julian Smith lists the elements that: 'would delight a Marxist critic searching for images of exploitation' in early Chaplin:

    in *Work*, Charlie is an undersized beast of burden; the drab janitor surrounded by the wealth and glamour of *The Bank* fights back in the only way he can,

with incompetence, laziness, and a final pathetic flight into the fantasy that he has some value in the marketplace; in *Shanghaied*, a corrupt businessman wants to blow up the ship to collect the insurance. Contemplating the last of the Essanay films, the Marxist critic would die and go to heaven, for in *Police* Chaplin plays a convict released from the security of the prison where he had been fed, sheltered and protected into a world of hunger, exploitation and danger.

Julian Smith, *Chaplin* (London: Columbus Books, 1986), p. 31.

23. This is a reversal of the usual order, in Keaton's case. Brought up in a vaudeville family, mechanics was the fantasy of the actor, not vice versa. Edward McPherson quotes Buster Keaton's autobiography:

I was so successful as a child performer that it occurred to no one to ask me if there was something else I would like to do when I grew up. If someone had asked me I would have answered 'civil engineer'.

McPherson notes the obvious, that 'his engineer's mind would serve him remarkably well in his career as a filmmaker. Edward McPherson, *Buster Keaton: Tempest in a Flat Hat* (London: Faber & Faber, 2004), pp. 16–17.

24. Viktor Shklovsky, 'The Man in the Glasses', in *Harold Lloyd* (Leningrad: 1926), pp. 3–4. Many thanks to Thomas Campbell for kindly translating this gratis.

25. There is a short catalogue of Chaplin's interactions with machines in André Bazin's *What is Cinema?*, ed. and trans. Hugh Gray (Berkeley, CA: University of California Press, 1992), and Raymond Durgnat has an exceptionally smart discussion of Chaplin's own machinic nature, which is closely akin to, if clearly arrived at separately from, the ideas of Shklovsky.

Often Charlie moves according to the most rigorous mechanical laws. If he wants to turn a corner at speed, he has to stick out one leg by way of counter-balance. If he wants to run away, he first has to rev up by running on the spot.

Durgnat adroitly links this both to Taylorism, and to the contemporary theories on comedy by Henri Bergson, where 'we laugh every time a person gives us the impression of being a thing.' Raymond Durgnat, *The Crazy Mirror: Hollywood Comedy and the American Image* (New York: Horizon Press, 1970), pp. 70–1.

## 2. Red Clowns to the Rescue

1. Harpo Marx with Rowland Barber, *Harpo Speaks* (Falmouth: Coronet, 1978), pp. 321–2.
2. Sergei Tretiakov, 'Our Cinema', in *October* 118, Special Issue: *Soviet Factography*, eds Devin Fore *et al.* (Cambridge, MA: MIT Press, 2006), p. 41.
3. Teachers' Labour League, *Schools, Teachers and Scholars in Soviet Russia* (London: Williams and Norgate, 1929).
4. Yevgeny Zamyatin, *We*, trans. Bernard Guilbert Guerney (Harmondsworth: Penguin, 1983), p. 21. *We* is often taken as a specifically anti-communist satire, which seems unlikely given that it was preceded by *The Islanders*, a satire of 1910s England in remarkably similar, anti-Taylorist lines. Yevgeny Zamyatin, *Islanders and The Fisher of Men* (London: Fontana Flamingo, 1985).
5. Zamyatin, *We*, p. 47.
6. Ibid., p. 24.
7. Ibid., p. 90.
8. Ibid., p. 61.
9. René Fülöp-Miller, *The Mind and Face of Bolshevism: An Examination of Cultural Life in Soviet Russia* (New York: A.A. Knopf, 1928), p. 33. But see his less critical description of an actual Soviet Taylorist laboratory, Gastev's Institute of Labour:

> The Institute works on the lines of the Taylor experimental investigations in America, but with the idea that the new Bolshevik man of the future can be produced here. On entering the building, you find here a number of investigators engaged in fixing the maximum output capacity of the human organism, and there, in a psycho-technical laboratory, other people, who are trying to ascertain how much energy is used in every movement, and how this movement can be made in the most economical way [. . .] Precision in the investigation of the energy of the organism here celebrates rousing triumphs.

> p. 301. This at least is confined to the factory. Meanwhile, the notion that, by ending the avant-garde experiment, Stalinism thus 'saved humanity' (albeit at the cost of millions of lives) is memorably advanced in Slavoj Žižek's *In Defence of Lost Causes* (London: Verso, 2009); though it is anticipated in the work of Boris Groys.

10. Louis Lozowick, *Survivor from a Dead Age* (Washington, DC: Smithsonian Institution Press, 1997), p. 235. In general, Lozowick's

account shows an awareness of America's industrial and technolog-ical specificity via his encounter with Berlin and Moscow's left artists – not, at first, from his direct experience. Meanwhile, on Taylorism and 'biology', Lozowick provides the following intriguing anecdote:

> The social meaning and function of art were to Moholy-Nagy of prime impor-tance. In this connection I came across a minor but curious case of distortion applied to his thought. In his book, *Von Material zu Architektur,* a footnote reads as follows [. . . ] here is the literal translation. 'The Taylor System, the conveyor belt, etc., are mistakes so long as they turn man into a machine and his manifold contributions serve no one but the employer (perhaps the consumer also, but least of all the worker, the producer) [. . .] And this is the way the translation appears in the English version: 'The "Taylor System", the conveyor belt and the like are mistakes in so far as they turn man into a machine without taking into account his biological basis' [. . .] I wonder whether Moholy-Nagy was aware of this 'biology'.

p. 191.

11. Lozowick, *Survivor from a Dead Age*, p. 235.
12. Richard Stites, *Revolutionary Dreams: Utopian Vision and Experimental Life in the Russian Revolution* (Oxford: Oxford University Press, 1989), p. 161.
13. Vsevolod Meyerhold, *Meyerhold on Theatre*, ed. and trans. Edward Braun (London: Methuen, 1991), p. 314.
14. Ibid. pp. 312–4.
15. It should be noted that Eisenstein later repudiates this, through 'ecstatic', cathartic montages such as the Odessa Steps massacre and, most of all, the cream-separator sequence in *The General Line* (1929).
16. Meyerhold, *Meyerhold on Theatre*, p. 202. Ippolit Sokolov's own conception was more straightforwardly machinic, redolent again of Chaplin-theory's ideas of automatons and marionettes, here with some faintly eugenic undertones:

> The actor on the stage must first of all become a mechanism, an automaton, a machine [. . .] henceforth, painters, doctors, artists, engineers, must study the human body not from the point of view of anatomy or physiology, but from the point of view of the study of machines. The new Taylorised man who has his own new physiology. Classical man, with his Hellenic gait and gesticulation, is a beast and savage in comparison with the new Taylorised man.

Quoted by Mikhail Yampolsky, 'Kuleshov's Experiments and the New Anthropology of the Actor', in Ian Christie and Richard Taylor (eds), *Inside the Film Factory: New Approaches to Russian and Soviet Cinema* (London: Routledge, 1994), p. 49.

17. Quoted in Alan M. Ball, *Imagining America: Influence and Images in Twentieth-Century Russia* (Oxford: Rowman & Littlefield, 2003), p. 29.

18. See Stites on 'Fordizatsiya', *Revolutionary Dreams*, p. 148.

19. Huw Beynon, *Working for Ford* (Wakefield: E.P. Publishing, 1975), p. 109. For a critique extending this to Gastev's own seeming indifference to – or embrace of – the suffering in industrial labour, see Rolf Hellebust, *Flesh to Metal: Soviet Literature and the Alchemy of Revolution* (Ithaca, NY: Cornell University Press, 2003).

20. Meyerhold, *Meyerhold on Theatre*, pp. 197–8.

21. An example of Taylor's unadorned contempt, which is – like much Taylorist thought – based on the assumption that those 'fit' for manual work are wholly distinct from those 'fit' for intellectual work, a 'natural' theory of the division of labour:

> Now one of the very first requirements for a man who is fit to handle pig iron as a regular occupation is that he shall be so stupid and so phlegmatic that he more nearly resembles in his mental makeup the ox than any other type. The man who is mentally alert and intelligent is for this reason entirely unsuited to what would, for him, be the grinding monotony of work of this character. Therefore the workman who is best suited to handling pig iron is unable to understand the real science of doing this class of work. He is so stupid that the word 'percentage' has no meaning to him, and he must consequently be trained by a man more intelligent than himself into the habit of working in accordance with the laws of this science before he can be successful.

Frederick Winslow Taylor, *The Principles of Scientific Management* (New York: Dover, 1998), p. 28.

22. Henry Ford with Samuel Crowther, *My Life and Work* (New York: CruGuru, 2008 [1922]), p. 73.

23. Ibid.

24. Ibid., p. 75.

25. Meyerhold, *Meyerhold on Theatre*, pp. 199–200.

26. Viktor Shklovsky, 'The Art of the Circus', in 1922's *Knight's Move* (London: Dalkey Archive Press, 2005), p. 87.

27. Ibid.

28. Herbert Marcuse, 'The Affirmative Character of Culture', in *Negations* (Harmondsworth: Penguin, 1972), p. 116.

29. Mike O'Mahony notes that the presence of the circus in Bolshevik cultural politics dates from as early as 1918, where 'the recently formed International Union of Circus Artists attended the parade to celebrate the first anniversary of the October revolution.' *Critical Lives: Sergei Eisenstein* (London: Reaktion Books, 2008), p. 31.

30. An honourable exception to this: Werner Graeff's 'Pleasurable Abundance – by Means of New Technology', in *G* issue 4, March 1926.

> Amusement park, pleasure flying, jazz band, elegance, Chaplin and snow-shoeing – in addition, world-travel now and then, and, if need be, spas – all this for everyone, and on demand, is no less important than clean streets and spacious, salutary dwellings. And all this with a two or four hour work day: it is achieved through a complete instrumental organisation of the earth.

*G – An Avant-Garde Journal of Art, Architecture, Design and Film, 1923–1926* (Los Angeles, CA: Getty Research Institute, 2010), p. 190.

31. Sergei Eisenstein, 'The Montage of Attractions', in *The Film Sense* (London: Faber & Faber, 1986).

32. Sergei Tretiakov, 'The Theatre of Attractions', in October 118, Fall 2006, p. 21.

33. Sergei Tretiakov, 'The Theatre of Attractions', in October 118, Fall 2006, p. 25.

34. Boris Arvatov, 'Art or Science', *LEF*, Vol. 4, translated in *Screen* (Winter 1971–72), p. 47.

35. Grigori Kozintsev, Leonid Trauberg, Sergei Yutkevich, Georgi Kryzhitsky, 'Eccentrism', in Richard Taylor and Ian Christie (eds), *The Film Factory: Russian and Soviet Cinema in Documents, 1896–1939* (London: Routledge, 1994), p. 58.

36. Konstantin Rudnitsky, *Russian and Soviet Theatre: Tradition and the Avant-Garde* (London, New York: Thames & Hudson, 1988), p. 124.

37. Although jazz may not have had this implication in *The Magnanimous Cuckold*, which according to Konstantin Rudnitsky marked the first use of it in any context in Russia, although Edward Braun claims this to have been in *D.E. – Give Us Europe*.

38. Edward Braun, *Meyerhold – A Revolution in Theatre* (London: Methuen, 1998), p. 198. The apparently accidental portrayal of the Americanised enemy as more seductive than the revolutionaries

opposed to them appears to have been fairly common. Elizabeth Souritz's *Soviet Choreographers in the 1920s*, trans. Lynn Visson, ed. and trans. Sally Banes (London: Dance Books, 1990) profiles the Bolshoi Ballet choreographer Kasian Goleizovsky's efforts in 1923 to create 'reshapings' and 'imaginative reworkings' of 'a foxtrot, a two-step and a tango' into what he called an 'eccentric erotica' (p. 167). In the 1927 ballet *The Whirlwind*, with Constructivist sets and costumes by Boris Erdman, Goleizovsky attempted to combine eroticism, nudity (with the express support of Lunacharsky), eccentrism, futurism and proletarian revolution. However, the result was apparently a failure, irrespective of the Communists' skimpy costumes: 'the forces resisting the revolution ("black marketeers, hooligans and riff-raff") were shown as incomparably more interesting.' p. 213. A. Petrysky's costumes for Goleizovsky's 1922 'Eccentric Dance' are indeed raffish and erotic, with more than a note of Suprematism's scything spatial drama: see the drawings in Olga Kerziouk, 'Kharkov', in Stephen Bury (ed.), *Breaking the Rules: The Printed Face of the European Avant-Garde, 1900–1937* (London: British Library, 2007), p. 100.

39. Mayakovsky was particularly scathing about the onstage juxtaposition of an (actual) jazz band and the (actual) red fleet, mocking its military pretensions as 'some kind of theatre institute for playing at soldiers'. Quoted in Edward Braun, *Meyerhold – A Revolution in Theatre*, London: Methuen, 1998), p. 199.

40. Christie and Taylor (eds), *The Film Factory*, p. 60.

41. Ibid., p. 60.

42. This poster is reproduced in Rudnitsky, *Russian and Soviet Theatre*, p. 124.

43. Katerina Clark, *Petersburg: Crucible of Cultural Revolution* (Cambridge, MA: Harvard University Press, 1995), p. 180.

44. Leonid Tauberg, 'The Red Clown to the Rescue!', in Richard Taylor and Ian Christie (eds), *The Film Factory: Russian and Soviet Cinema in Documents, 1896–1939* (London: Routledge, 1994), pp. 104–5.

45. Jay Leyda, *Kino: A History of the Russian and Soviet Film* (London: George Allen & Unwin, 1960), p. 201.

46. The use of abstraction in the FEX films appears in a different form in the far less circus-like *The Overcoat* (1926), scripted by and clearly under the theoretical influence of the Formalist Yuri Tynianov; a depiction of commodity fetishism under heavy German Expressionist influence. The abstraction of objects (most obviously the titular coat)

induces its own kind of defamiliarisation, in a far quieter, less immediately disruptive form. Vladmir Nedobrovo wrote in 1928 of this approach as 'the Eccentric association of objects, the disassociation of the object from its normal mileu and the demonstration of its relationship with unusual surroundings'. Ian Christie and John Gillett (eds), *Futurism/Formalism/*FEXS*: Eccentrism and Soviet Cinema, 1918–1936,* (London: British Film Institute, 1978), p. 20.

47. Barbara Leaming, *Grigori Kozintsev* (Boston, MA: Twayne Publishers, 1980), p. 40.

48. Ibid.

49. Leon Trotsky, *Literature and Revolution* (London: Redwords, 1991), p. 267.

50. Leyda, *Kino*, p. 172.

51. Lev Kuleshov, 'Mr West', (1924) in Richard Taylor and Ian Christie (eds), *The Film Factory: Russian and Soviet Cinema in Documents, 1896–1939* (London: Routledge, 1994), p. 108.

52. Olga Bulgakova, 'The Hydra of the Soviet Cinema', in Lynne Attwood (ed.), *Red Women on the Silver Screen: Soviet Women and Cinema from the. Beginning to to the End of the Communist Era* (London: Pandora Press, 1993), pp. 154–6.

53. Ibid.

54. Boris Barnet and Fyodor Otsep's three-part serial *Miss Mend (1926)* is a masterpiece of Kuleshov-style Soviet Americanism, but like *Mr West* its satirical target is American anti-Soviet conspirators, rather than the 'new stupidities'; though the final scenes, both in the depiction of the Red Army's failure to get the baddies and in the lead conspirator's striking death via elevator shaft, are notable, to say the least. Pudovkin's *Chess Fever* (1925) meanwhile, although a formally advanced film (with its use of the 'Kuleshov effect' of montage to make Chess champion Capablanca 'star' in the film inadvertently) has no particular political purpose, which stops it from being directly relevant to this chapter – although it does stand as especially clear evidence that avant-garde methods could result in light, enjoyable comedy rather than arid didacticism, unless perhaps the popularisation of this favourite game of Lenin's was considered of urgent educational value.

55. Ian Christie and Julian Graffy (eds), *Yakov Protazanov and the Continuity of Russian Cinema* (London: British Film Institute, 1993), p. 36.

56. Yet for all its interesting devices, the slow pace and theatrical acting
which apparently made it more palatable to Soviet audiences make
it appear immeasurably more dated to the twenty-first-century
viewer than the work of the FEX or Eisenstein, let alone Vertov. J.
Hoberman, meanwhile, considers *Aelita* to be a 'Trotskyist' film –
something which does not seem altogether far-fetched. J. Hoberman,
*The Red Atlantis: Communist Culture in the Absence of Communism*
(Philadelphia, PA: Temple University Press, 1998), pp. 145–8.

57. As in many works heavily concerned with *Byt*, objects have their own
life in the film; as contemporary critic L. Vulfov pointed out at the
time, 'the bed and the sofa that stand in the room – these are the real
heroes of the picture'. Quoted in Julian Graffy, *Bed and Sofa: The Film
Companion* (London: IB Tauris, 2001), p. 97.

58. Denise Youngblood, *Movies for the Masses: Popular Cinema and Soviet
Society in the 1920s* (Cambridge: Cambridge University Press, 1992),
pp. 36–7.

59. Ibid., Fig. 25. Vance Kepley Jr posits that the filmic avant-garde can
be divided into a commercial, Americanised, narrative-driven faction
(Kuleshov, Barnet, Pudovkin) and an abstract, non-linear, experi-
mental wing (Vertov, Eisenstein, Dovzhenko). In this case, it's clear
that it is only the latter who Youngblood critiques. Yet the cross-
over between these groups is immense, with Pudovkin frequently
'abstract', Eisenstein frequently comic and 'Americanist', Vertov's
films' use of fiercely driven, if non-traditional narrative dynamics, etc.
And Kozintsev and Trauberg fit both descriptions equally well; so the
use of the divide is unclear. Vance Kepley Jr, *The End of St Petersburg:
The Film Companion* (London: IB Tauris, 2003).

### 3. No Rococo Palace for Buster Keaton

1. Louis Lozowick, *Survivor from a Dead Age* (Washington, DC:
Smithsonian Institution Press, 1997), p. 226.

2. Dziga Vertov, 'Film-Makers, A Revolution', in *Screen* (Winter 1971–
72), p. 54.

3. A joke expanded upon in the extraordinary, life-threatening stunt at
the end of *Steamboat Bill Jr* (1928).

4. René Fülöp-Miller, *The Mind and Face of Bolshevism: An Examination
of Cultural Life in Soviet Russia* (New York: A.A. Knopf, 1928), p. 54.

5. Susan Buck-Morss, *Dreamworld and Catastrophe: The Passing of Mass Utopia in East and West* (Cambridge, MA: MIT Press, 2002), p. 105.
6. Fülöp-Miller, *The Mind and Face of Bolshevism*, p. 307.
7. Ibid., p. 70.
8. Ibid.
9. Theodore Dreiser, *Dreiser Looks at Russia* (London: Constable, 1928), p. 27.
10. Ibid.
11. Dreiser, interestingly, sees them as examples of the same species; Dreiser, *Dreiser Looks at Russia*, p. 90.
12. An exemplary analysis of advertising-utopianism: the 'Bullrich Salt' ad discussed in Walter Benjamin, *The Arcades Project* (Cambridge and London: Belknap Harvard, 1999), pp. 173–4.
13. I owe this reference to Gail Harrison Roman, 'Tatlin's Tower – Revolutionary Symbol and Aesthetic', in Gail Harrison Roman and Virginia Hagelstein Marquardt (eds), *The Avant-Garde Frontier: Russia Meets the West, 1910–1930* (Gainesville, FL: University of Florida Press, 1992).
14. Kurt Johansson, *Aleksej Gastev: Proletarian Bard of the Machine Age* (Stockholm: Almqvist & Wiksell, 1983), p. 88.
15. On Hugh Ferris and the formal logic of the zoning code, see Rem Koolhaas, *Delirious New York: A Retroactive Manifesto for Manhattan* (New York: Monacelli Press, 1994).
16. Norbert Lynton, *Tatlin's Tower: Monument to the Revolution* (London: Yale University Press, 2009), p. 129. A recent and hysterical take on 'God-building' as a means of raising the dead by killing millions can be found in John Gray's *The Immortalization Commission: Science and the Strange Quest to Cheat Death* (London: Allen Lane, 2011).
17. Ibid.
18. Sigizmund Krzhizhanovsky, *Memories of the Future*, trans. Joanne Turnbull with Nikolai Formozov (New York: New York Review of Books, 2009), pp. 17–21.
19. Ibid.
20. Ibid.
21. Vladimir Tatlin, Tevel Shapiro, Iosif Meerzon, Pavel Vinogradov (trans. Catherine Cooke), 'The Work Ahead of Us', in Catherine Cooke, *Russian Avant-Garde: Theories of Art, Architecture and the City* (London: Academy Editions, 1995), p. 97.
22. Johansson, *Aleksej Gastev*, pp. 65–6. In an article on Futurism (on

which, like Trotsky and Lunacharsky, he hedged his bets) Gastev wrote: 'contemporary futurism is a child of the street – the street of consumers, not the street of producers.' Ibid., p. 66.

23. Benjamin, *The Arcades Project*, p. 171.

24. Pavlov's reflexology proceeds entirely along the paths of dialectical materialism. It conclusively breaks down the wall between physiology and psychology. The simplest reflex is psychological, but a system of reflexes gives us 'consciousness' [. . .] but the psychoanalyst does not approach problems of consciousness experimentally, going from the lowest phenomena to the highest, from the simple reflex to the complex reflex; instead, he attempts to take all these intermediate stages in one jump, from above downwards, from the religious myth, the lyrical poem, or the dream, straight to the physiological basis of the psyche.

Leon Trotsky, 'Culture and Socialism', (1926) in *Problems of Everyday Life: Creating the Foundations for a New Society in Revolutionary Russia* (New York: Pathfinder Press, 1973), p. 233.

25. These sketches are all collected in Selim Khan-Magomedov, *Nikolai Ladovsky* (Moscow: Russian Avant-garde Foundation, 2007).

26. Nikolai Ladovsky, 'The Psychotechnical Laboratory of Architecture: Posing the Problem', in Catherine Cooke, *Russian Avant-Garde: Theories of Art, Architecture and the City* (London: Academy Editions, 1995), p. 98.

27. Ibid.

28. Münsterberg's applied psychological laboratory work was applied by the author in interestingly Taylor-like terms to industrial and clerical work as well as advertising in Hugo Münsterberg, 'The Market and Psychology', in *American Problems: From the Point of View of a Psychologist* (New York: Moffat, Yard & Co., 1910), p. 151–76; the fixation on psychological perceptions of space was most likely of interest to Ladovsky.

29. This tower, produced in Ladovsky's Vkhutemas atelier, is variously credited to Silchenko (by Cooke) and to Lopatin (by El Lissitzky). The clearest image is on page 61 of El Lissitzky's *Russland: Architektur für eine Weltrevolution* (Berlin: Ullstein, 1965, original 1929). That a skyscraper of this design would not have the psychotechnical effect of inducing a socialist consciousness can be fairly clearly seen in its status as a possible source (unacknowledged, entirely possible, given Ludwig Hilberseimer's role in Chicago architecture in the 1960s)

for the Sears Tower, finished in the early 1970s and still the tallest building in the USA.

30. Ladovsky, 'The Psychotechnical Laboratory of Architecture'.

31. Quoted in Ben Brewster, 'Documents from *Lef*', in *Screen* (Winter 1971–72).

32. Christina Kiaer, *Imagine No Possessions: The Socialist Objects of Russian Constructivism* (Cambridge, MA: MIT Press, 2005).

33. Richard Pare, *The Lost Vanguard: Russian Modernist Architecture 1922–1932* (New York: Monacelli Press, 2008), p. 38.

34. The idea of the New York style building helping affect the rest of the city by example that is central to the discussion here of the Mosselprom tower is supported in Lars T. Lih's essay on Trotsky and war communism:

> Maybe next spring, Trotsky mused at the end of (1920), we could tear down some of Moscow's rotten, filthy, disease ridden apartment buildings and replace them with ones like those in New York City – buildings that included a bath, that provided gas and electricity and where the trash was collected every day. If we could build just one building like this, the response would be colossal. Because up to now the workers see the wheels turning but they don't see the economic machinery working.

It's telling that, given the changed priorities of NEP, the building when constructed was a department store rather than a residential building – which, when constructed, around the same time in the Sokol district, followed a practical but decidedly rustic mode (on Sokol, see Pare, *The Lost Vanguard*, pp. 54–5). Mike Haynes and Jim Wolfreys (eds), *History and Revolution: Revisiting Revisionism* (London: Verso, 2007), pp. 131–2.

35. A scorn shared by Bogdanov. Ben Brewster notes that: 'the Proletkult denounced the "advertising artist Mayakovsky"' A.A. Bodganov, 'Critique of Proletarian Art', in *Proletarskaya Kultura*, No. 3 (1918), referenced in *Screen* (Winter 1971–72), p. 60.

36. Vladimir Mayakovsky, *Listen!: Early Poems 1913–1918*, trans. Maria Enzensberger (London: Redstone Press, 1987), p. 21.

37. Kestutis Paul Zygas, *Form Follows Form: Source Imagery of Constructivist Architecture, 1917–1925* (Ann Arbor, MI: UMI Research Press, 1981), p. xxii.

38. Cooke, *Russian Avant-Garde*, p. 112.

39. This is certainly what is implied in the Mayakovsky-Rodchenko

posters translated by Kiaer in *Imagine No Possessions*, in which the Mosselprom consumer is: 1) personalised as working-class; and 2) spoken to both as a political subject, and someone who will appreciate the humour of exaggeration and coarseness. The argument, which for all its facetiousness is directly linked to the internal politics of NEP, in which state-run or co-operative stores like Mosselprom had to compete with private enterprise, is essentially – 'this beer (or cooking oil, or biscuit) kills capitalism!'. Kiaer, *Imagine No Possessions*, pp. 143–98.

40. Jencks shows an especially vivid example of these in San Francisco. A similar experiment to Vesnins' is the Bila Labat department store in Prague, designed by a group of Czech left Constructivists, Josef Kittrich, Josef Hraby and Jan Gillar. Jaroslav Andel notes:

> the architects were proponents of radical functionalism who saw architecture as science, not art. As members of the Left Front and the Socialist Union of Architects professing social radicalism, their commitment to the building type which was seen as a symbol of organised capitalism might seem a glaring contradiction. However, the ideas of rationalisation and scientific approach which they advocated in architecture were associated with the department store from its beginnings in the 19th century – a fact that becomes obvious by realising how many of the features presented by the architects as novelties, including lifts, conveyers, pneumatic post, and a special system for lighting and advertising, were already present in the department store.

Indeed; but we should note with Benjamin how many of these things have their ancestry in Fourier. In this sense, the Vesnin brothers and the Czech architects were unconsciously bringing these novelties back to their roots in utopian socialism. Jaroslav Andel, *The New Vision for the New Architecture: Czechoslovakia 1918–38* (Zurich: Scalo Verlag, 2006), p. 59.

41. See for instance the design process of the Vesnin brothers' 'Theatre of Massed Musical Activities' in Kharkov. First a modernist building, which is then accepted with the proviso that monumental sculpture be included as part of the building, then a forcible redesign with the Stalinist apparatchiks of VOPRA, then finally the monumental principle takes over the entire design – while the Modernists never had to be forced to turn their works into billboards. Catherine Cooke and Igor Kazus, *Soviet Architectural Competitions: 1920s–1930s* (London: Phaidon Press, 1992), pp. 50–7.

42. Mayakovsky and Tretiakov (eds), *Novyi Lef*, No. 10 (1927). An intriguing backstory to these illuminations is suggested in Ivan V Nevzgodin's '"Press – Fight for Socialist Cities!" Perception and Critique of the Architecture of Novosibirsk, 1920–40'. In reference to a plan for slogans to be projected on the clouds outside the Siberian city's 'Lenin Institute', Nevzgodin claims a possible Futurist root: the 'skybooks' promised by Velimir Khlebnikov in *Lebedia of the Future*. The article is in *Thema*, Vol. 7, No. 2 (January 2003).

43. Regardless, this should at least in part be regarded as a successful mystification. A very different version of the same celebration could be found in the memoirs of a Left Oppositionist, for whom this was all an enormous distraction from the perversion of the revolution's original aims – for Serge, it was the precise date of the Soviet Thermidor. Victor Serge, *Memoirs of a Revolutionary* (Oxford: Oxford University Press, 1975), pp. 225–6.

44. Meyer's co-op works are reproduced in K. Michael Hays' *Modernism and the Posthuman Subject: The Architecture of Hannes Meyer and Ludwig Hilberseimer* (Cambridge, MA: MIT Press, 1997).

45. Anikst, Figure 198.

46. For instance in Maria Gough's *The Artist as Producer*, or Christina Lodder's *Russian Constructivism*.

47. See Christopher Mount, *Stenberg Brothers – Constructing a Revolution in Soviet Design* (New York: Museum of Modern Art, 1997), p. 47.

48. Ibid., pp. 50–1.

49. Ibid., p. 66.

50. I outline these at some length in 'One Better than Stonehenge: On the Gosprom Building and Dzherzhinsky Square, Kharkov', in *AA Files* 62 (2011).

51. Which, in its use in Marfa's dream sequence, perfectly exemplifies the Constructivist 'dream of efficiency'. In 'A Dialectic Approach to Film Form', Eisenstein uses a dynamic, heavily foreshadowed shot of Burov's fantasy factory farm as a depiction of 'spatial conflict' within the shot, via the intersection of architectural planes. Sergei Eisenstein, *Film Form: Essays in Film Theory*, trans. Jay Leyda (New York: Hartcourt, 1977), plate 4.

52. I was able to check this impression due to the screenshot in Anders Kreuger, Asa Nacking, *After Eisenstein* (Lund, 2008), p. 38.

## 4. The Rhythm of Socialist Construction

1. Jay Leyda, *Kino: A History of the Russian and Soviet Film* (London: George Allen & Unwin, 1960), p. 282.
2. 'A Statement', in Sergei Eisenstein, *Film Form: Essays in Film Theory*, trans. Jay Leyda (New York: Hartcourt, 1977), p. 257.
3. Ibid., p. 258.
4. Ibid., p. 259.
5. This scene is replayed as phallic sexual innuendo in Dusan Makavajev's *Love Affair – the Tragedy of a Switchboard Operator* (1967).
6. This generalised mass of noises, often not precisely distinguishable, led to criticism at the time – one viewer complaining:

   if Comrade Vertov and his entire group, who worked on this film, do indeed perceive a difference among these sounds, for the spectator they all merge nonetheless into an unbroken roaring noise without proper nuance. Thus, they do not affect [the viewer] organically, but affect instead his nervous system. Listening to these terrible sounds, at moments one closes one's eyes and feels like falling asleep.

   Quoted in John McKay, 'Disorganised Noise: *Enthusiasm* and the Ear of the Collective', at: www.kinokultura.com/articles/jan05-mackay.html (accessed 1 September 2010). McKay quotes another description of the work as 'a poster in sound', and if so it is clear what sort of poster.
7. Viktor Shklovsky claimed at the time that the viewers were 'physically exterminated by Vertov while watching the film'. Quoted in McKay, 'Disorganised Noise'. McKay also notes that among the film's few contemporary defenders were several actual Donbas workers, supporting the film's stress on the unromantic difficulty of their labour. Perhaps this point is more relevant in reference to the film's closing scenes on a kolkhoz, where this time it is Ukrainian folk songs that are made weird and metallic – the scenes of agricultural abundance here would be followed by famine just over a year later.
8. As in, the left-wing appropriation of the notion of 'the worse, the better'. See Benjamin Noys's *Malign Velocities: Accelerationism and Capitalism* (Winchester: Zero Books, 2014).
9. Cf. Ian Christie, 'Enthusiasm', *Sight and Sound*, March 2006.
10. On Hanns Eisler's use of industrial sound, see his 'Blast-Furnace Music: Work on a Sound Film in the Soviet Union', in Manfred

Grabs (ed.), *A Rebel in Music: Selected Writings*, trans. Marjorie Meyer (London: Kahn & Averill, 1999).

11. Antonio Gramsci, 'Americanism and Fordism', in Quintin Hoare and Geoffrey Nowell-Smith (eds), *Selections from the Prison Notebooks* (London: Lawrence & Wishart, 2005), p. 305.

12. Alan M. Ball, *Imagining America: Influence and Images in Twentieth-Century Russia* (Oxford: Rowman & Littlefield, 2003), p. 123.

13. For a fine analysis of the play of languages and noises in *Men and Jobs*, see Emma Widdis, 'Making Sense Without Speech', in Lilya Kaganovsky and Masha Salazkina (eds), *Sound, Speech, Music in Soviet and Post-Soviet Cinema* (Bloomington, IN: Indiana University Press, 2014).

14. The original is in Joseph Stalin, *Foundations of Leninism* (London: Lawrence and Wishart, 1941), p. 112.

15. Isaac Deutscher, 'Socialist Competition', in *Heretics and Renegades, and Other Essays* (London: Hamish Hamilton, 1955), p. 138.

16. Ibid., p. 143.

17. Ibid., p. 146.

18. Ibid.

19. Ernst Toller, *Which World: Which Way?: Travel Pictures from America and Russia*, trans. Hermon Ould (London: Sampson Low, 1931), p. 114.

20. Ibid., p. 116.

21. Jay Leyda, *Kino: A History of the Russian and Soviet Film* (London: George Allen & Unwin, 1960), p. 297.

22. The most reliable account is R.W. Davies and Stephen G. Wheatcroft, *The Years of Hunger: Soviet Agriculture, 1931–1933* (Basingstoke: Palgrave Macmillan, 2008).

23. Irina Margolina, quoted in the booklet to *Soviet Propaganda, Russia's Animated Propaganda War: Capitalist Sharks and Communism's Shining Future* (DVD, Odeon Entertainment, 2007).

24. Emma Widdis argues that *Happiness'* form was indebted to Medvedkin's viewing of *Grandma's Boy* in 1930; she describes the director's scientific response to its humour, as 'Medvedkin later recalled that he spent four days writing out the entire script of the film from memory, frame by frame, with a full analysis'. Emma Widdis, *Alexander Medvedkin* (London: IB Tauris, 2005), p. 20.

25. Widdis, *Alexander Medvedkin*, p. 52.

## Conclusion: Life is Getting Jollier, Comrades!

1. *Internationale Lettriste* issue 1, 1952, at: www.cddc.vt.edu/sionline/ presitu/flatfeet.html (accessed 30 October 2008). Originally distributed as a leaflet on the occasion of a Chaplin visit to Paris to promote *Limelight* (1952).

2. The phrase is used throughout Kestutis Paul Zygas, *Form Follows Form: Source Imagery of Constructivist Architecture, 1917–1925* (Ann Arbor, MI: UMI Research Press, 1981).

3. This oft-quoted Stalin line, taken from a speech to the first conference of Stakhanovites in November 1935, lends itself to the title of Karen Petrone's *Life Has Become More Joyous, Comrades: Celebrations in the Time of Stalin* (Bloomington, IN: Indiana University Press, 2000), which charts the 'new outbreak of festivity' following the first Five Year Plan. The full quote is: 'life has become better, comrades, life has become more joyous; and when you are living joyously, work turns out well.' Petrone, p. 6.

4. Theodor Adorno, 'The Schema of Mass Culture', in *The Culture Industry: Selected Essays on Mass Culture* (London: Routledge, 1991), p. 70.

5. Ibid., pp. 73–5.

6. Harpo Marx with Rowland Barber, *Harpo Speaks* (Falmouth: Coronet, 1978), pp. 318–19.

7. Susan Buck-Morss, *Dreamworld and Catastrophe: The Passing of Mass Utopia in East and West* (Cambridge, MA: MIT Press, 2002), p. 155.

8. Quoted in Richard Taylor, 'The Happy Guys', in Birgit Beumers (ed.), *The Cinema of Russia and the Former Soviet Union* (London: Wallflower Press, 2007), pp. 79–89.

9. This fact I owe to S. Frederick Starr, *Red and Hot: The Fate of Jazz in the Soviet Union 1917–1991* (New York: Limelight Editions, 1994), p. 154. It is worth noting, however, that Jay Leyda convincingly finds the influence of Salvador Dali and Luis Buñuel in the film; Jay Leyda, *Kino: A History of the Russian and Soviet Film* (London: George Allen & Unwin, 1960), pp. 307–8.

10. For an account of a not-dissimilar flight and its less utopian results, see Langston Hughes's Soviet travelogue, *I Wonder as I Wander: An Autobiographical Journey* (New York: Hill & Wang, 1993), pp. 205–9.

11. Quoted in J. Arch Getty and Oleg Naumov, *The Road to Terror: Stalin and the Self-Destruction of the Bolsheviks, 1932–1939*, trans. Benjamin

Sher (New Haven, CT: Yale University Press, 1999), pp. 87–9.

12. Raymond Durgnat, *The Crazy Mirror: Hollywood Comedy and the American Image* (New York: Horizon Press, 1970), p. 82.

13. Sergei Eisenstein, *Notes of a Film Director* (Moscow: Foreign Languages Publishing House, 1959), p. 169.

14. Ibid., pp. 178–9.

15. Getty and Naumov, *The Road to Terror*, p. 472.

16. Slavoj Žižek, *Did Someone Say Totalitarianism?: Five Interventions in the (Mis)Use of a Notion* (London: Verso, 2002), pp. 102–3.

17. See Alexei Yurchak, *Everything was Forever, Until It Was No More: The Last Soviet Generation* (Princeton, NJ: Princeton University Press, 2005).

# Index

Owen Hatherley writes for *Architectural Review*, *Icon*, *Guardian*, *London Review of Books* and *New Humanist*, among others. His books include *Militant Modernism*, *Landscapes of Communism* and *The Ministry of Nostalgia*.